PEOPLE

PHOTOGRAPHS BY HARRY BENSON

PEOPLE

PHOTOGRAPHS BY HARRY BENSON

Chronicle Books • San Francisco

First published in the United States in 1991 by Chronicle Books.

First published in Great Britain in 1990
by Mainstream Publishing Company, Ltd., Edinburgh.

Printed in Japan.

Library of Congress Cataloging-in-Publication Data

Benson, Harry.
 Harry Benson's people.
 p. cm.
 Includes index.
 ISBN 0-8118-0037-7
 1. Photojournalism. 2. Benson, Harry. I. Title.
TR820.B43 1991
779'.2'092--dc20 91-10181
 CIP

Jacket design by Brenda Rae Eno

10 9 8 7 6 5 4 3 2 1

Chronicle Books
275 Fifth Street
San Francisco, California 94103

To Gigi, Tessa and Wendy

ACKNOWLEDGMENTS

To be a photojournalist you have to have a picture editor who likes your work and will give you the important assignments. Three people come to mind: M.C. Marden of *People,* John Loengard of *Life,* and Mary Dunn of *Time.* Without their encouragement I wouldn't have a career, let alone a book. I also owe a special thanks to some editors: Dick Stolley, who is the editor I've worked with the longest in my career; Lanny Jones of *People;* Jim Gaines of *Life,* Tina Brown of *Vanity Fair;* and Ed Kosner of *New York* magazine. It has also been a privilege working alongside the greats in photography like Alfred Eisenstaedt. I must mention Susan Vermazen of *New York* magazine, Susan White and Charles Churchward of *Vanity Fair;* David Friend of *Life;* David Breul of *European Travel and Life;* Gunn Brinson of the London *Sunday Times Magazine;* Lord Beaverbrook, proprietor of the *Daily Express;* Derek Marks, editor, and Frank Spooner, picture editor, of the *Express* when I came to America with the Beatles; Charlie McBain of the *Hamilton Advertiser;* and Tommy Fitzpatrick and Carlo Pediani. I would also like to thank my assistant of several years, Jon Delano, who I'm sure has a story or two to tell himself. And Mary Sue Morris, Lynn Crystal, Mary Lou Davis and Joyce MacRae, and especially Jackie Lacey of Christie's Glasgow and Jack Jensen and Lesley Bruynesteyn of Chronicle Books for making this book a reality. And last I would like to thank my mother in Glasgow for never doubting and always encouraging me.

CONTENTS

O WAD SOME POWER THE GIFTIE GIE US
TO SEE OURSELS AS ITHERS SEE US!

Robert Burns

FOREWORD

by

James L. Brooks

There he was, a man on the cutting edge of mergers and acquisitions, the 80s, and there she was, the good Catholic girl, the fully trained businesswoman. Since he was also a married man, considered for a cabinet post, he had traveled the country denying their romance and had then made his words particularly hard to swallow by divorcing his wife and marrying the subject of his denials.

Bill Agee and Mary Cunningham were, as a couple, a metaphor for almost anything you can think up, and Harry Benson came to take their picture. In the background of their room was a painting of a young girl kneeling in prayer. Harry, allowing himself to be instinctive (an attribute extraordinarily consistent in his work), asked Board Chairman, C.E.O., power-guy Bill Agee to duplicate the position in the picture (a request that required an extraordinary, pardon me please, set of balls, which is also a consistent element in Harry's life and work) and Bill Agee agreed. Harry took the picture. And Agee's boss saw Harry's picture and reputedly said, "a man who shows judgement that poor in posing for a picture will probably show judgement as poor in running a business." Maybe the boss had never been in love. He fired Bill Agee. It's a great picture, I think. It not only caught the couple but human frailty as well. How foolish we can all be when we're brave enough to fall for the girl. Anyway, I saw the picture in a magazine, talked about little else for days, then tracked down Gigi Benson, Harry's wife and manager, and bought a very large print of the Agee/Cunningham picture. This was years ago, and the picture still hangs in the heavily trafficked video room at my work. It's been there for years, and I stopped telling the story behind it some time ago. It's taken on another life now. No one ever recognizes the couple or questions the oddity of the pose. It is no exaggeration at all to say the picture, at its time, shook at least two business empires and certainly redirected the lives of the Agees, while ushering out an old age (the controversy about Mary Cunningham having galvanized one last public paroxysm over sex roles in the work place), and heralding in a new one (the acquisition of Agee's Bendix Corporation produced the first great corporate war of that recent long, sad era in American business). To me the photograph is no less dramatic after being stripped of its gossipy currency by the passage of a little time. It affects me even more these days when I look above the heads of the people I work with, even as they talk to me, and view the

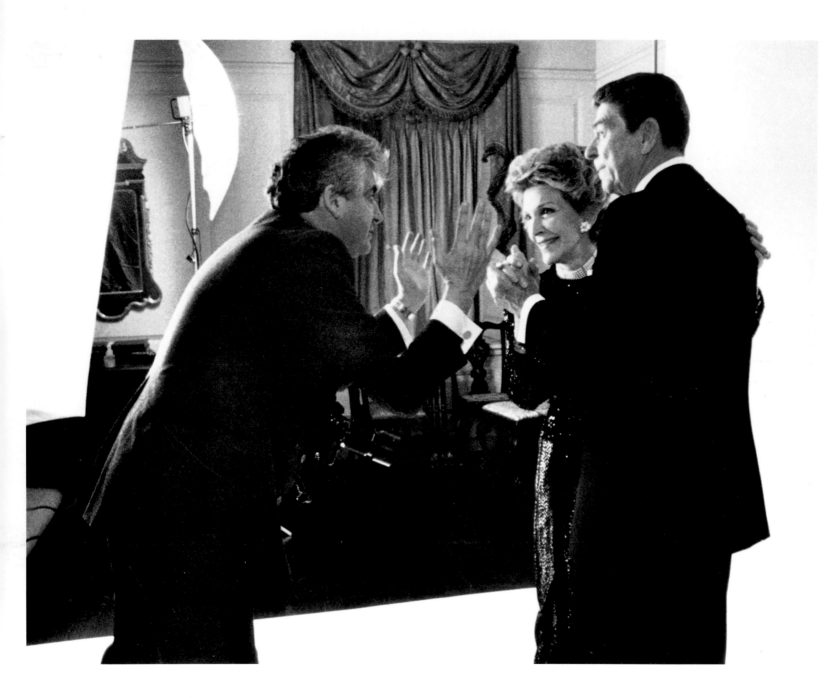

Harry directing the Reagans in the White House for the 'kiss' photograph.

now-anonymous couple caught in that awful and vulnerable moment.

About a year after acquiring that photo I asked for a slew of Harry's pictures to decorate the house of my favorite character in *Broadcast News*, a solid journalist whom I knew would appreciate the horrible truths in the Benson photographs of such newsworthy figures as John Mitchell.

I was getting ready to contact the Bensons again, looking through the soft-cover edition of this book, trying to narrow the field to a few photographs that I would ask to purchase, when Gigi Benson called to ask if I'd write a foreword for the book. Complying with her request has had an impact on my struggle to choose which pictures I most want. It was much easier before my sense of responsibility forced me to study the book rather than just enjoy innumerable browses. For awhile there, I was sure of the ones I wanted.

I've spent a good deal of my adult life in comedy so naturally I thought first of that shot of Mrs. Helmsley with the hotel maid in the background. I spent some time in Washington and heard a lot of "inside stories" about President and Mrs. Reagan. I don't think anyone has captured the essence of this couple in rumor or writing better than Harry did in the six minutes they gave him to take their picture.

I find one aspect of Harry Benson's career enormously praiseworthy and yes, inspiring. He has refused to stray for too long from his roots, even though those roots appear truly grungy alongside the top assignments from high-gloss magazines that constantly roll in like silk from the worm farm. Harry started as a news photographer, a raw group of critters to spring from. I once knew a top photo-journalist for a big city daily who carried baby shoes with him always. He didn't have a baby but thought they might come in handy to decorate any major car accident he happened across. I bring this up not because it has anything to do with Harry, but because it does have to do with the breed he jostled elbows with as he competed to define and capture the passing scene in his news photos. Invariably he realized a higher goal than these men—who will stoop to anything as a first resort—could possibly imagine. Do you think anyone in the mob of photographers got nearer to the truth of the moment than Harry did as they battled for a shot of Jacqueline Kennedy in London in 1961 or of Ethel Kennedy in Los Angeles in 1968. Has anyone produced a photograph that has more haunting delicacy than Harry Benson's picture of the schoolboy, David Field, who escaped the fate that made all his classmates vanish? Harry Benson has even managed to dignify the most tacky of all assignments: Laying in wait to photograph someone who doesn't wish to be photographed. Check out the Garbo picture to sample the richness of

the soil at Harry's roots. The Garbo picture is my current choice in the puzzle of which one to go after for my wall.

This book, it occurs to me, is a dangerous first-date volume. Any new couple sharing a look would also be sharing such an extraordinary gaze into the human condition that they might never discover whether it was their chemistry or Harry Benson's art and craft which drew them close.

A last thought before clearing out: I know two of the people portrayed in this book quite well. I know Tracy Ullman. I am therefore quite sure that deep within her subconscious lay the ambition to be photographed with her dog pissing on her foot. It couldn't possibly have happened without Harry's luck. I know Bill Hurt, and once, during an exhausting photo session with another photographer, I asked him how he managed to get through the ordeal of posing. (I was particularly hungry for advice because I was next up to have my picture taken). Bill said, the thing to do is to try to see the photographer through the lens and react. The way Harry appears to Bill, as evidenced by the picture, might be the greatest compliment of all.

James L. Brooks

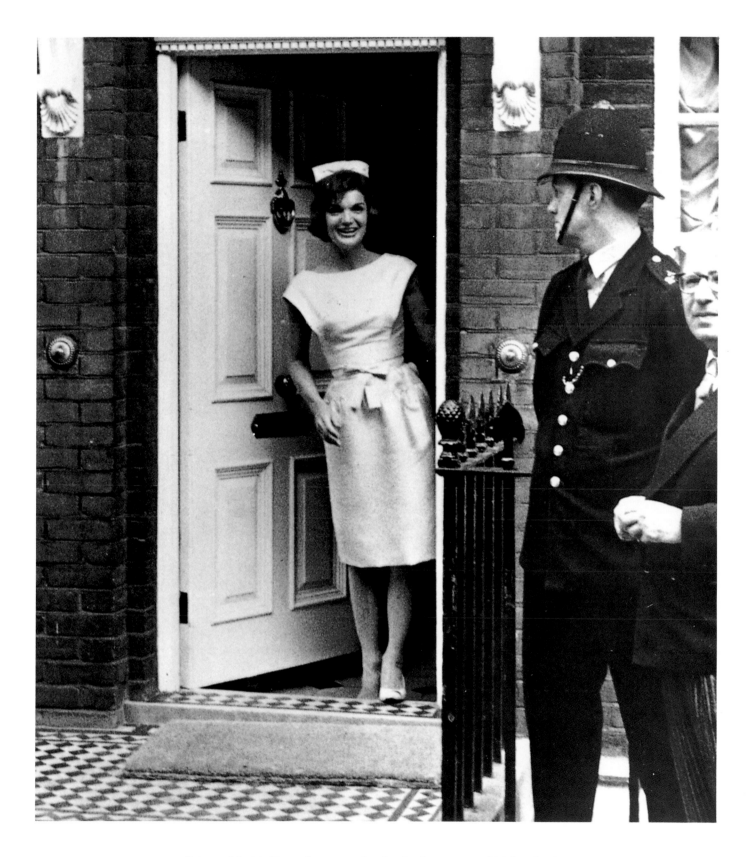

John and Jackie Kennedy came to London in the summer of 1961, after he became President. London and Paris belonged to Jackie – the press couldn't get enough of her. I must have stood outside her sister Lee Radziwill's house for six or seven hours, for it was late in the afternoon when Jackie stepped out to give the waiting photographers a picture.

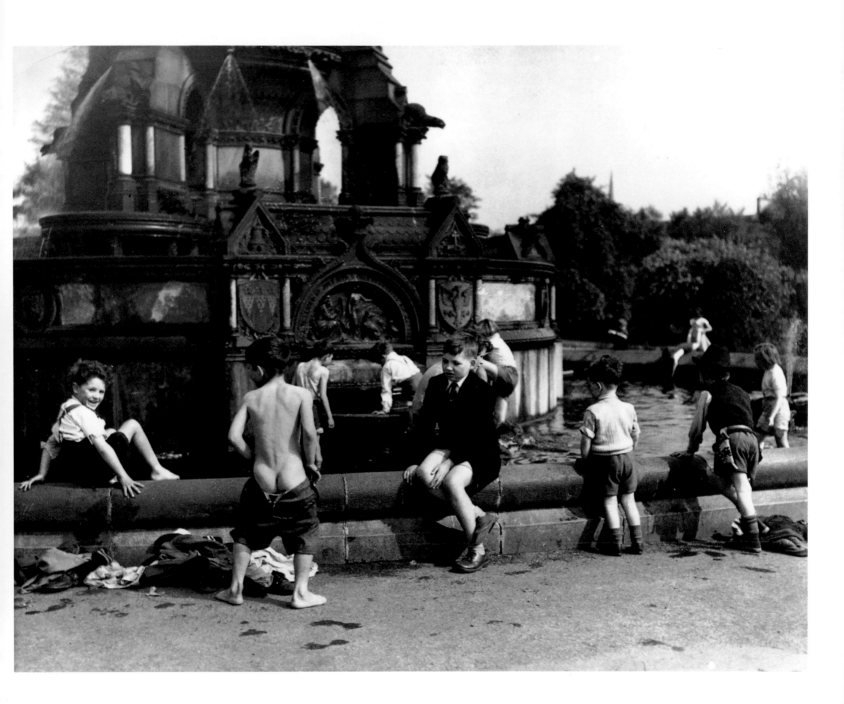

One afternoon in 1956 I was walking around the Botanic Gardens looking for a picture
for the *Sketch*. I happened upon some Glasgow boys up to some mischief. They were
cooling off in the Glasgow heatwave although the temperature was no more than
seventy-five degrees.

INTRODUCTION

To HAVE an air around my photographs, a space between me and my subjects, is what I like. It's the way I like to work all the time. I don't have a traditional approach. That's why I don't agree with a lot of photographers holding and controlling – there's no air. Trying to control and impose limits on what is happening stifles a photograph. Give the subject air – a freedom – on the off-chance that something spontaneous and natural, something you hoped for, will happen. Something spontaneous is what I always hope for in a photograph. Not trying to hide my presence, I want the whole situation to move, to give the subject some room. Either nothing happens or something wonderful will happen. I don't want my subjects to be made of wood or granite. Photography has got to be fun, it has to be. Why should I try to take photographs like another photographer?

Since I started taking pictures, the content has always been much more important to me than having the sharpest focus or best lighting. Getting the picture is what I want. It's the subject-matter, the content, that counts. 'But what does it mean?' are the words I hear, is the question I've asked all my life in photography. To me a photograph must give information. I like to have information in my photographs. If there is no information, after a time the picture is no longer valid. Pictures I like to take say, 'This was the time, this was the place, I was there.' It doesn't always happen. It's awful when it doesn't.

The problem, the trouble I have with pictures is that afterwards sometimes they embarrass me. I feel really embarrassed by a picture with no wit or edge. A photograph must have a wit and an edge, when you get the better of the subject and get something unexpected, something different.

When I take a picture, sometimes it's very hard to move and other times – not all that often – things get going very well, everything is there on a high level of energy. I'm in another area, on another plane, and it's a wonderful feeling. I push that moment as long as I can to make sure I've taken everything out of the situation, as far as I can go and back again.

Sometimes I have to work very quickly. If I'm not starting to show

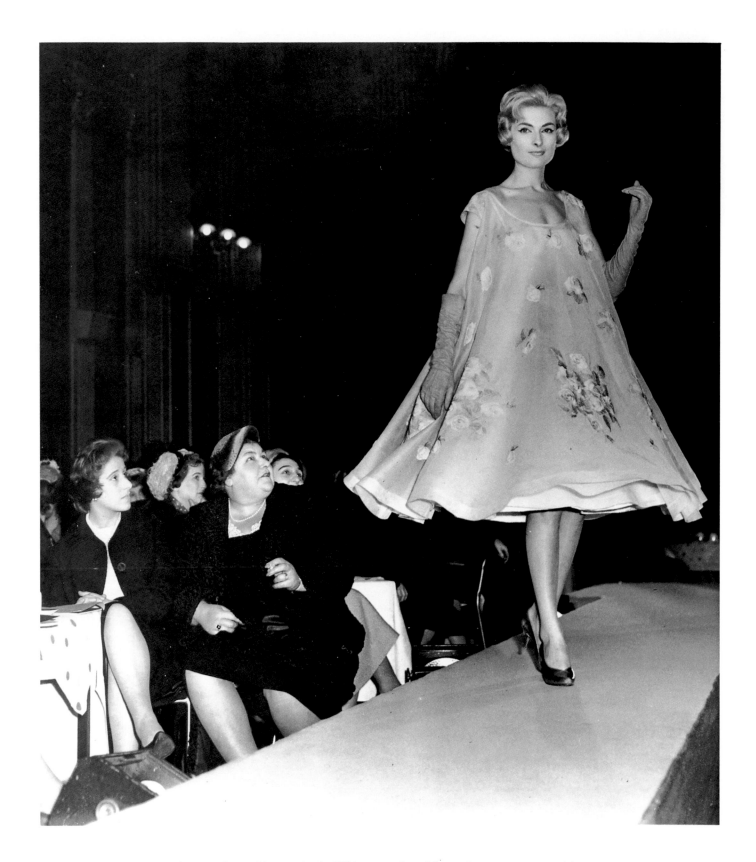

Photography in Glasgow in the Fifties was a lot of fun and very, very competitive.
There were an awful lot of good photographers around. It was very hard to get a job.
This photograph was taken in 1957 at Daley's Department Store in Glasgow for the
Daily Sketch when the trapeze-style dress first appeared. The picture was taken with an
MPP, a British copy of the Speed Graphic plate camera.

signs of getting people moving in the first ten minutes, I've got problems. Usually I'm a stranger working in the subject's territory, their home, their office, their familiar ground. If I'm not careful, I can lose it, the momentum. But if I can get myself moving, I can usually get the subject moving. My photography is schizophrenic, dissociated — I don't like to make people too important. A lot of photographers are overawed by their subjects, after all we are keeping their image alive.

Opportunity comes up in photography like an express train, and you've just got to catch it. Looking back on some assignments, I missed it and wish I could go back and photograph them again. Not the Beatles, I feel I photographed them well, even though at the time they were being touted by some as just a flash in the pan, a six-month wonder.

A good picture is obvious, it speaks for itself. It's not a secret. Either you like it or you don't . . .

Photography for me was a godsend. I really don't know what I would have done if photography hadn't been invented. Having to leave

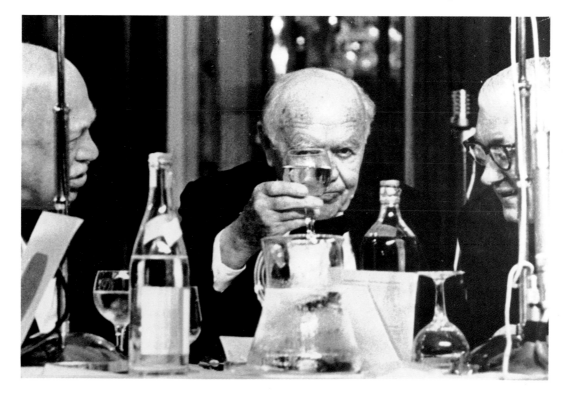

Lord Beaverbrook, proprietor of the London *Daily Express* when I worked there, was the most important person in my journalistic life. I thought he was terrific, the greatest of the press lords. Here he is being given an eighty-fifth birthday party at the Savoy Hotel by another Canadian newspaperman, Lord Thompson of Fleet.

school at fifteen or having to repeat the same grade for the third time were my choices. It was obvious that traditional schooling was not for me. I fared better at the Glasgow School of Art.

My father gave me a box camera, a Coronet Cub, for Christmas when I was eleven years old. My first published picture of a roe deer was taken in Calder Park Zoo, which was founded by my father. It was published in the Glasgow *Evening Times* and I sat and looked at that picture for hours. I can't remember if they paid me for using it, but that wasn't important. Seeing the picture in print was what mattered. That feeling has never left me.

When I was in the Royal Air Force I tried to join a camera club on the base in Bedfordshire. Submitting my photographs to the committee that ran the club, I was told my pictures were not up to standard. Looking back, they were probably right because the pictures were only of things that interested me – football players and dogs. I find it so depressing to remind myself of all this.

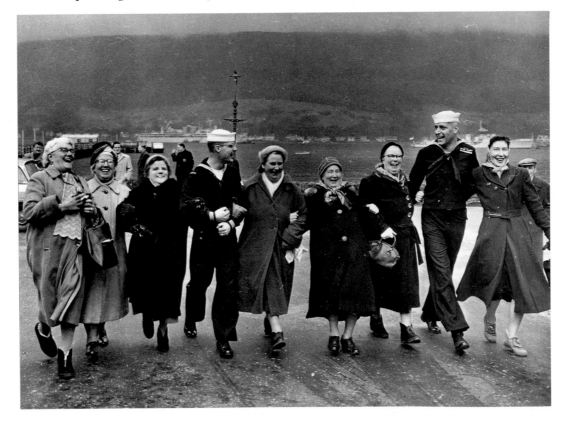

There is an energy in these women, these Glasgow housewives, greeting American sailors from a submarine carrying Polaris missiles when they docked in Glasgow in 1961. There had been a controversy over whether or not the sub should be based in Glasgow, but these women didn't seem concerned. They were giving the sailors an enthusiastic welcome.

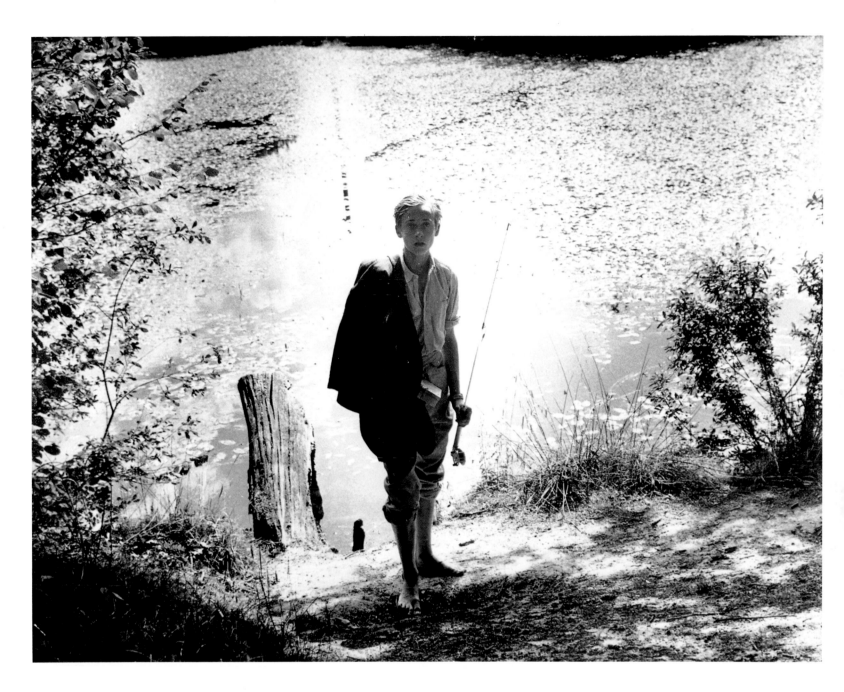

English schoolboy, David Field, couldn't afford the plane ticket when his class
went on a school trip to Norway in 1962. The plane crashed, killing all his
classmates. I went to his home outside London to photograph him the morning
after. His parents had sent him fishing to take his mind off the tragedy. He
seemed so isolated, so alone.

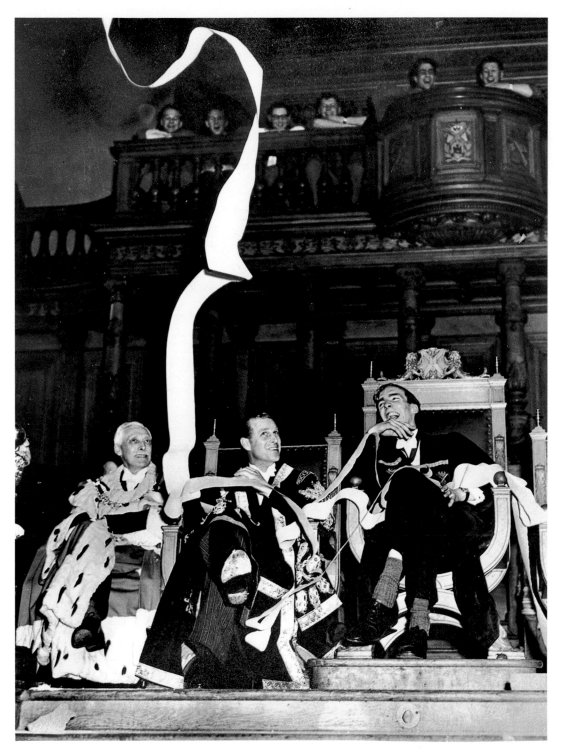

Prince Philip, Duke of Edinburgh, had just been made Chancellor of Edinburgh
University. The ceremony became a riotous affair, with the students showing
their appreciation by throwing toilet paper and flour at him. This picture helped
me win a British Press Photographer of the year award in 1957.
When I asked the *Daily Mail* office to develop the film for me (my paper, the
Sketch, was part of the same newspaper group), I made the mistake of telling
them I had a picture of the toilet paper flying through the air, which their
photographer had missed. When the plate went into the developer, the printer
turned on the light in the darkroom. As a result, this picture is only half
the frame; the other half was fogged — deliberately.

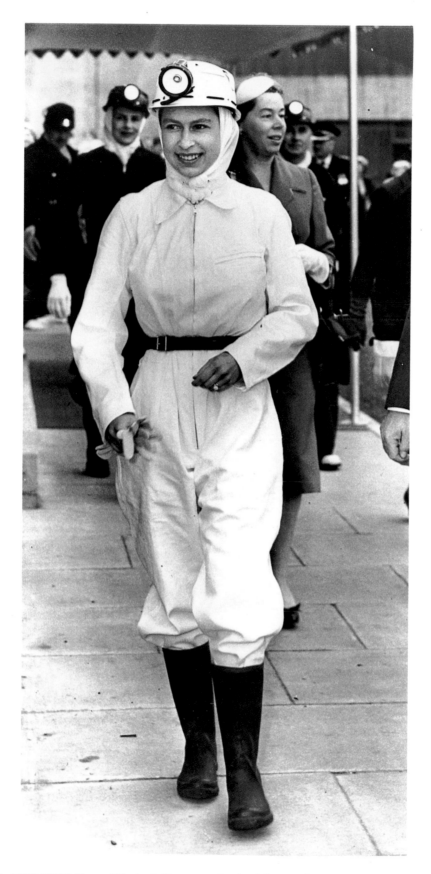

In 1957 HRH Queen Elizabeth II came to Scotland for an official function, to open a coal mine. She dressed for the occasion.

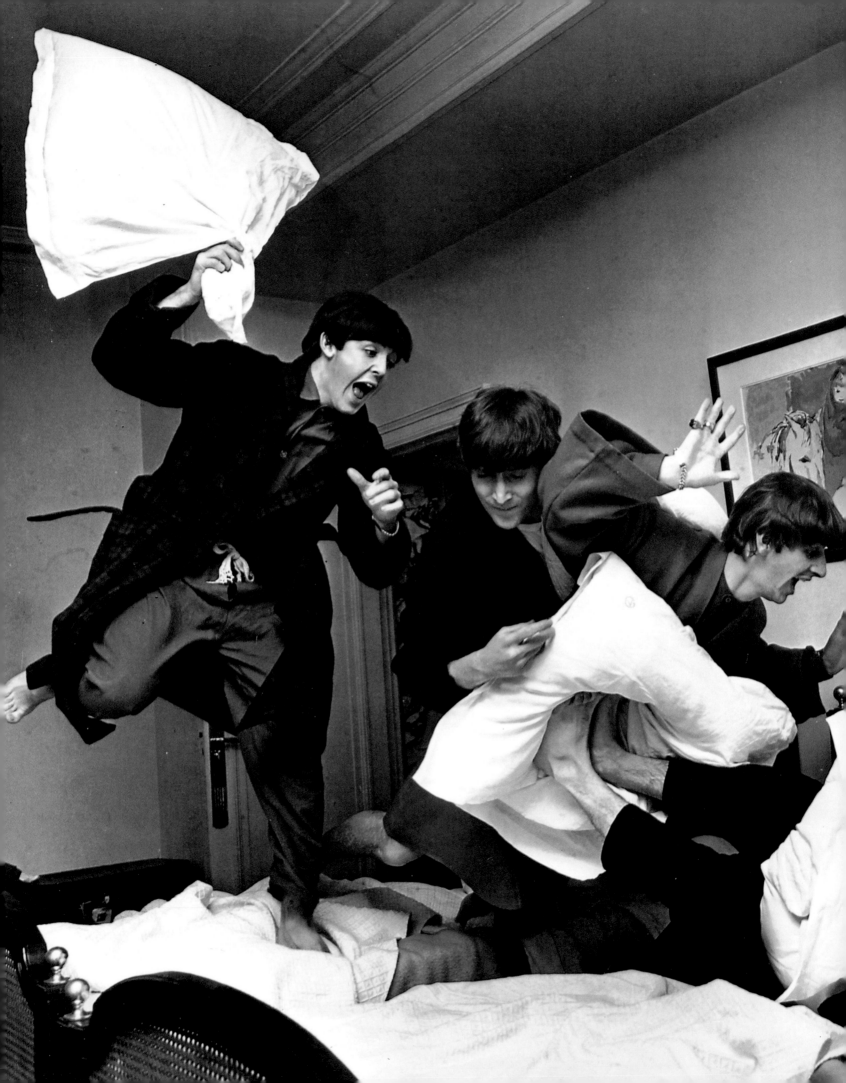

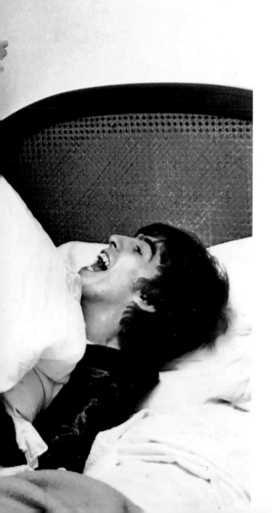

The Beatles. Paris, France, 1964
They were all just young kids, not really knowing what
was happening. It was all happening so fast. We were
in John Lennon's room in the George V Hotel. They
couldn't go out because they would be mobbed. It was
three in the morning when Brian Epstein rang to say 'I
Want to Hold Your Hand' was Number One in
America and they would be going there to appear on
the Ed Sullivan Show. They were elated. I had seen
them have pillow fights before, but the exuberance of
this one almost became violent at times.

When I tried to get a job on the Glasgow *Evening Citizen*, the picture editor told me I should be feeding animals in my father's zoo. I hated that man when I left his office. Criticism like that knocks you right off balance for a long time.

My first newspaper job which was really my beginning in journalism was for the *Hamilton Advertiser*, the largest local weekly in Scotland. Four years under editor Tom Murray was the equivalent of a university education. Some days I took the train to London trying to get a job on Fleet Street, then the home of the British press. My colleague at the *Advertiser* and my friend today, Charlie McBain, used to cover for me and do my work while I went walking around Fleet Street with my portfolio. On about my seventh trip, I finally got to see the assistant picture editor of the *Daily Sketch,* Freddy Wackett. I could tell, I got the feeling, that he was slightly impressed. On the way out I asked if there was a chance, and he gave me a little nod. Within two years of covering Scotland for the *Sketch*, I moved to London, working later for *Queen* magazine and the *Daily Express*. When I came to America with the Beatles on their first tour I knew I would never go back.

I'm just as keen now as when I started out, just as apprehensive, just as insecure, just as excited at the prospect of taking pictures that hopefully people will want to look at. I like the challenge of not knowing what lies ahead.

One minute I'm on the second floor of the White House; in a few hours I'm working on a cover photograph in the studio. It's a little like changing channels on the television set. I have to be able to switch channels, to switch emotional channels quickly.

It's an adventure to record the lives of important, intelligent or famous people and if they are all three, better yet. To give an honest impression, to get people to let their guard down so that I can photograph what they usually like to keep hidden, to capture a moment that won't be repeated, to take that one photograph worth looking at, is what I want to do.

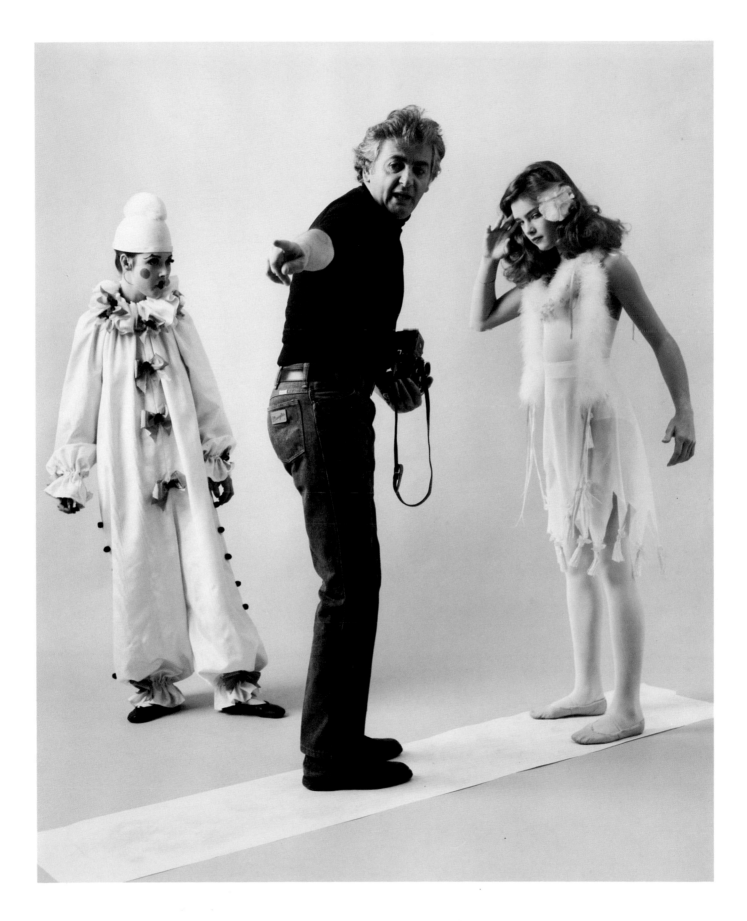

Harry in the studio with Brooke Shields and model, Kay Zunker.

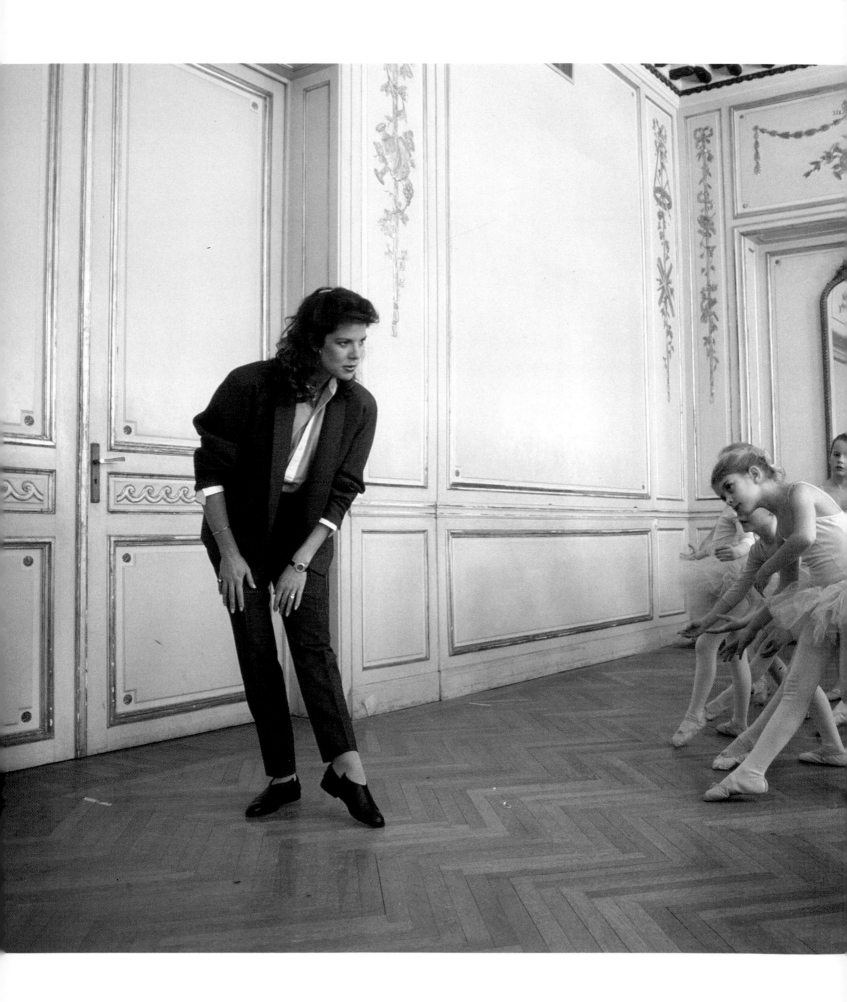

Princess Caroline of Monaco. Monte Carlo, Monaco, 1986
Having preconceived notions and expecting some kind of flighty jet-setter, I was
pleasantly surprised by her gracious, sensitive manner. She is a patron of the
Royal Ballet of Monaco which was a favorite of her mother's.

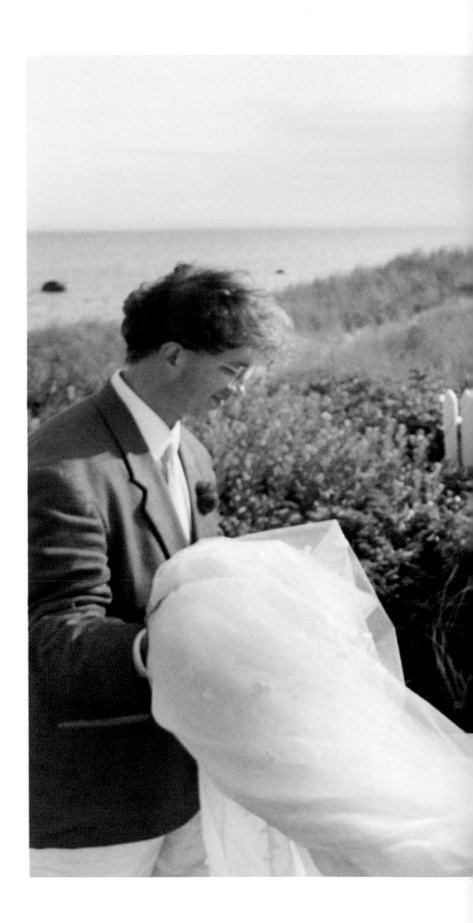

Caroline Kennedy.
Hyannis Port, Massachusetts, 1986
A very happy wedding day with the whole family in
attendance, she was given away by her Uncle Ted. Her
mother was nervous and Caroline was making the most
of her day. Of all the photographs I took that day
Caroline, her mother and I all liked this one the best.

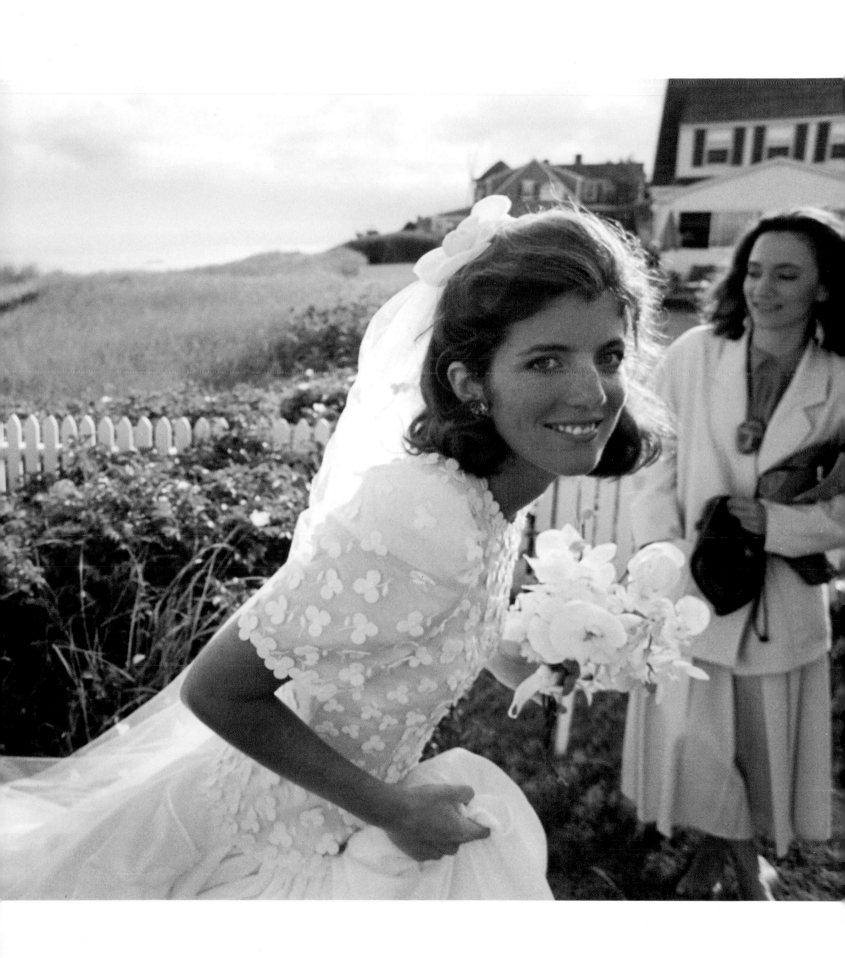

Alexander Solzhenitsyn. Vermont, 1981
It was the first time in his eight years of exile from
Russia that anyone had been allowed to photograph
him at his home. I asked him what he liked about
his adopted country, and he said the air smelled
free in America.

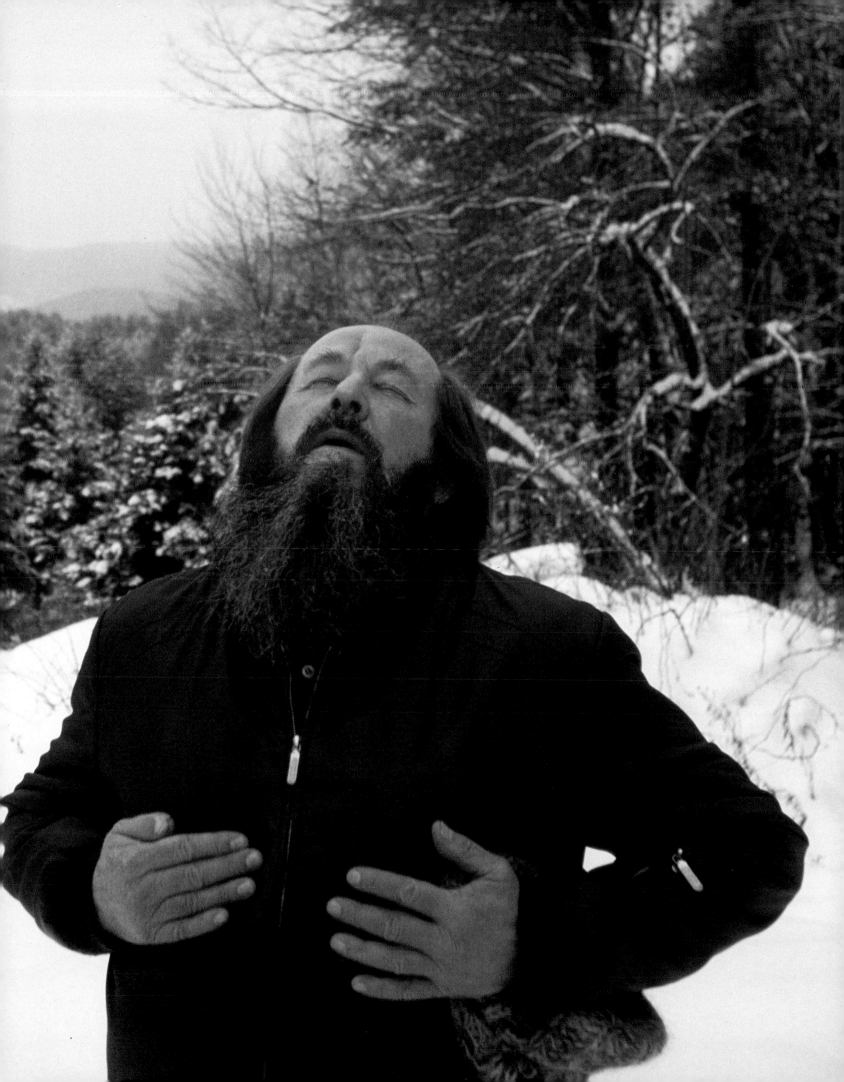

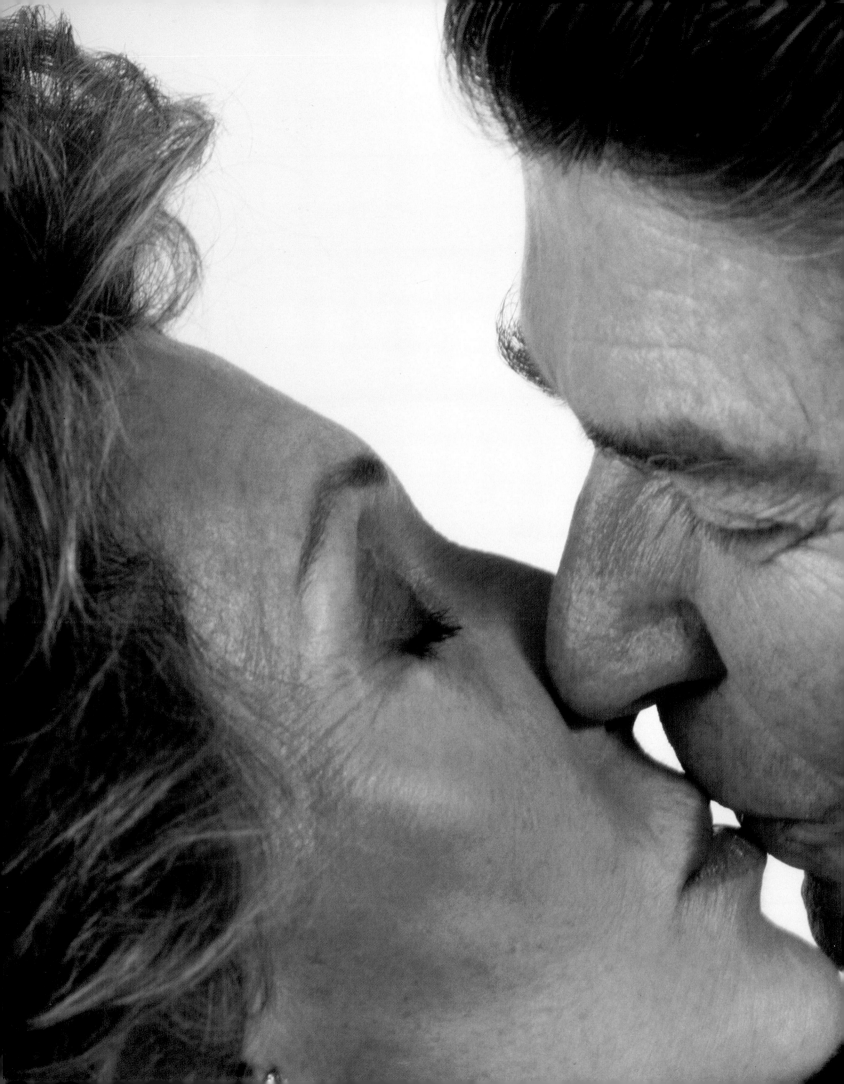

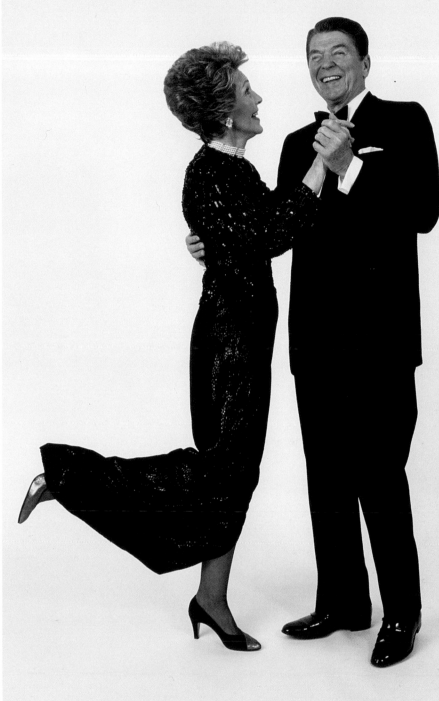

President and Mrs. Ronald Reagan. The White House, Washington D.C., 1985

It was apparent that theirs was a genuine love story. I wanted to show it in the form of the big-screen kiss at the fade out of a Hollywood film. When *Vanity Fair* asked me to photograph them in the White House, I got my chance, but only for six minutes. In a small room off the main ballroom on the night of a state dinner they were to stop off for a quick photograph. When they arrived I put on a tape of Sinatra singing 'Nancy with the Laughing Face'. They smiled and started dancing.

33

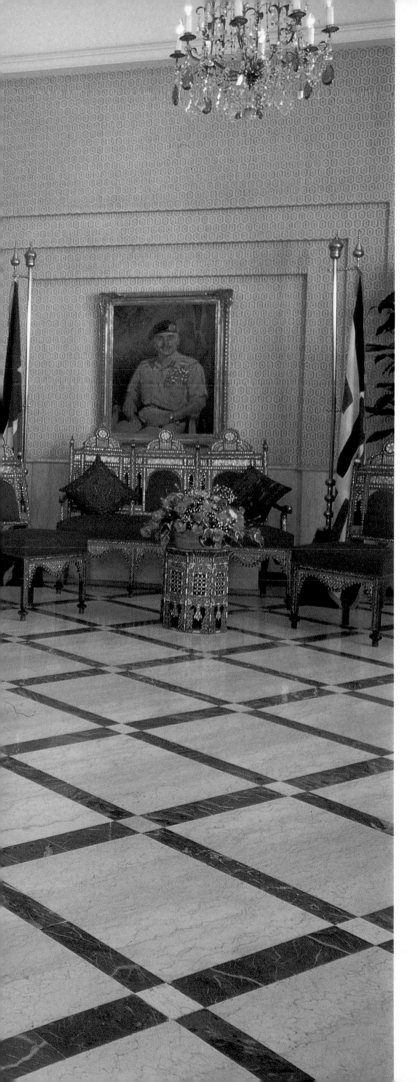

**Queen Noor al-Hussein of Jordan.
Amman, Jordan, 1988**
On first impression, I thought she was going to be a
really happy, good-natured, young American woman,
but I was wrong. Every time I addressed her I had to
say, 'Your majesty.' 'Would you stand here, your
majesty? Would your majesty sit there?' It seemed
so undemocratic for someone who had
attended Princeton.

35

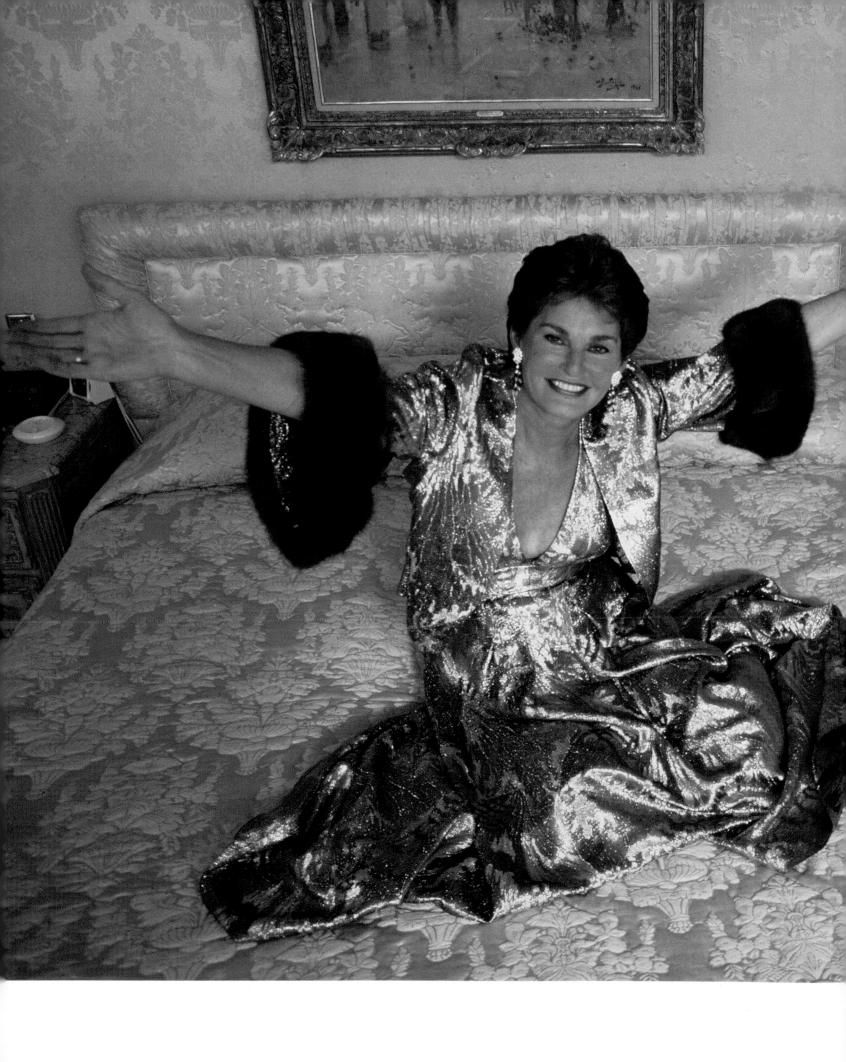

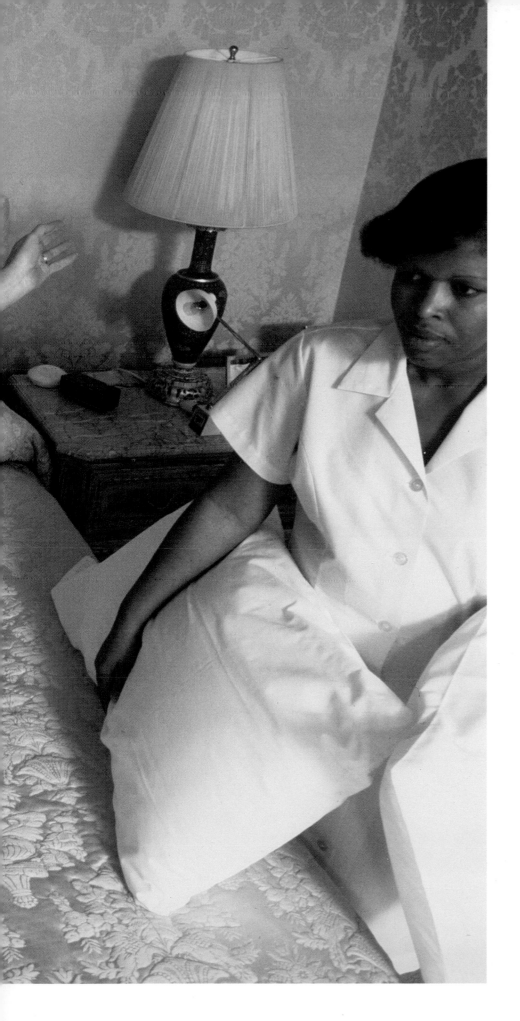

Leona Helmsley. New York, 1984
She enjoyed being queen of her hotels. She relished the
power. She liked to walk down the corridors telling any
of her employees in passing who she was and what to
do – dust the table, empty the ashtray.

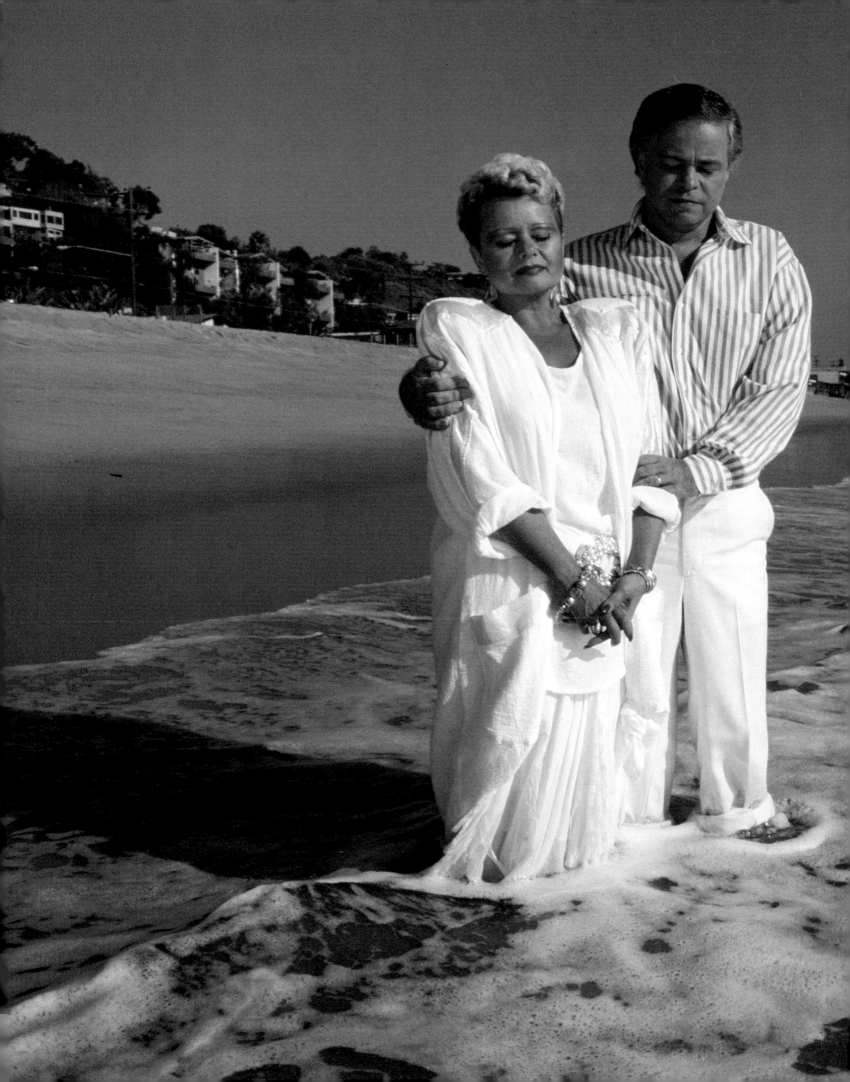

Jim and Tammy Bakker. Malibu, 1987
I wanted to photograph them near the water at the beach-house they had rented shortly after his trouble began with the PTL (Praise the Lord) Ministry began. Working them down to the water's edge I heard someone from the house shout, 'Don't go any further, you'll get your feet wet.' I sent my assistant, Jon Delano, to tell that person to keep quiet. The water eventually came up around their feet. Tammy told me she was worried that in the heat her mascara would melt. He was smaller and she was larger than I had expected. If anything, they were bewildered by the situation they were in—being accused of diverting funds from the PTL for their personal use and having a secretary accuse Jim of asking for sexual favors with hush money thrown in.

39

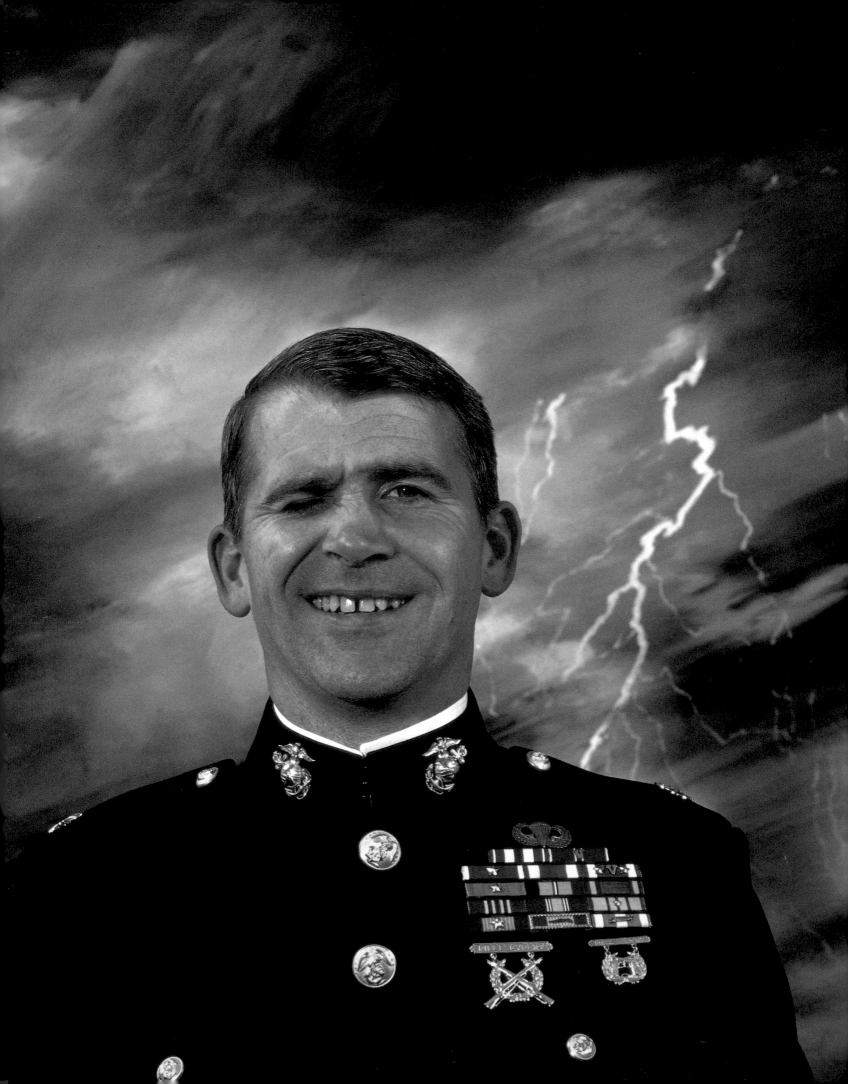

Marine Lt. Col. Oliver North. Washington D.C., 1987
He completely believed that what he had done in the Iran-contra affair was right. Fifty-five million television viewers watched as he explained why he believed the U.S. was right in selling arms to Iran and in using the money to aid the Nicaraguan contras. Very self-righteously he also told me none of the men under him in Vietnam had ever smoked any dope. Some people thought he was an American hero, a man who would go through fire and brimstone in his fight against what he felt was a Communist threat.

41

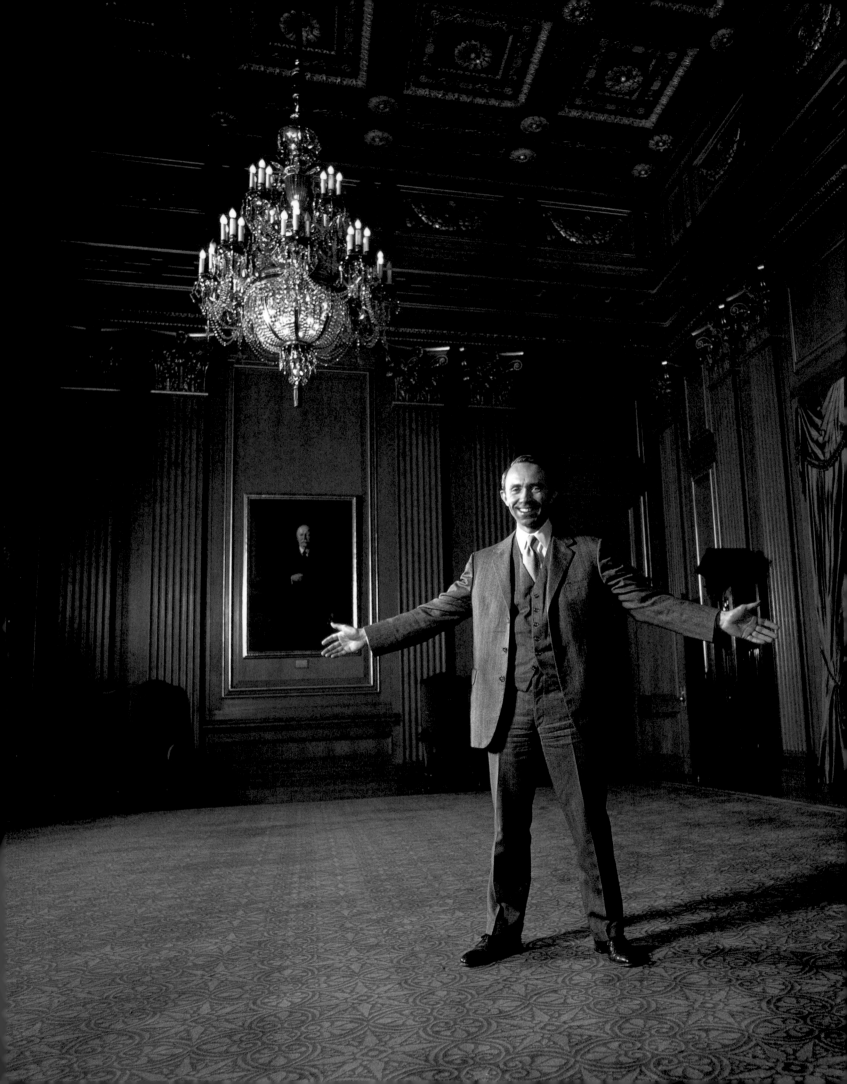

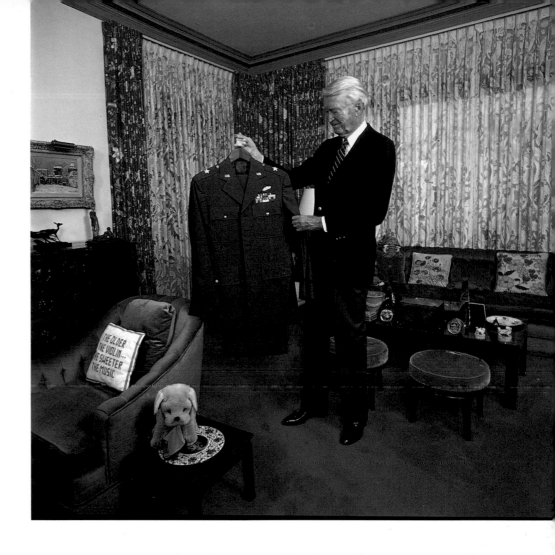

Jimmy Stewart. Los Angeles, California, 1991

James Stewart appears to be a man no one has ever said no to. He appears to
have had a charmed life. I knew he had been in the Army Air Corps, a pilot
during World War II. I told him that I remembered how the British people
always liked him for being one of the first American movie stars to volunteer
for service in WWII. He liked the fact that I knew a bit about him. When I
asked if I could see his uniform, he said he hadn't had it out in twenty years. I
tried to get him to put it on, but he came back into his living room and said it
was too tight.

Supreme Court Justice David Souter. Washington, D.C., 1990

His appointment to the Supreme Court by President Bush had caused a stir and
I expected him to be uptight and distant. I found Judge Souter to be charming
and happy. When I told him there was a boy named Willie Souter in my class
at school and that Souter was a real Scottish name, he seemed pleased and said he
would like to go hiking in Scotland.

FOLLOWING PAGE

USA for Africa. Los Angeles, 1985

It took all night when America's biggest rock stars came together to record 'We
Are the World' to raise money to feed the hungry in Africa. Quincey Jones, the
musical director, posted a sign at the entrance of the recording studio which
said, 'Leave your ego outside' — and they did. It was fun watching some of them
trying very hard to be humble.

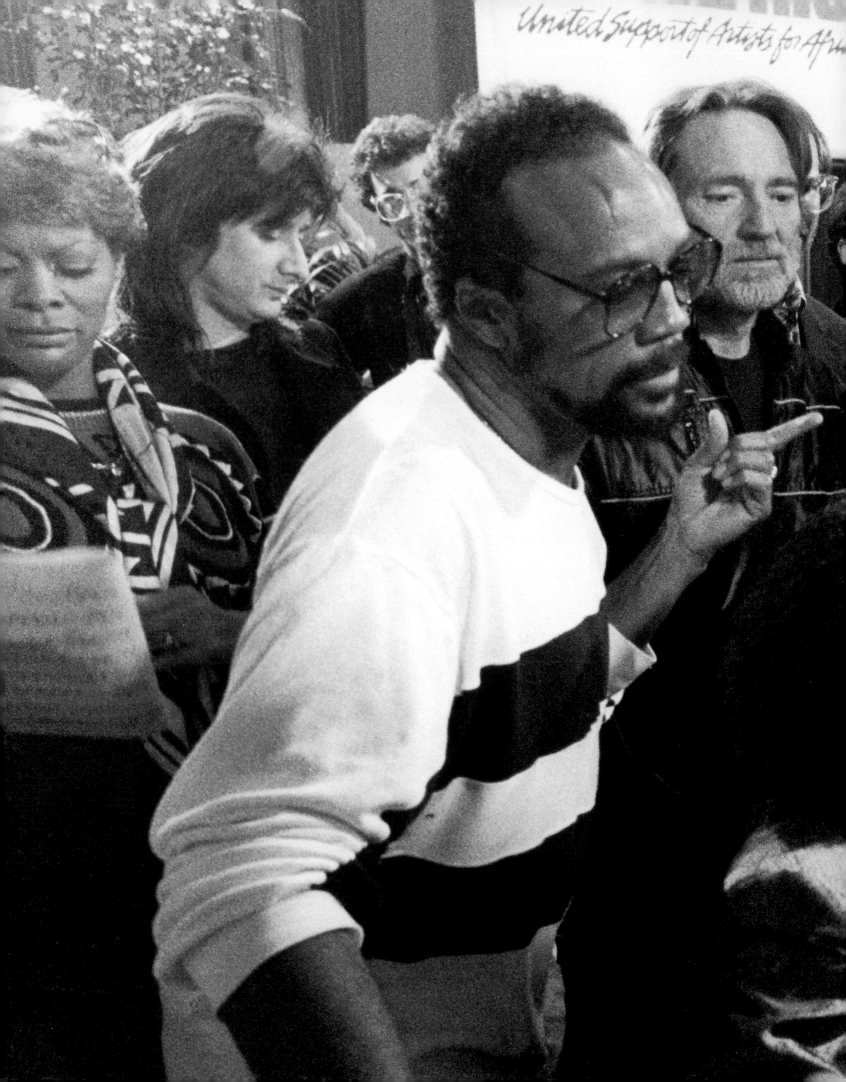

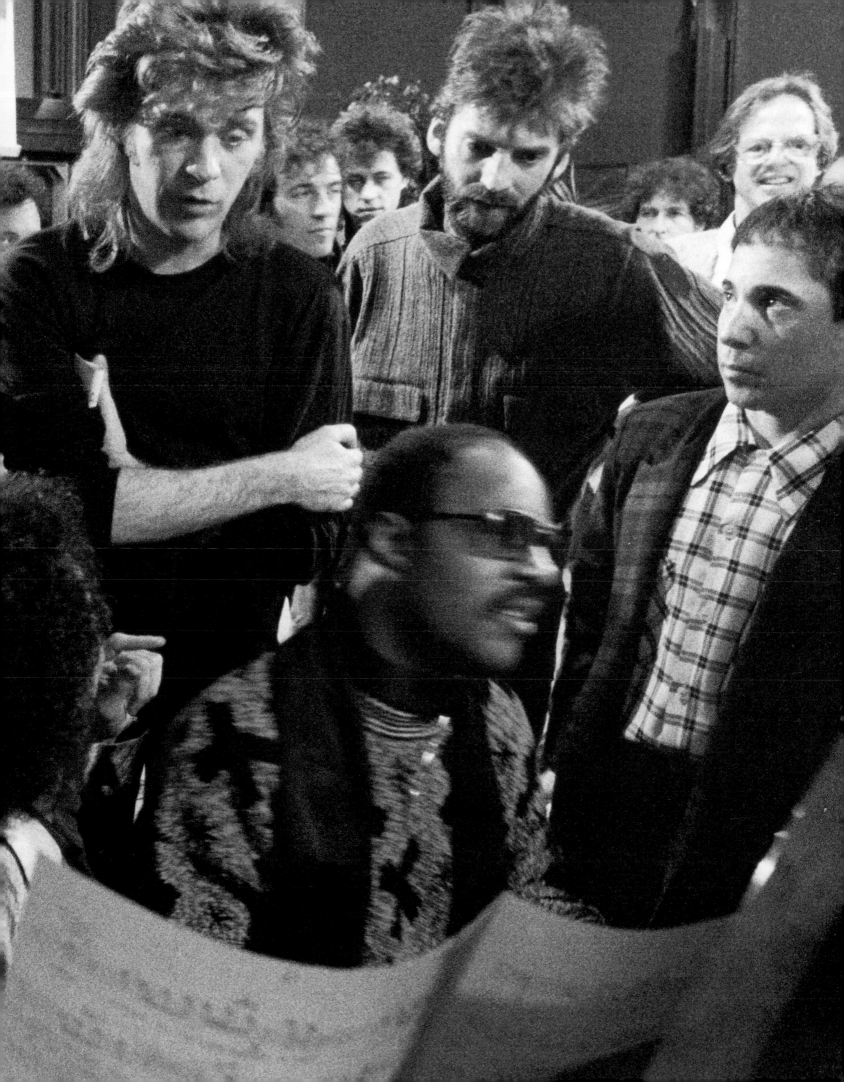

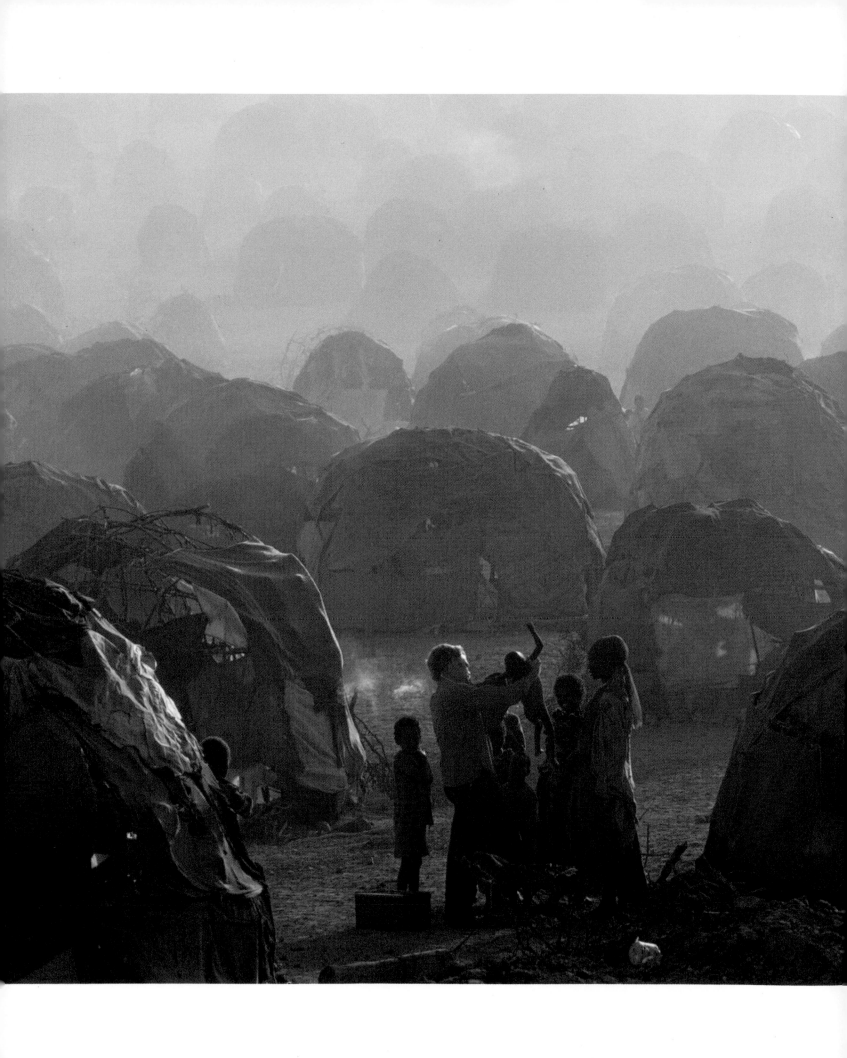

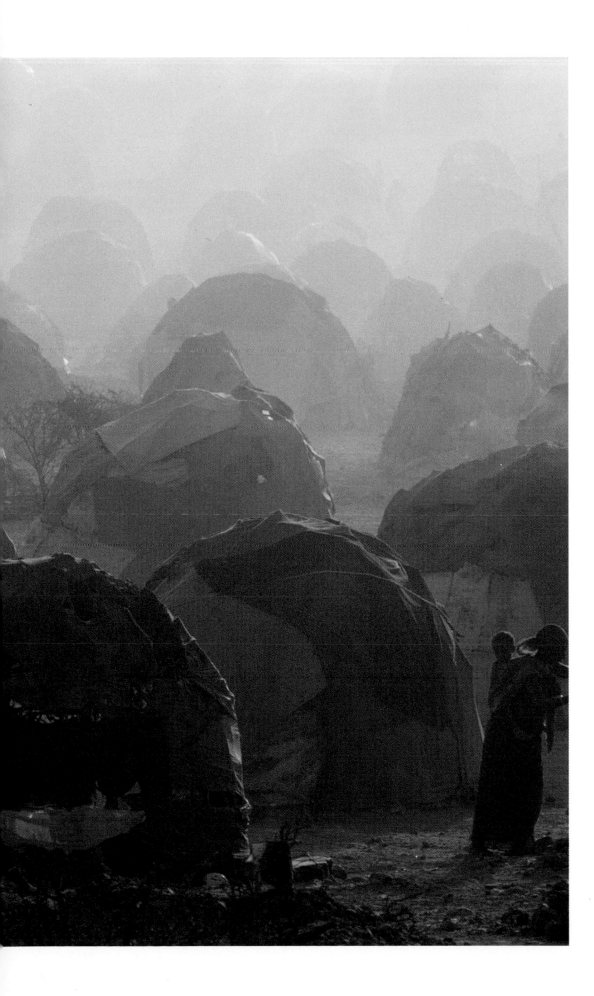

Somalia refugee camp
with Dr. Eric Avery.
Las Dhure, 1981
Thousands arrive daily from war-
torn Ethiopia to the refugee camps
set up in Somalia. The chanting and
moaning of the starving children
never stop.

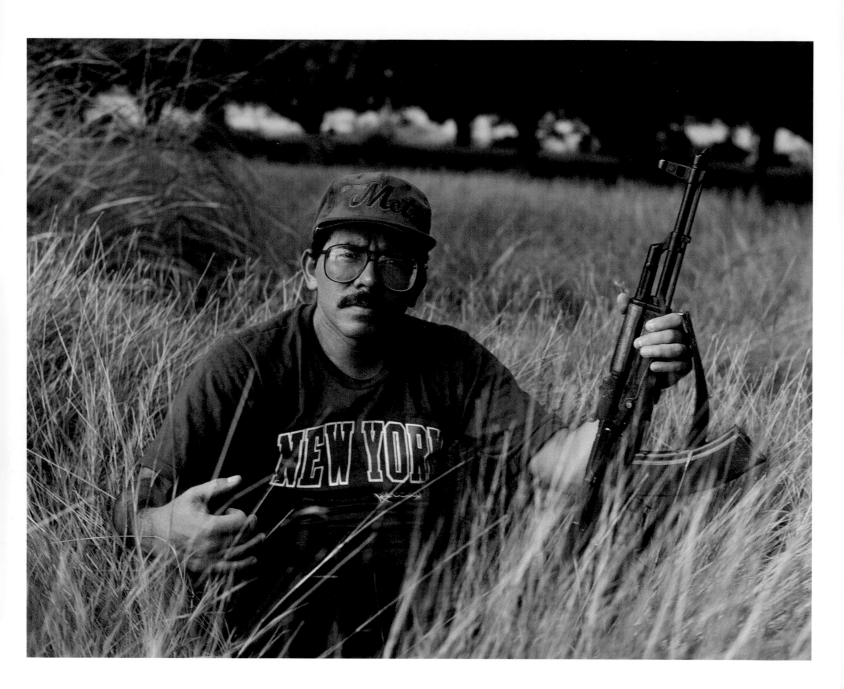

President Daniel Ortega. Managua, Nicaragua, 1986
Hearing he was a big baseball fan, I brought down a New York Mets tee-shirt
and cap which delighted him. Catching him just as he finished jogging, his
rifle never left his side. That night I got a call asking if the entire family could
be photographed. Explaining that my plane left at nine the next morning, I was
told to be there at seven. Explaining that airport security would take longer,
Mrs. Ortega laughed and said, 'We'll take care of that.' Leaving, I had a
military escort right up to the plane.

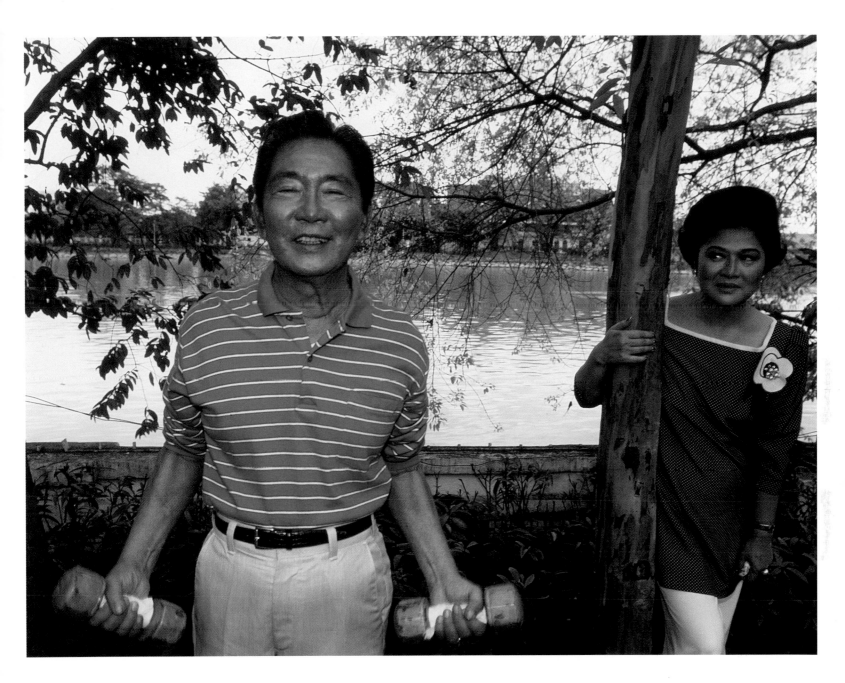

President Ferdinand and Imelda Marcos. Manila, Philippines, 1985
His palace was surrounded by slums but inside it was very luxurious with huge
paintings and ornate thrones. He told me people said he was a fanatic but the
only thing he was fanatical about was his health. I wanted to show the strong
man keeping fit.

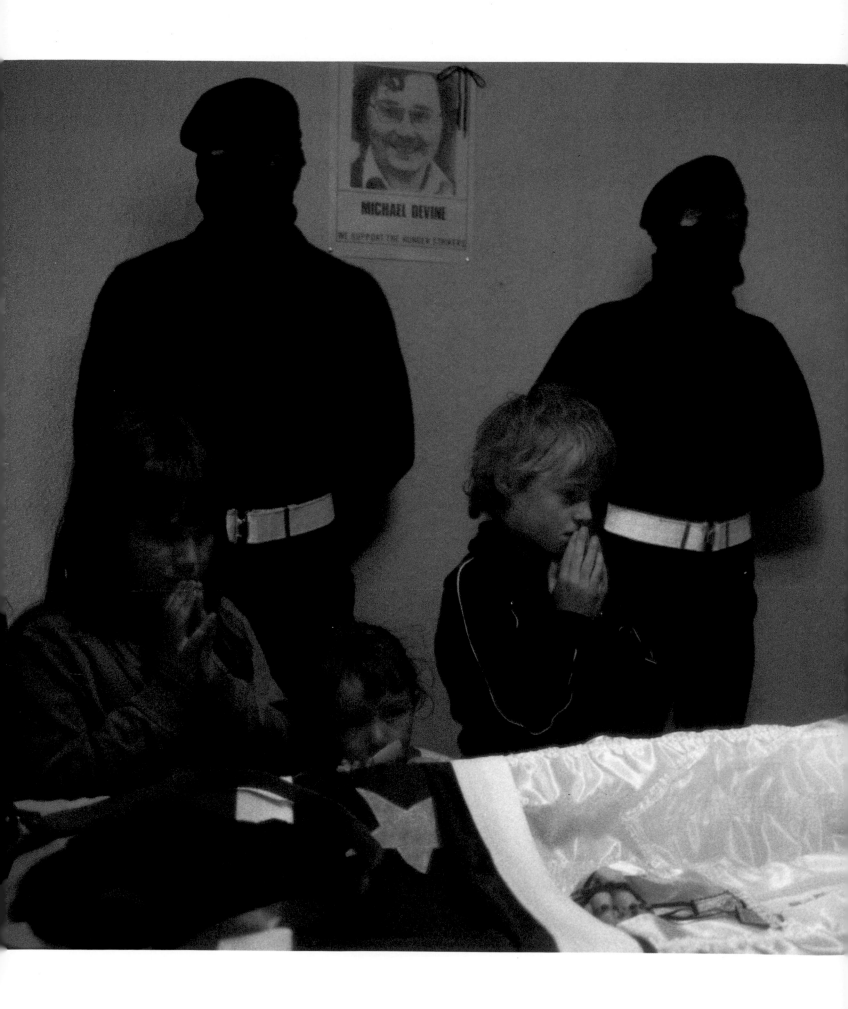

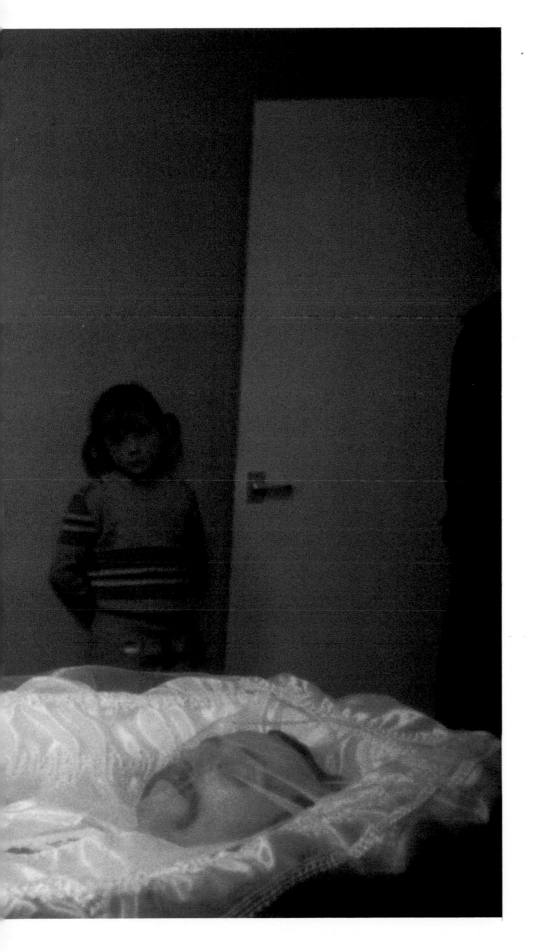

Mickey Devine. Londonderry, 1981
He was the last of the IRA hunger-strikers to die. I'd never been to an Irish wake before and in the room adjacent to where he lay were tea, cake and sandwiches. All the neighbors would come in to have something to eat and pay their respects. It was incongruous to see in the room beside the body masked IRA soldiers with machine guns while 200 yards down the road were British Army patrols.

51

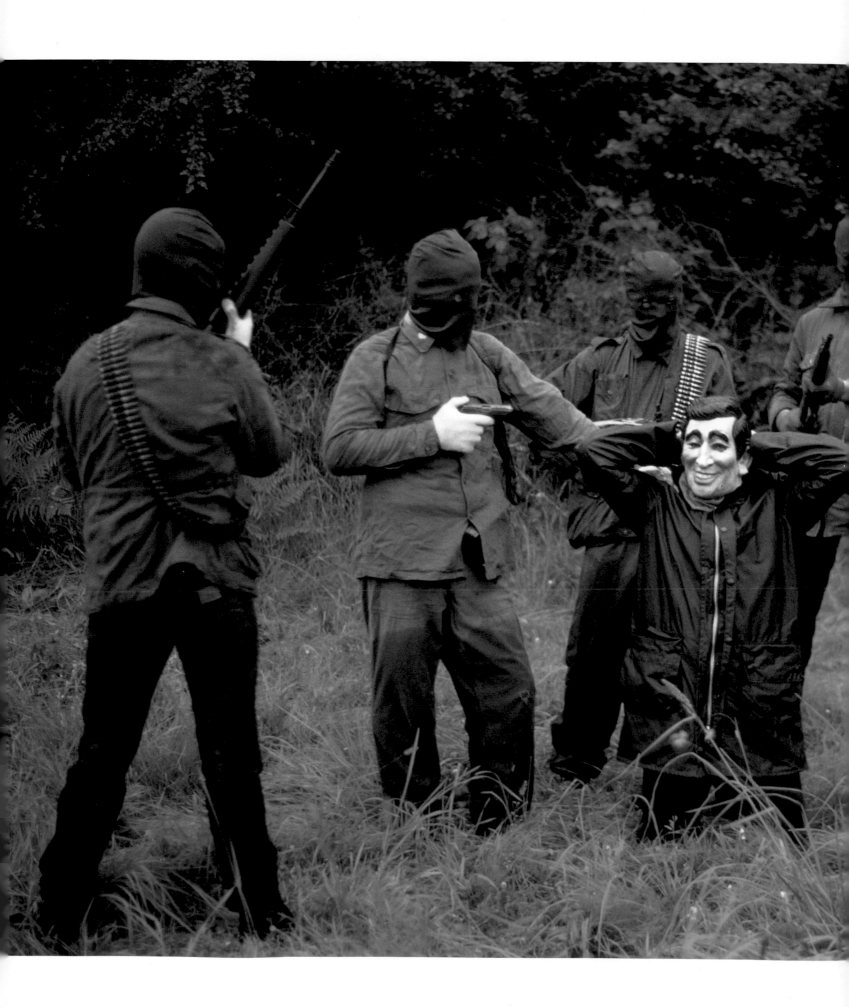

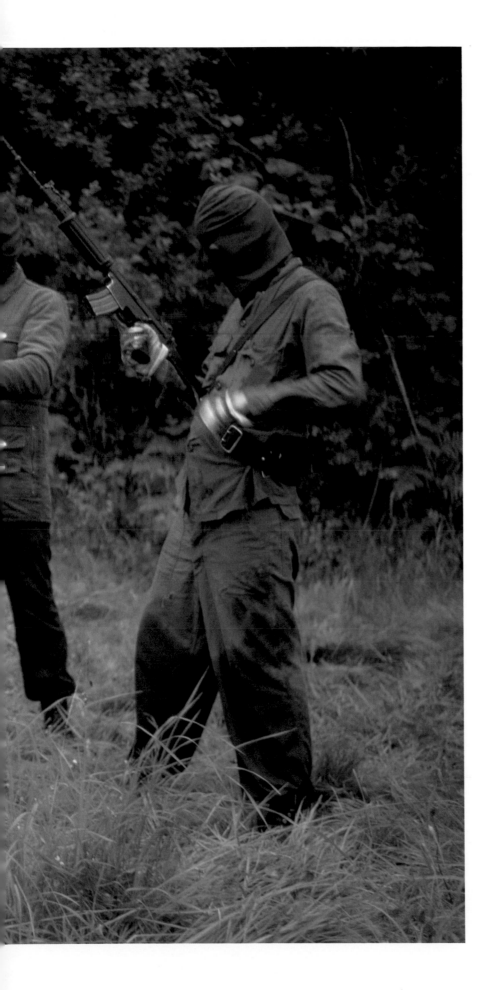

FOLLOWING PAGE

General H. Norman Schwarzkopf.
Saudi Arabia, 1990

First impressions can be misleading. The first time I saw General Schwarzkopf I spent the afternoon following him around photographing for *Life* and not speaking to him. I thought he was just exactly what he looked like, a Commander-in-Chief who didn't have time for small talk or anything that didn't have to do with the army. How wrong I was. Here was a man whom I found to be sensitive, kind, and romantic. Romantic in the sense that he knew exactly where he was and what he was doing in Arabia, leading the biggest army in the history of Arabia, and he was not going to foul it up. We were on the Navy hospital ship *Mercy* in Bahrain where the first woman POW, Melissa Rathbun Nealy, had been sent with nine other POWs. She stood laughing and crying at the same time. General Schwarzkopf stood three yards away, looking at her. He told her he had thought a lot about her while she was held captive by the Iraqis and added, 'What I would like to do is give you a big hug. Do you mind?' Sort of laughing/crying she said she would like that very much. The general was so perceptive, so aware, he didn't presume that he could hug her without asking how she felt about it. He is definitely at the top of my list of people I have photographed.

IRA soldiers. Northern Ireland, 1985

To go on maneuvers with the IRA in the late afternoon I had to be blindfolded to be taken where they were. They all wore masks so that I couldn't identify them. One wore a mask of Prince Charles. When I asked what they would do if they saw him the masked man got down on his knees and the others pointed their guns at his head.

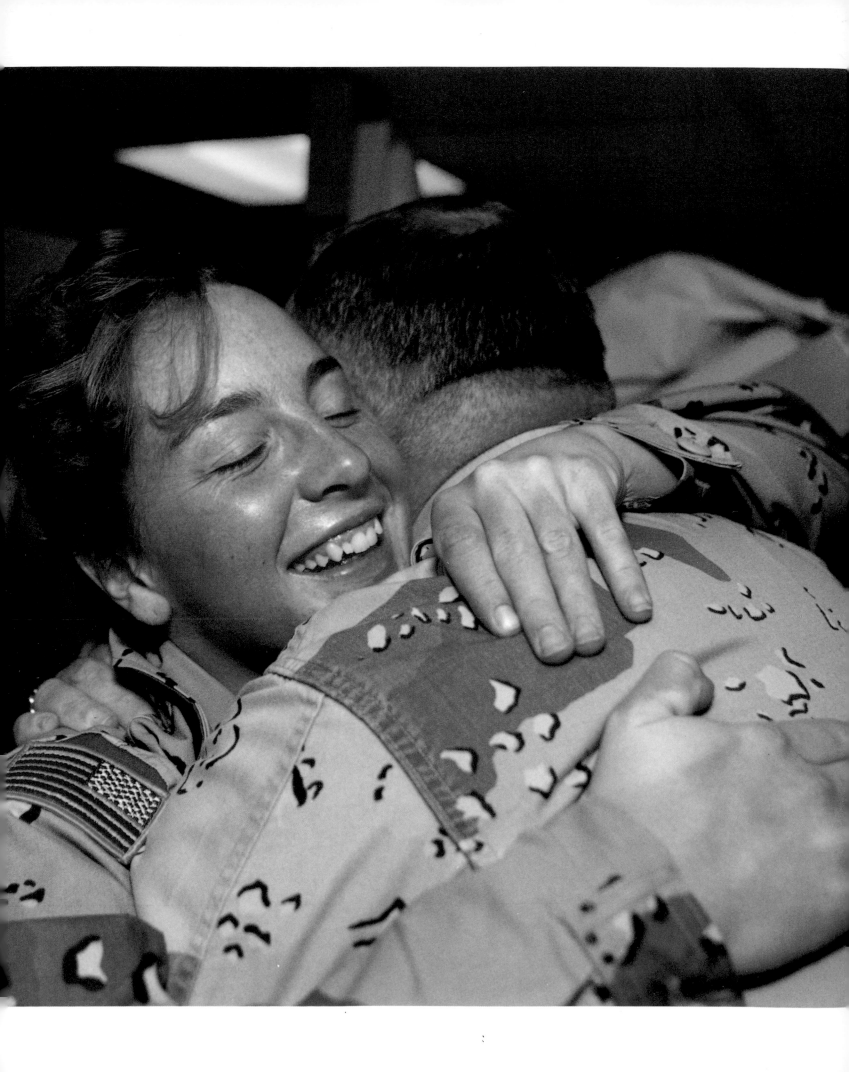

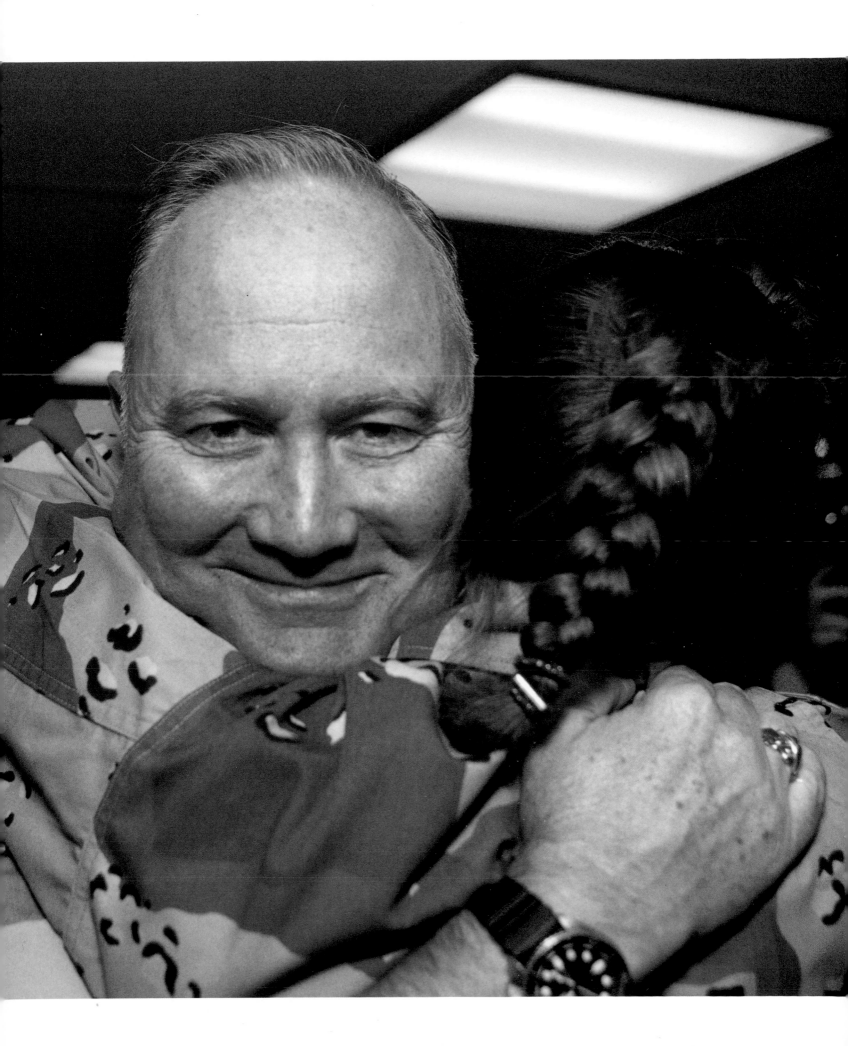

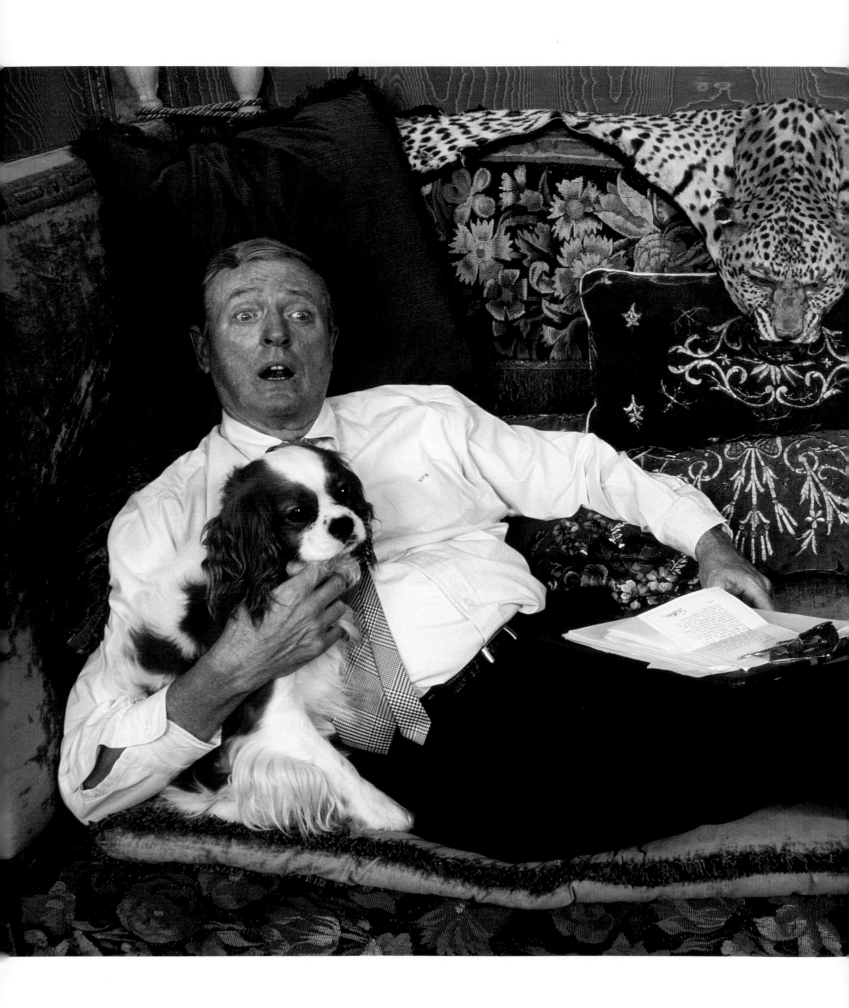

William F. Buckley, Jr. New York, 1988
There was something very sensous about this
couch, not a word that normally springs to mind
when you think of a conservative Republican. It
reminded me of the Victorian era when people
presented a very proper appearance to the outside
world but their private lives were luxurious,
almost to the point of decadence.

57

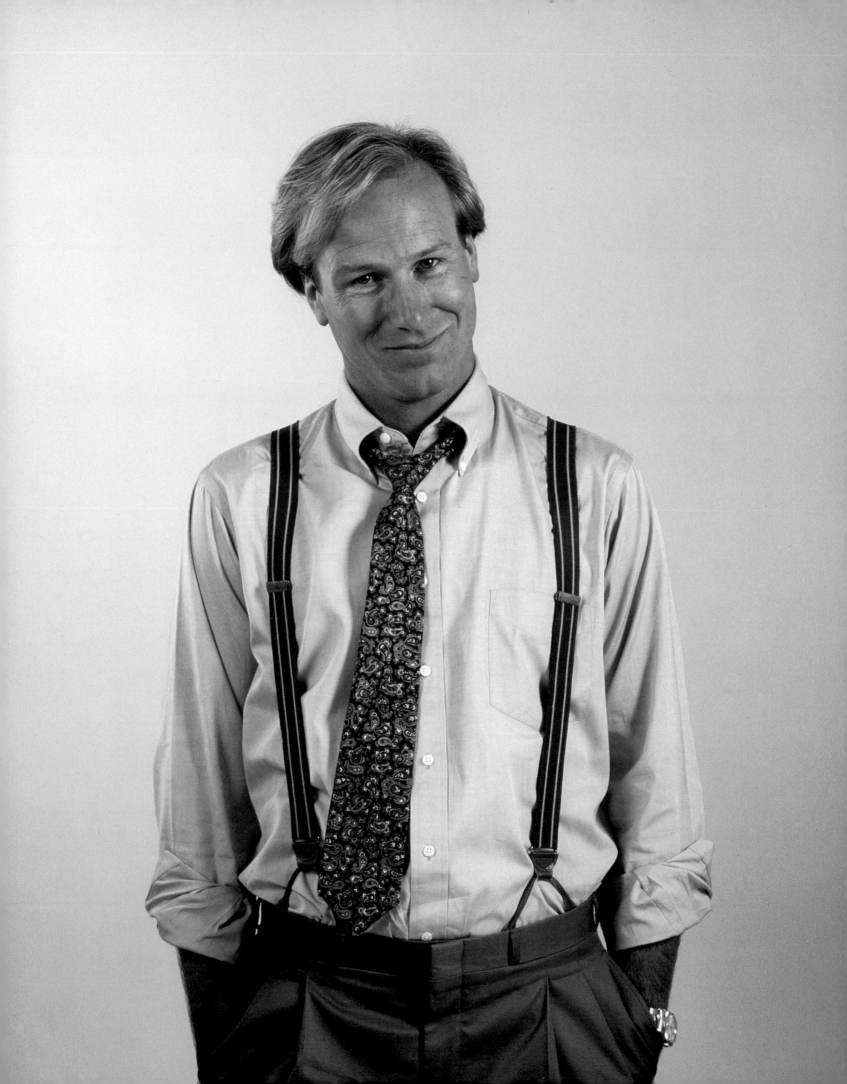

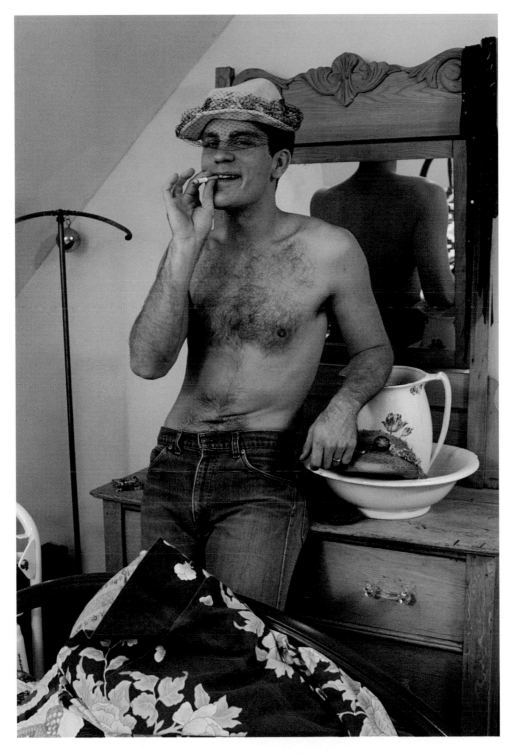

John Malkovich. Chicago, 1984
He was being touted in a press release as 'The New Bogart' and I was sent to see for myself. I didn't think he looked or acted in the least like Bogart. He was intelligent and accommodating, but what amazed me were his crooked teeth.

William Hurt. Los Angeles, 1987
He likes to go salmon fishing in Scotland. He had just won the Academy Award for Best Actor and was filming James Brooks' *Broadcast News*. I kept calling him John instead of William, and he told me not to worry, everyone did that all the time.

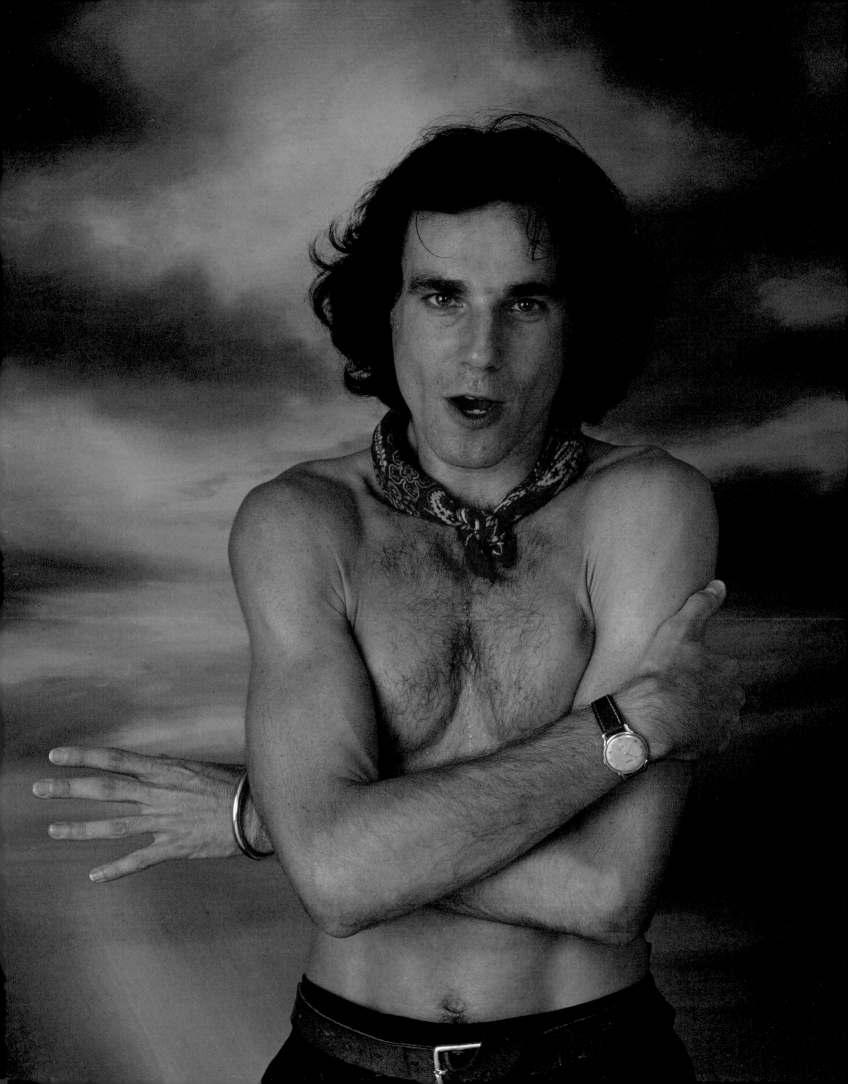

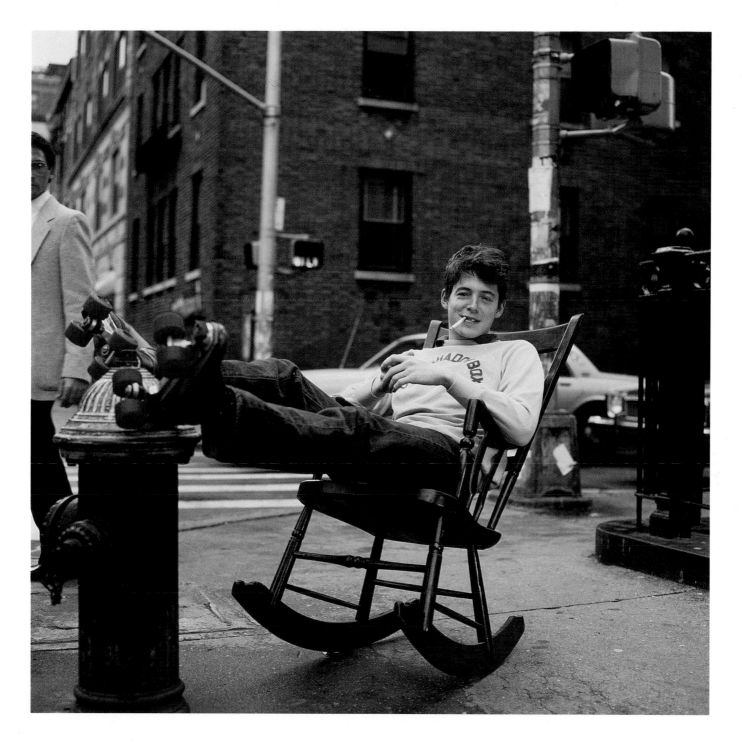

Matthew Broderick. New York, 1983
He was appearing in a play at the time and his first hit film, *War Games*
had just come out. I asked him what he liked to do for relaxation and
this is what I got.

Daniel Day Lewis. New York, 1989
He was very accessible and open. His tremendous success has not made him close
off to people yet. He was more interested in talking about soccer than acting. He
wasn't thinking about his image – in other words, he was an actor, sure of
himself. Shortly after this photograph was taken he won the Oscar for Best Actor.

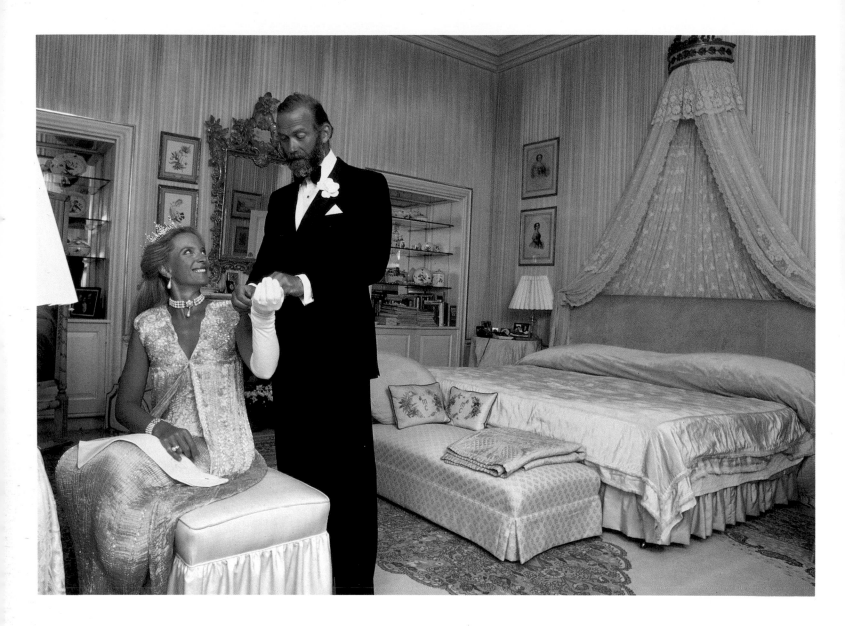

HRH Prince and Princess Michael of Kent.
London, 1986
They were in their bedroom in Kensington Palace. The Princess told the Prince to try not to look stupid for the photograph. Afterwards I found it embarrassing to look at or speak to him. Sometimes you find people are like what you have been told about them. She wanted to edit and choose the photographs, telling me that was the Royal way. I explained that I was not a Royal photographer.

Mrs. Ronald Reagan. The White House, 1985
In recent years the Red Room in the White House has been the room most of the First Ladies want to be photographed in. Mrs. Reagan turned up in an elegant red evening dress, her favorite color being red, for her portrait for a story on six First Ladies for *Life*.

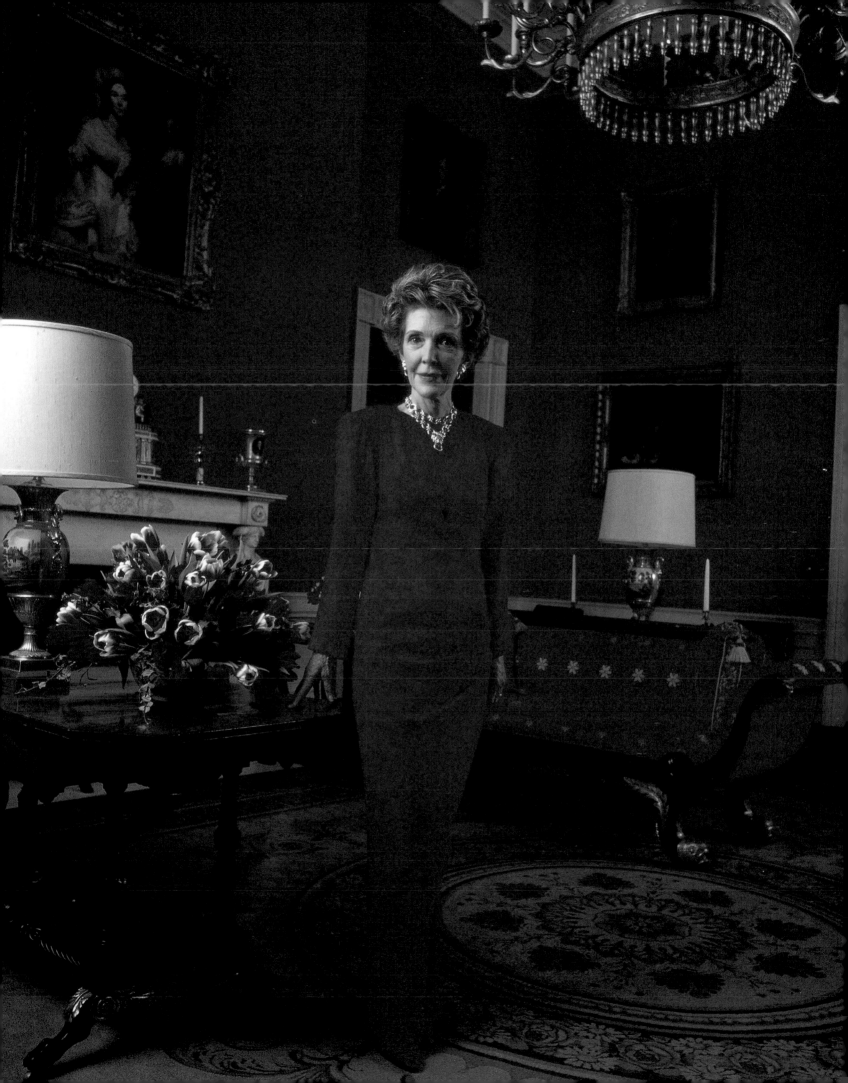

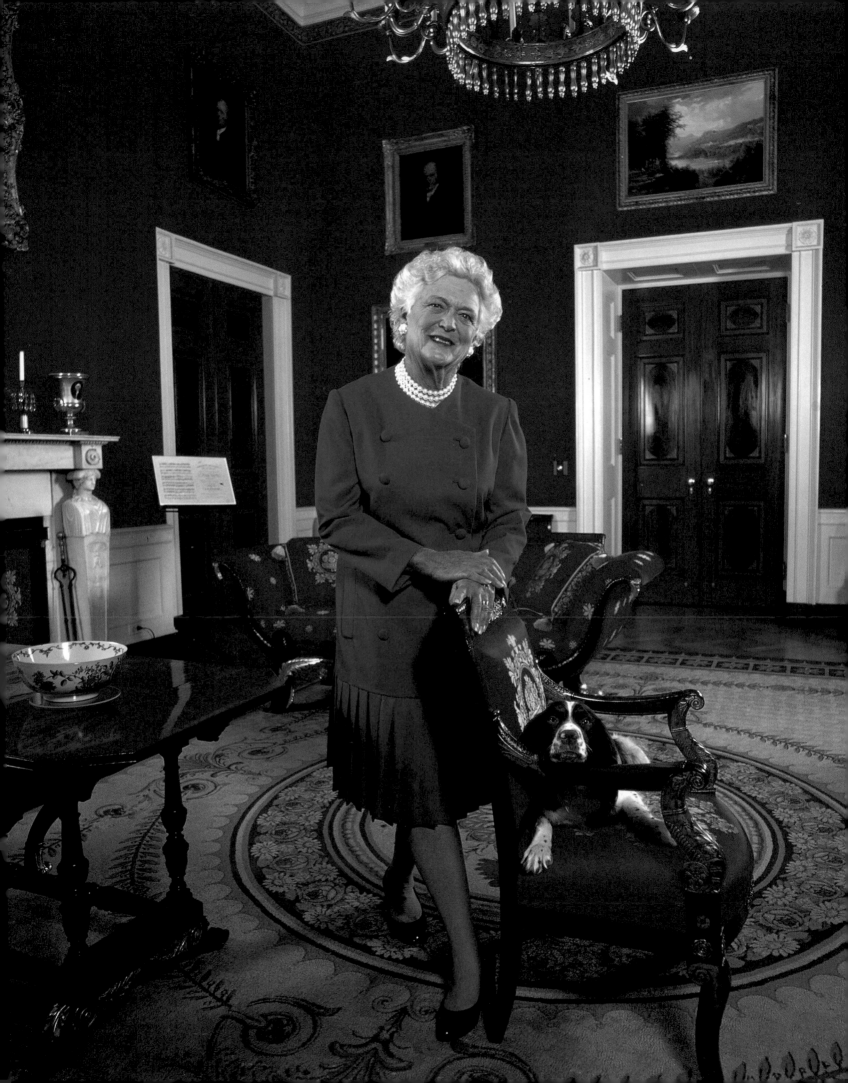

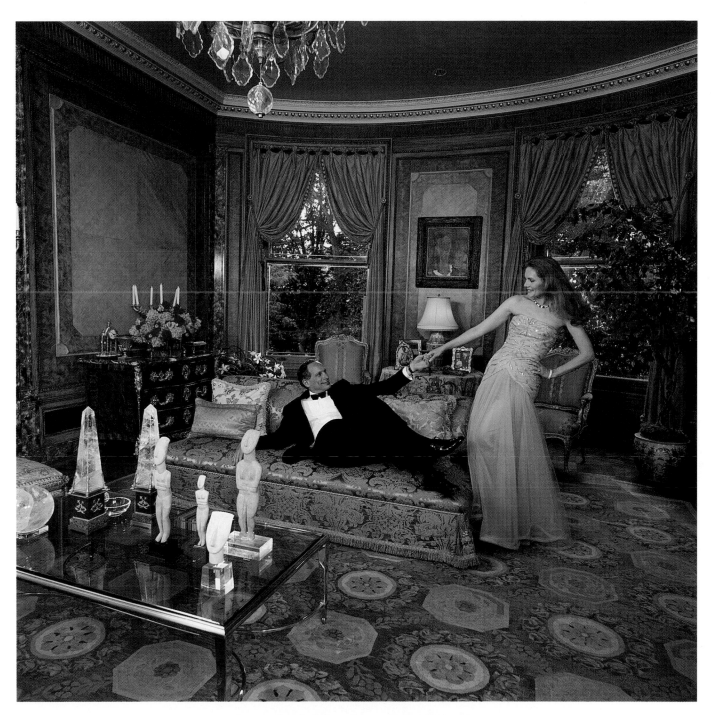

Leonard and Allison Stern. New York, 1989
Allison playfully coaxes her husband, Leonard, from the sofa in their art-filled
Fifth Avenue townhouse. She is an Emmy Award-winning television
documentary producer and devotes much of her time to the causes of Central
Park Zoo while he oversees his publishing and the Hartz Mountain pet-food
empire. In conversation, Allison is one of the few busy people who really seem to
listen when someone else is talking.

Mrs. George Bush. The White House, 1990
Mrs. Bush and her English springer spaniel, Millie, posed together in the Red
Room after they had written Millie's diary about life in the White House.
Straightforward and candid about her recent bout with Graves' disease, she had
resumed her hectic schedule as First Lady.

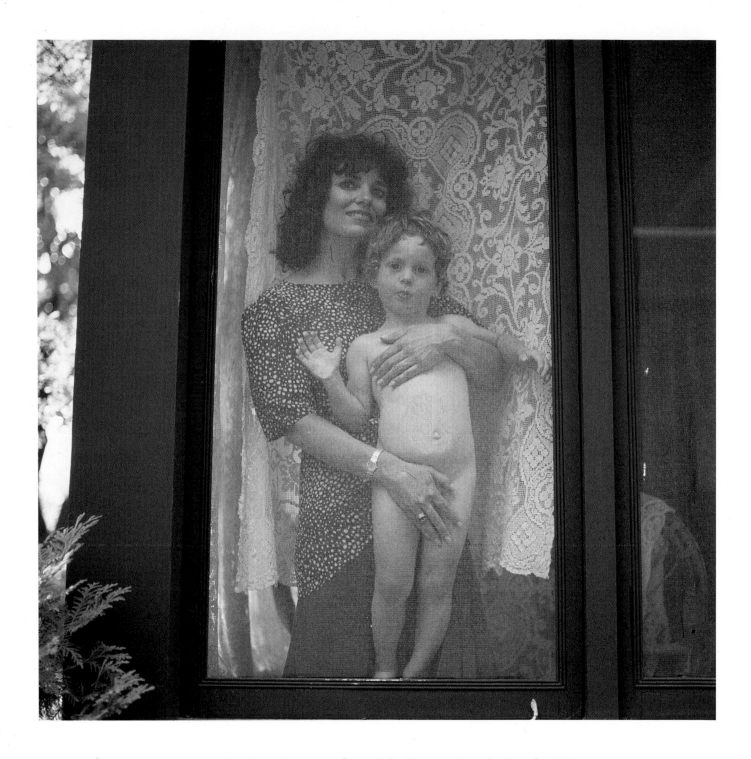

Margaret Trudeau Kemper and son Kyle. Ottowa, Ontario, Canada, 1988
Now remarried and a housewife who cooks and plants in her garden . . . To
think, a few years ago the former First Lady of Canada was driving her husband
crazy with her antics.

Fawn Hall. Annandale, 1987
Oliver North's loyal secretary who had to testify during the Iran-Contra
hearings. I wanted to show her as a fawn, running through the woods.

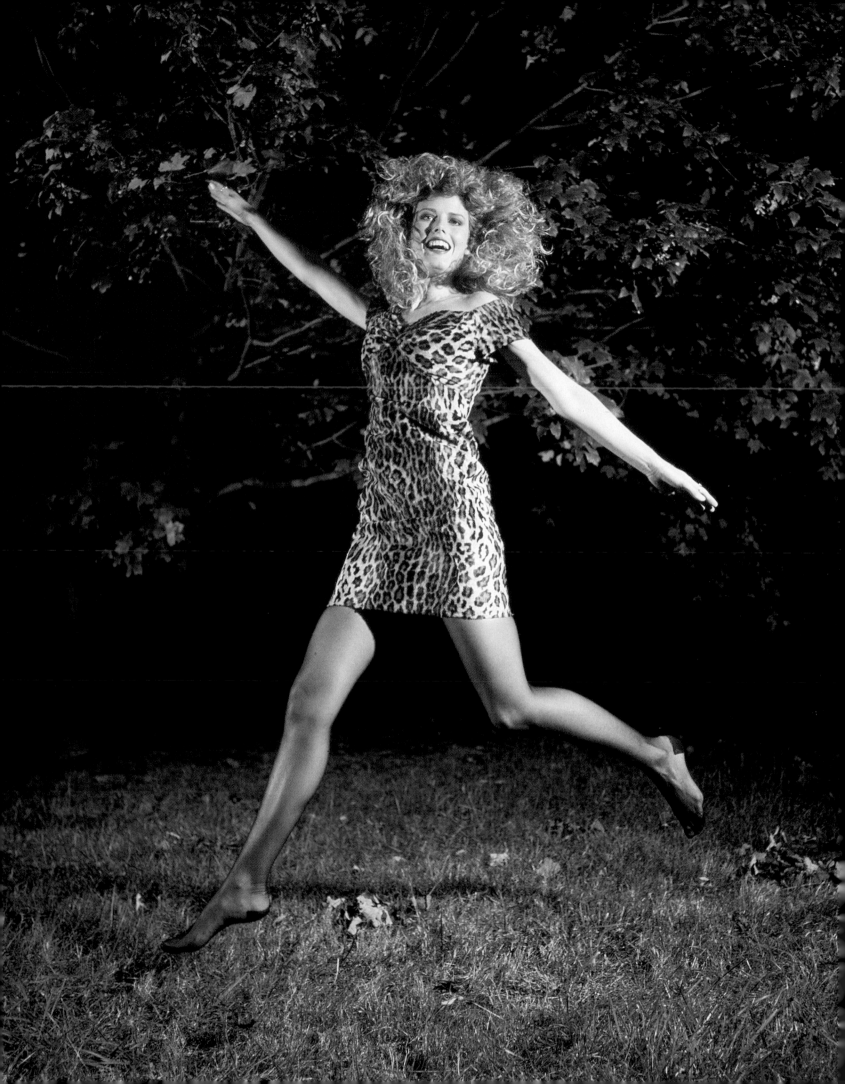

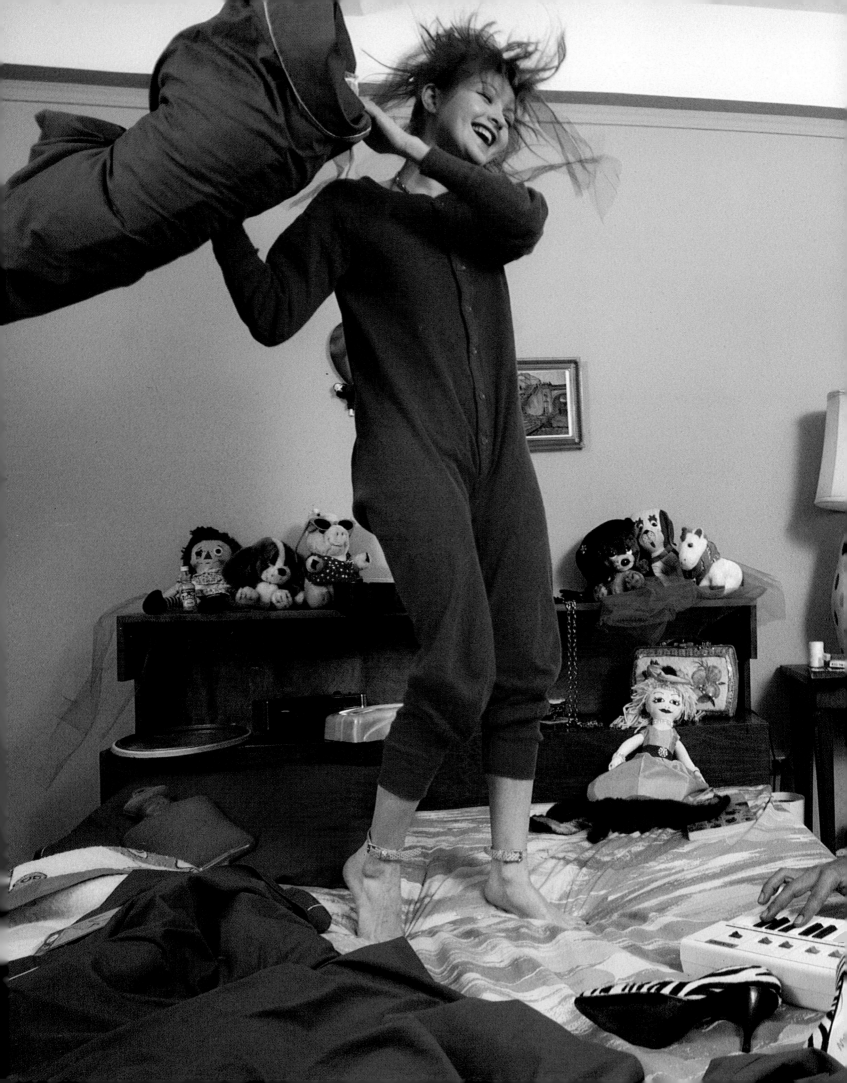

Cindy Lauper. New York, 1984
Rock singer Lauper had once paid a visit to London and
I think she never got any further than the King's Road.

69

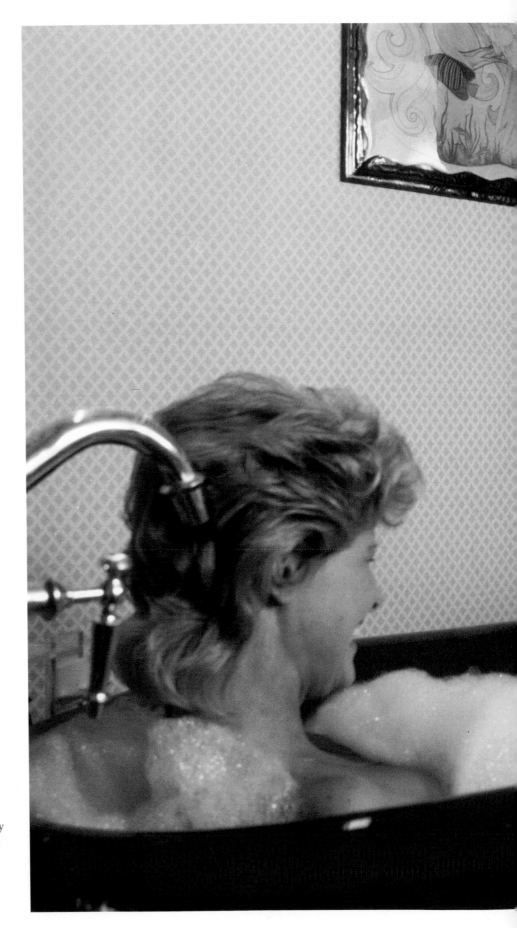

Willie and Connie Nelson.
Evergreen, Colorado, 1983
Wife Connie was happy to oblige when I suggested they
take a bubble bath together. She wanted his fans to see
she was number one in Willie's life.

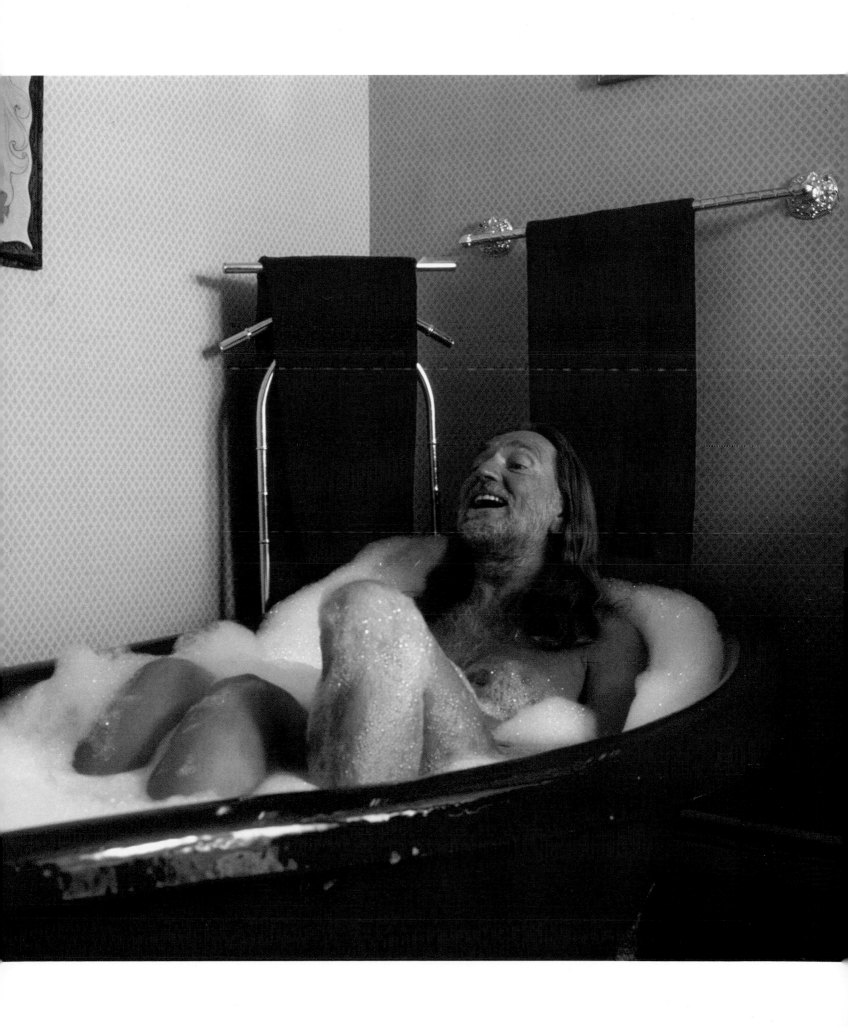

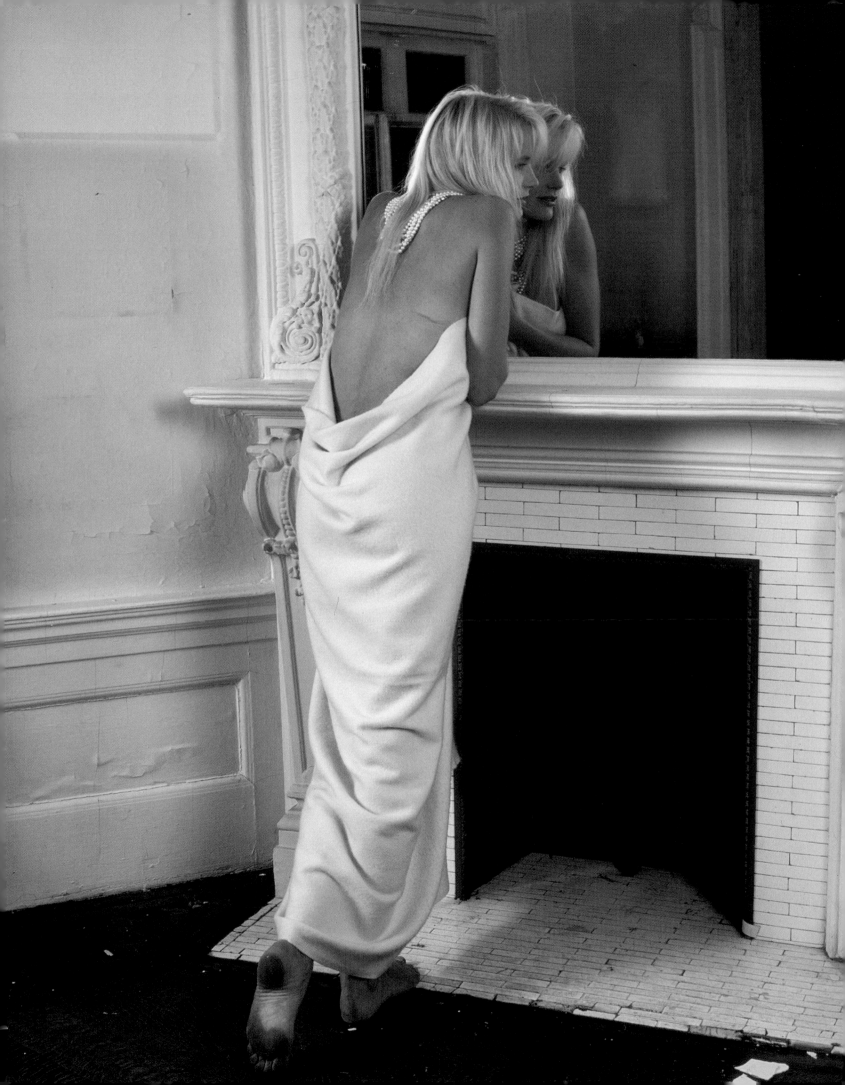

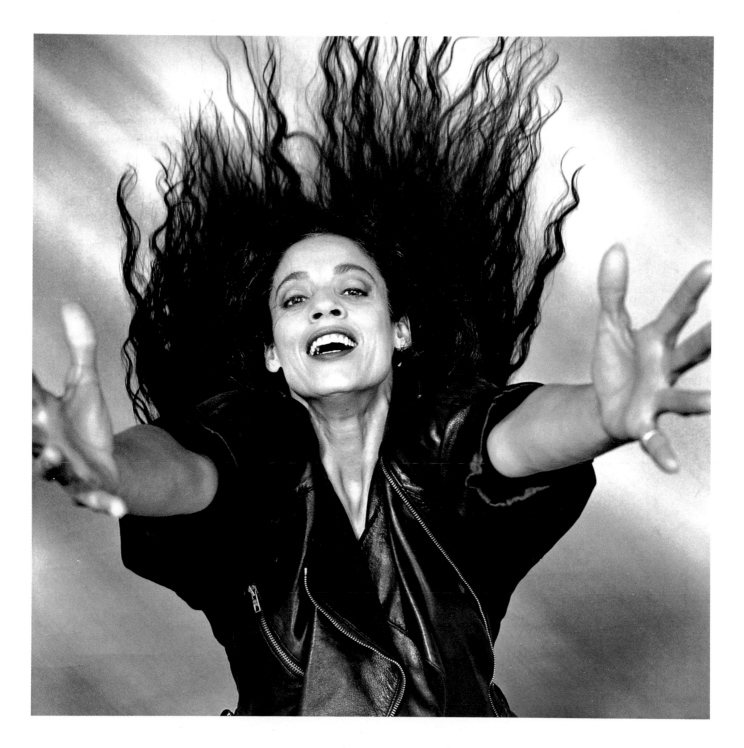

Daryl Hannah. New York, 1989

I remember having to wait about four hours for her to have her hair and make-up done on a very hot September day. We had never met before, and she had very little to say. In the empty living-room of her new apartment I asked her to lean against the mirror over the fireplace and noticed the soles of her feet were dirty. I always hope that something unexpected, out of my control, will happen.

Sonia Braga. New York, 1988

She had just filmed *The Milagro Beanfield War* when she came into my studio—this petite woman with great long hair. She was full of life. I could tell it was going to be a good day, she got along with my dog, Carlo, which is not an easy thing to do.

**Fred and Robyn Astaire.
Los Angeles, 1981**
When I asked him to dance, he
said he would. His wife Robyn
told him not to and he said no.
Then she said go ahead. The
closest I got was when he crossed
his legs in the recognizable Astaire
pose. A very elegant man. As I
was packing the car with my
equipment, he came outside and
asked me to join him for a drink. I
stayed for over two hours and he
reminisced at great length about
how the English, and especially the
Duke of Windsor, a great dandy in
his time, had given him his
inspiration on the elegant way
he dressed.

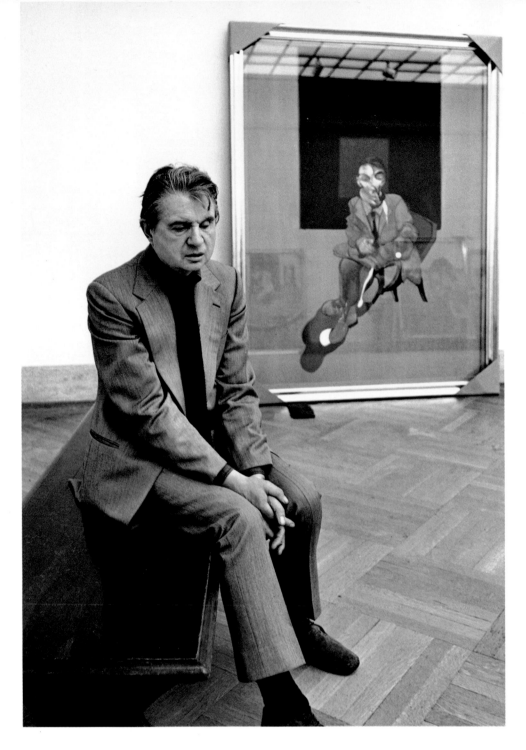

Francis Bacon. New York, 1975
Overseeing the hanging of his work at the Metropolitan Museum of Art,
he rested for just a moment. Later in a bar on the Upper East Side he
seemed uncomfortable and suggested going somewhere else. Never
thinking it would be the Bowery, skid row, we left. In a bar down there,
drunks and addicts would come over to him and talk. He changed from
being sullen to being animated. I wouldn't be surprised if part of his
inspiration came from these forays.

Sammy Davis Jr. Los Angeles, 1990
I photographed him when he opened in London in 1959 at the Pigalle and have
never, then or now, seen an entertainer like him – one who could do so much.
While photographing him recently, I reminded him of our earlier meeting. He
had recently been operated on for throat cancer. He was a small man and I was
shocked to see just how small he had become.

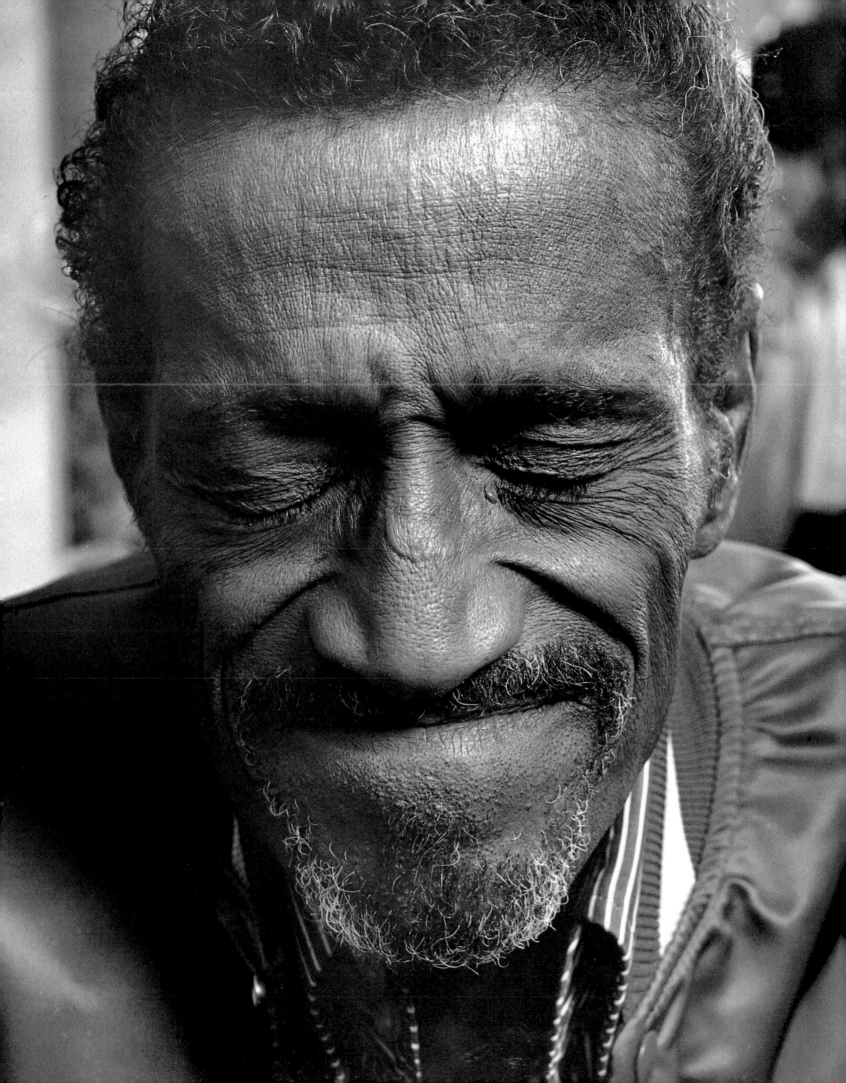

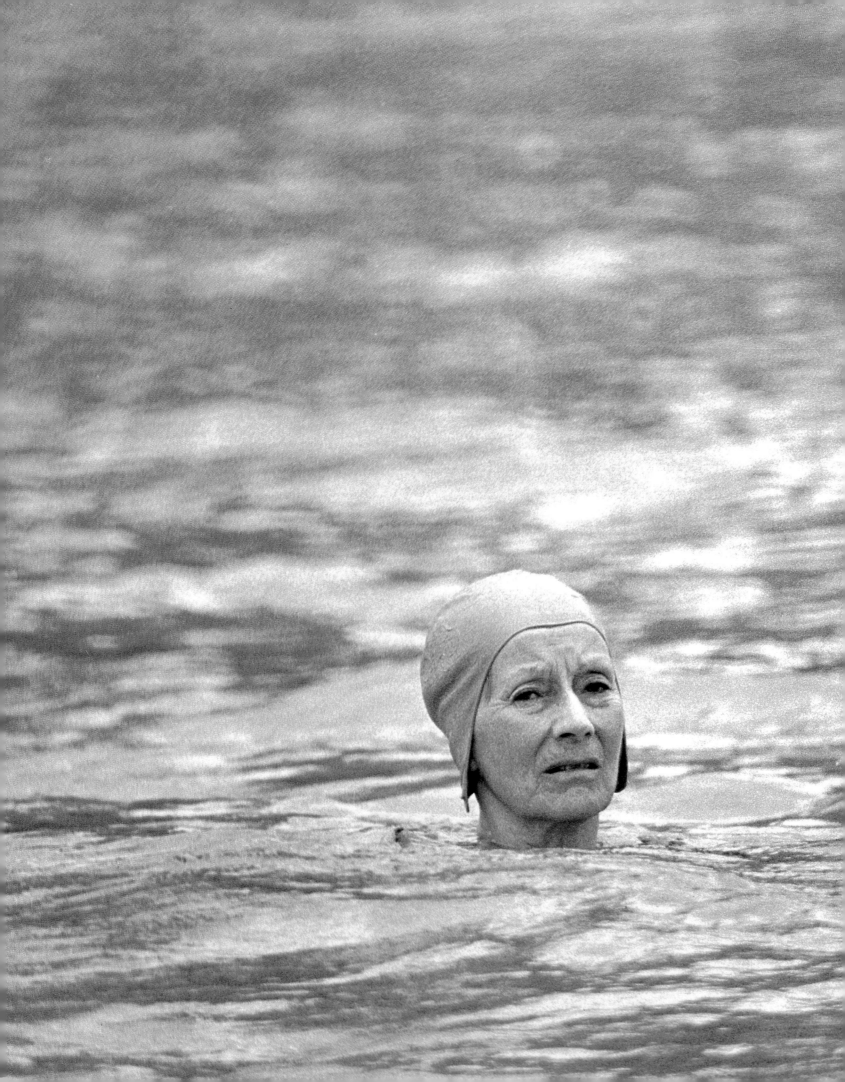

Greta Garbo. Antigua, 1976
As a child I heard my mother and father talking about
the 'great Garbo'. When she looked straight at me
without her sunglasses on, I wasn't going to let the
chance pass. Staking out some one like Garbo on the
beach can be fun, but most of all it keeps me honest. It
really means I haven't forgotten how I started out.
There is strategy and cunning involved, working alone,
not sharing any information with colleagues.
It's a loner's business, photojournalism. It is
not a team sport.

79

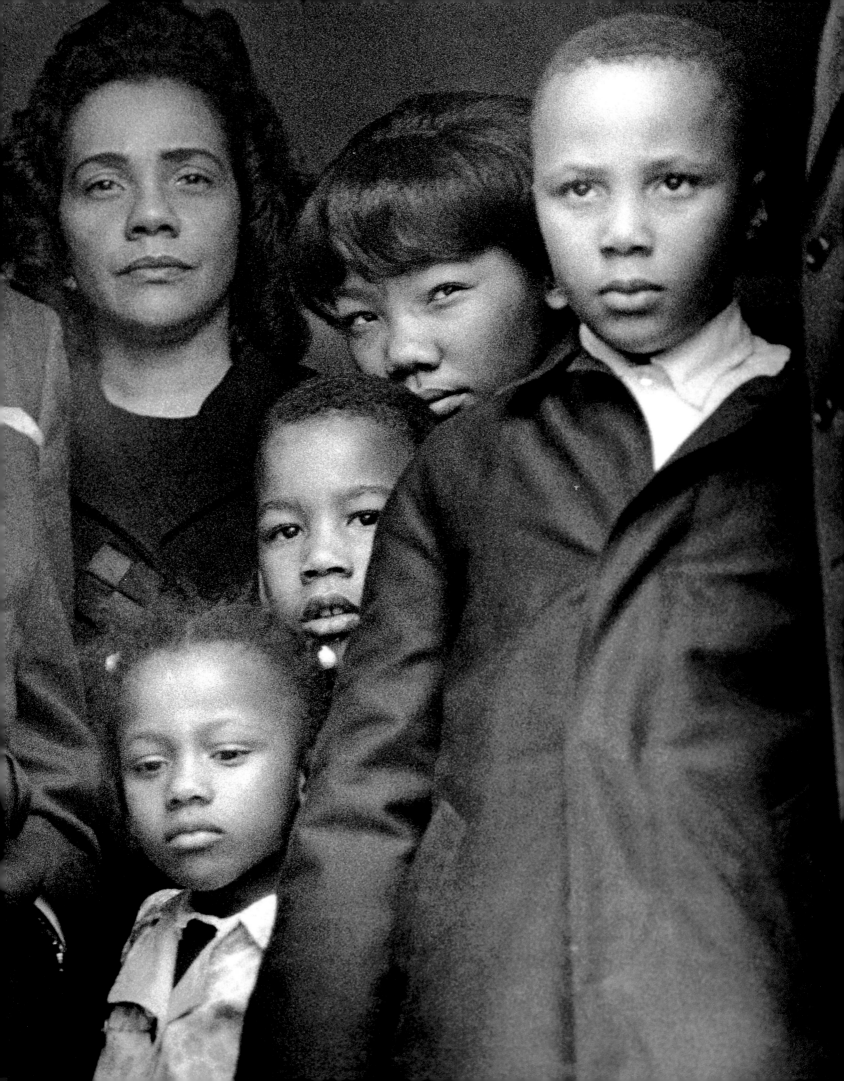

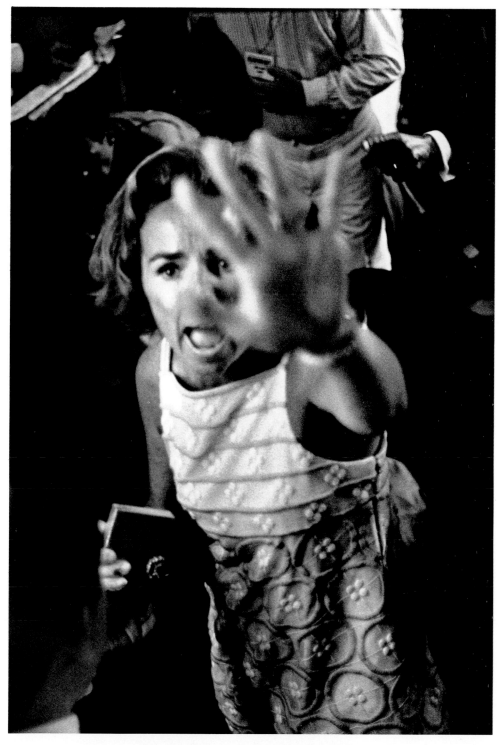

Mrs. Ethel Kennedy. Los Angeles, 1968
After Robert Kennedy was shot, there was hysteria and chaos. The noise was
deafening. There had been all that happiness at the beginning of the
evening. When Mrs. Kennedy was taken to his side, she cried, 'Give him
air.' At times I still can't believe I was beside him at the end of his life. I
liked Bobby. I kept thinking, he'd understand how important this is,
recording history, doing my job.

Coretta Scott King and Children. Atlanta, 1968
Mrs. King and her children were getting off the plane that carried her
husband's body back to Atlanta for burial. They all came together in the
doorway for just a moment.

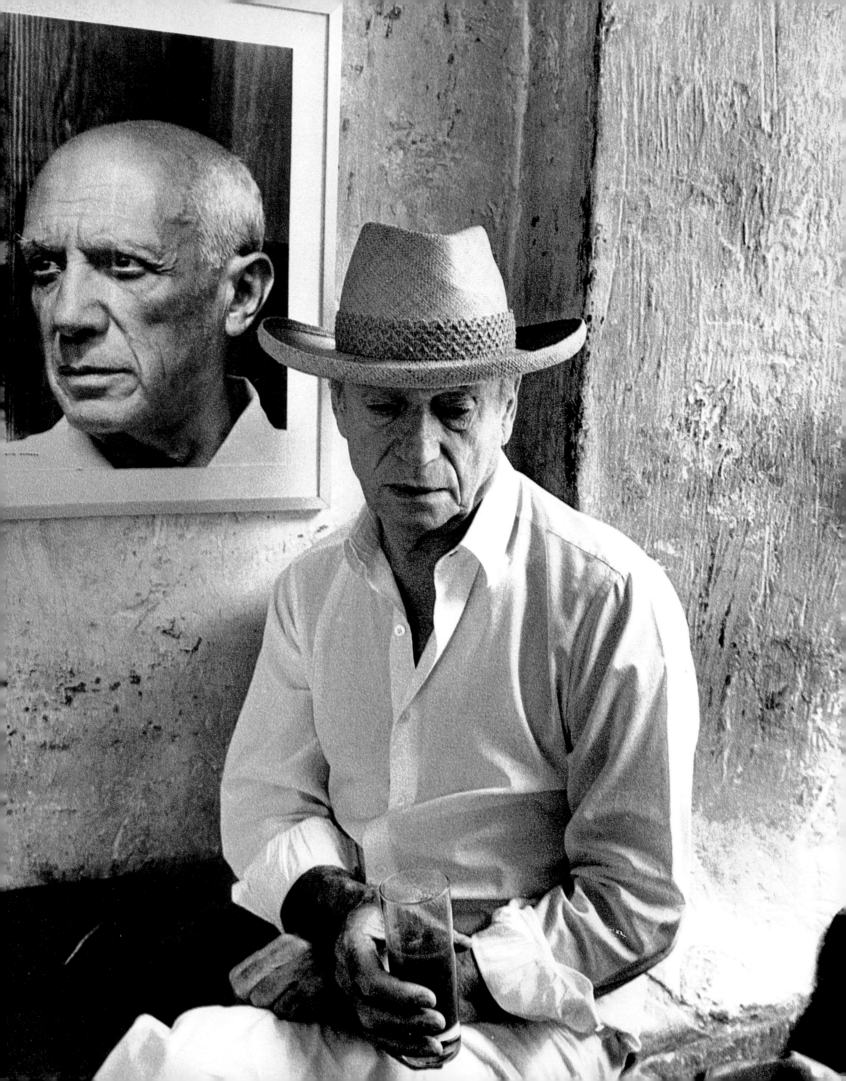

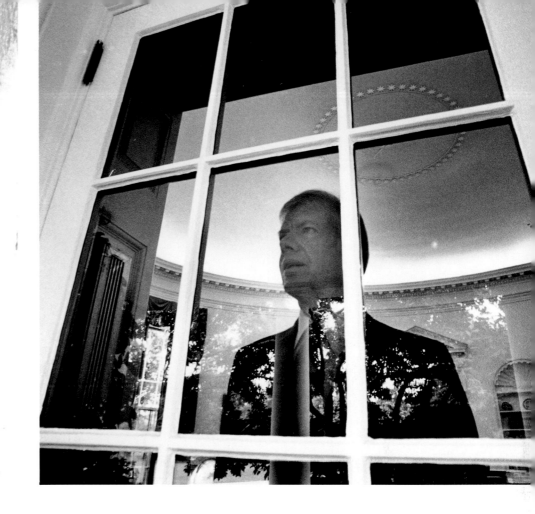

President Jimmy Carter. The White House, Washington D.C. 1979
At the time the United States embassy staff was being held hostage in Iran,
President Carter was worried and anxious. It was a crisis situation. Looking out
of the window, he seemed to show his loneliness in the Oval Office.

Yves Montand. St Paul de Vence, France, 1987
Our appointment was set for nine in the morning and I had travelled all night
from New York to get there. We were both having breakfast, separately, at La
Colombe d'Or. At five to nine he left and I could see he was getting into a car
outside. I rushed out. He thought I wanted his autograph. He had forgotten our
appointment and was very apologetic. Later he told me that Simone Signoret,
who had recently died, had been the love of his life.

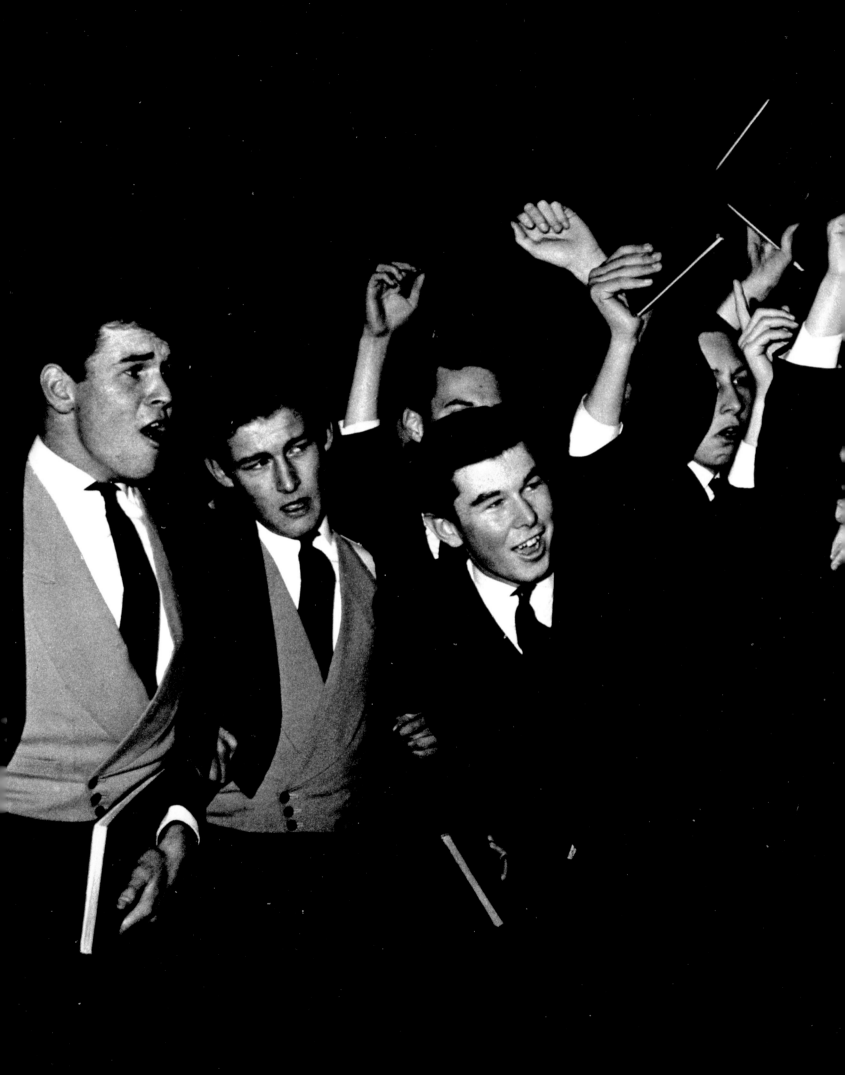

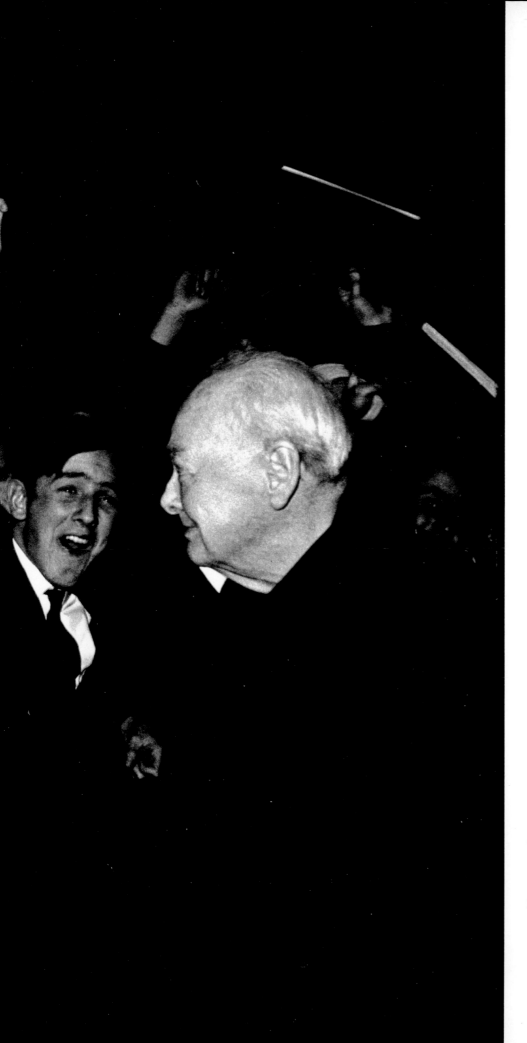

Sir Winston Churchill. Harrow School, England, 1965

It was Sir Winston's last visit to his old school, Harrow. He went back each year at Christmas. The students cheered and sang out, 'And Churchill's name shall win acclaim through each new generation.' What can I say about Churchill? I can say I'm glad to have photographed him a few times. It was a privilege.

Growing up in Glasgow during World War II, listening to his speeches on the radio, made me want to be at the center of things. He influenced me and the way I think about things today.

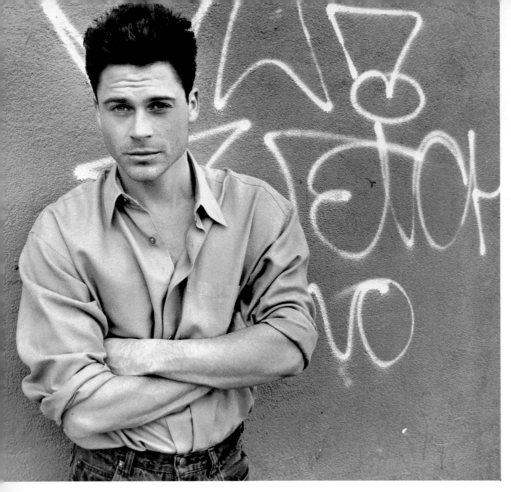

Rob Lowe. Los Angeles, 1990
Driving along, he honked the horn and waved at any pretty girls we passed. At the pier at Santa Monica we stopped. He told me he had gone to school nearby. I liked his openness and honesty about the ups and downs of his career.

Norman Parkinson. Tobago, 1983
We had known each other since the Fifties, working on *Queen* magazine. He was a photographer who understood what I meant when I said, 'Let's do something outrageous and fun.' He showed me his wardrobe. I chose the long kaftan and pith helmet and we were off to the beach near his home. The movement and fun in some ways tell you more than if he were standing still, looking straight into the camera.

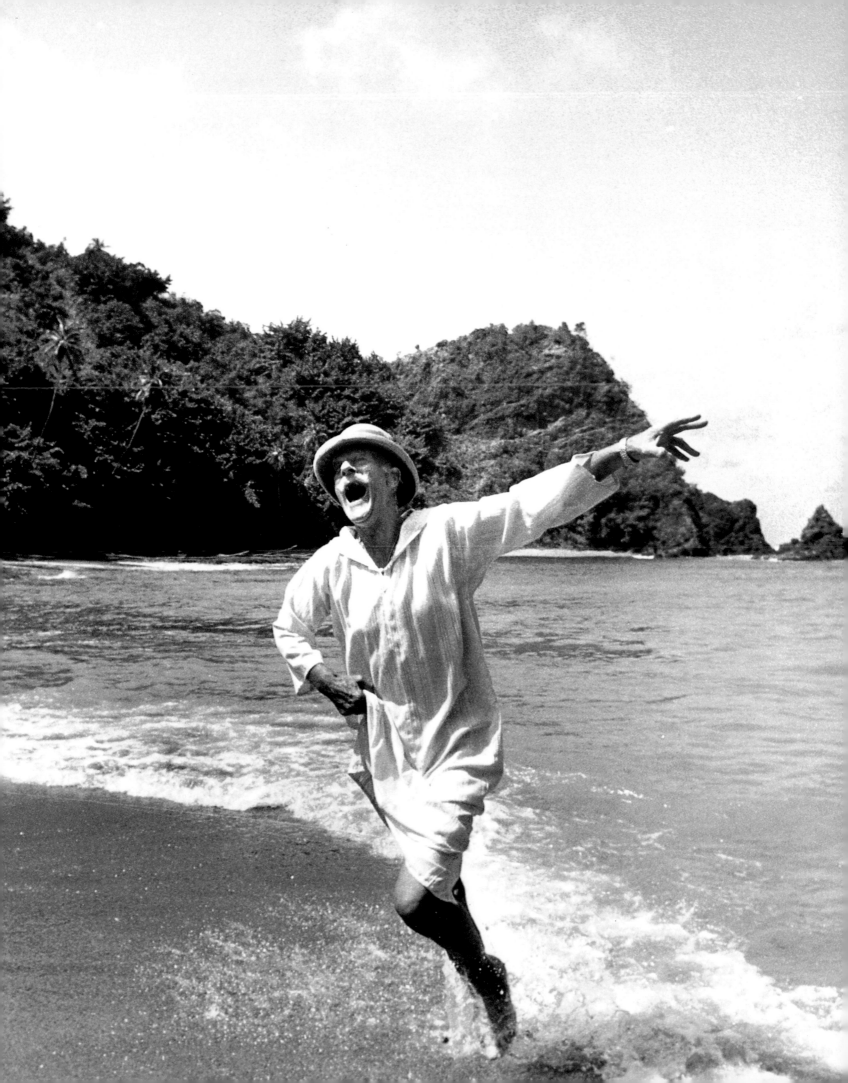

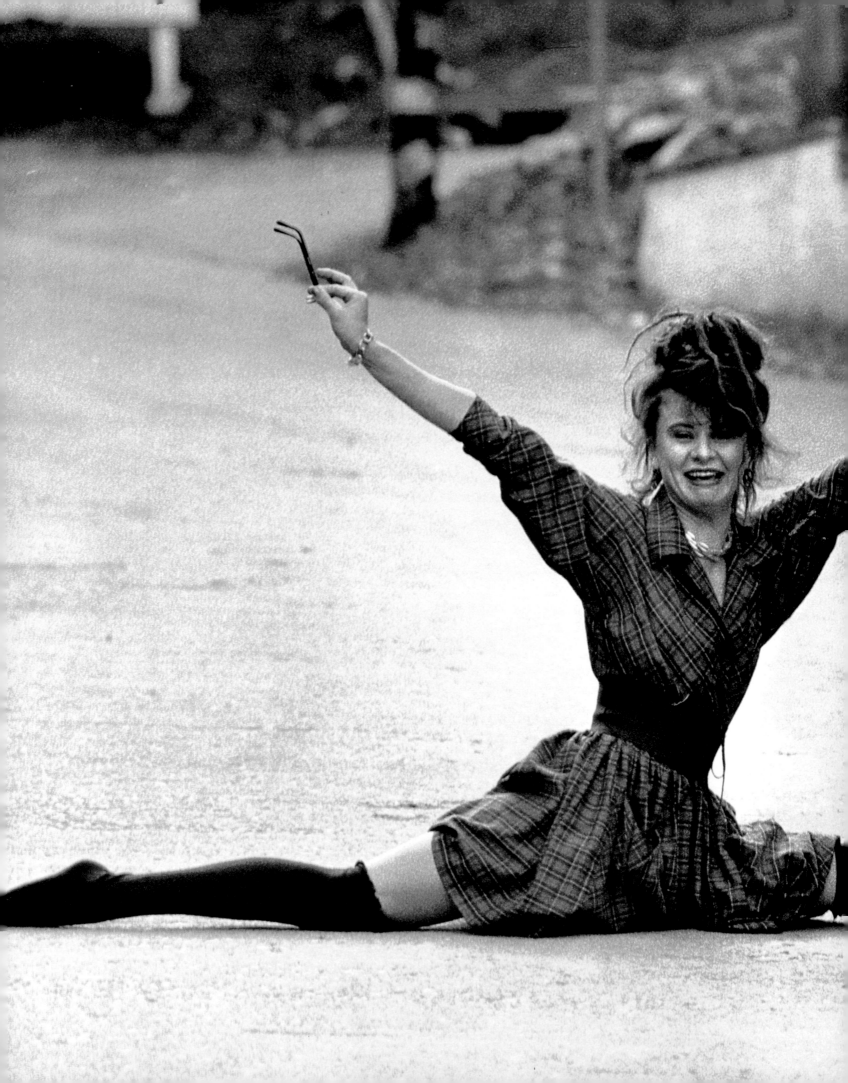

Tracy Ullman. Los Angeles, 1987
She is a big hit in Hollywood. When she heard my
voice she said, 'You're from Glasgow.' She said she
loved Glasgow and had worked there for the BBC.
Again, something beyond my control that was amusing
happened. As she was posing, her Yorkshire terrier had
a pee on her foot. A very funny lady in person as well as
on television.

89

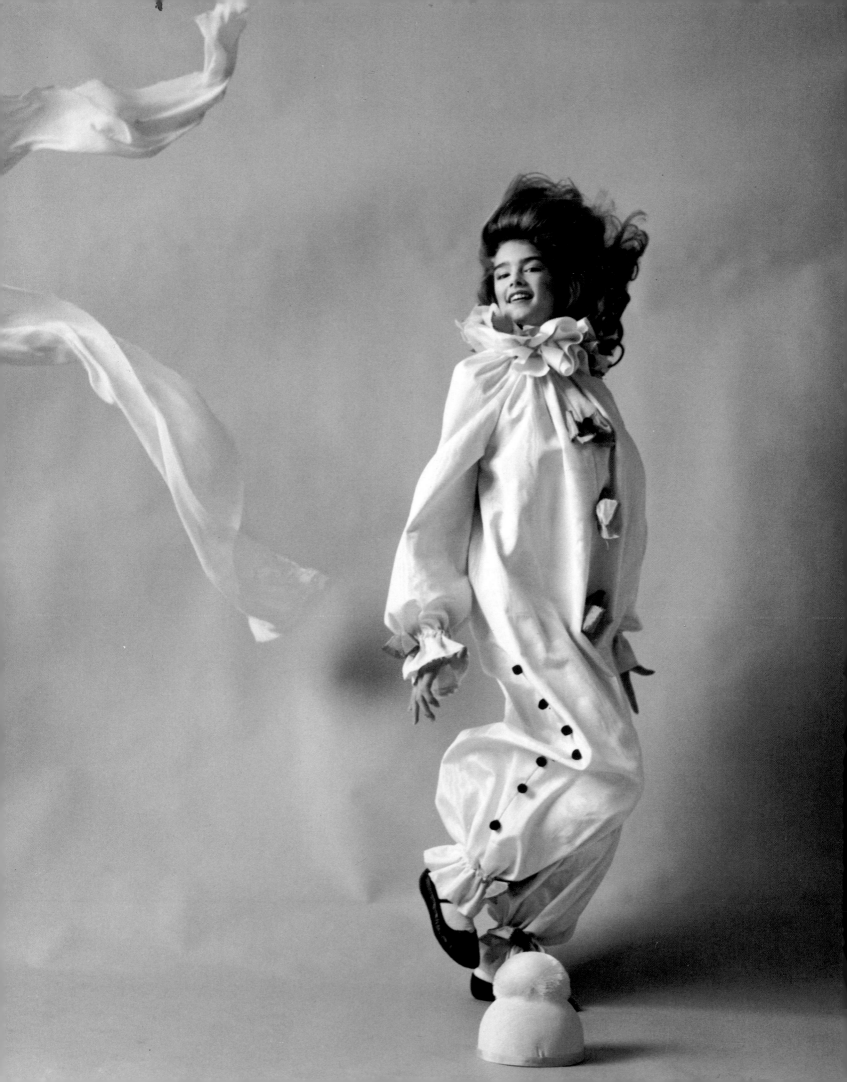

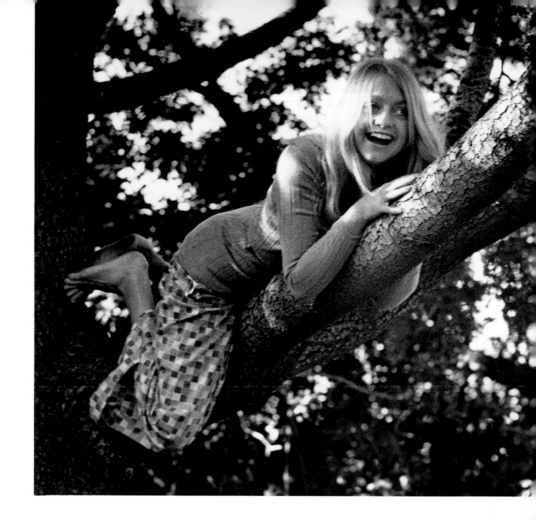

Goldie Hawn. Los Angeles, 1975
She had just completed the film *Shampoo* when this photograph was taken.
Julie Christie, who was also in the film, was with us that day. The
photographs were taken at Warren Beatty's house on Mulholland Drive. Julie
Christie was sketching Goldie on the lawn when she got up and climbed into
the tree on her own accord.

Brooke Shields. New York, 1978
Tired of seeing her made to be what she was not, I wanted to show what I
had seen – a thirteen-year-old capable of clowning around like the youngster
she was.

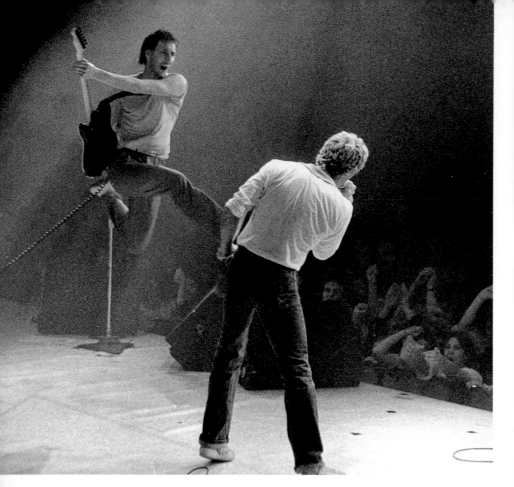

The Who. Vancouver, British Columbia, 1980
People warned me to be careful with Pete Townshend, that he was difficult
and had a history of being impossible. I found him to be very cooperative to
the point of giving orders that I could roam around and even go on stage
during a performance.

Dennis Quaid. New York, 1984
The Right Stuff had just come out. It was his first major film and he portrayed an
astronaut. He talked incessantly and I kept calling him Randy, which was his
brother's name. He laughed and said it didn't matter. He keeps fit by boxing
and said an actor must know how to move. So I asked him to move.

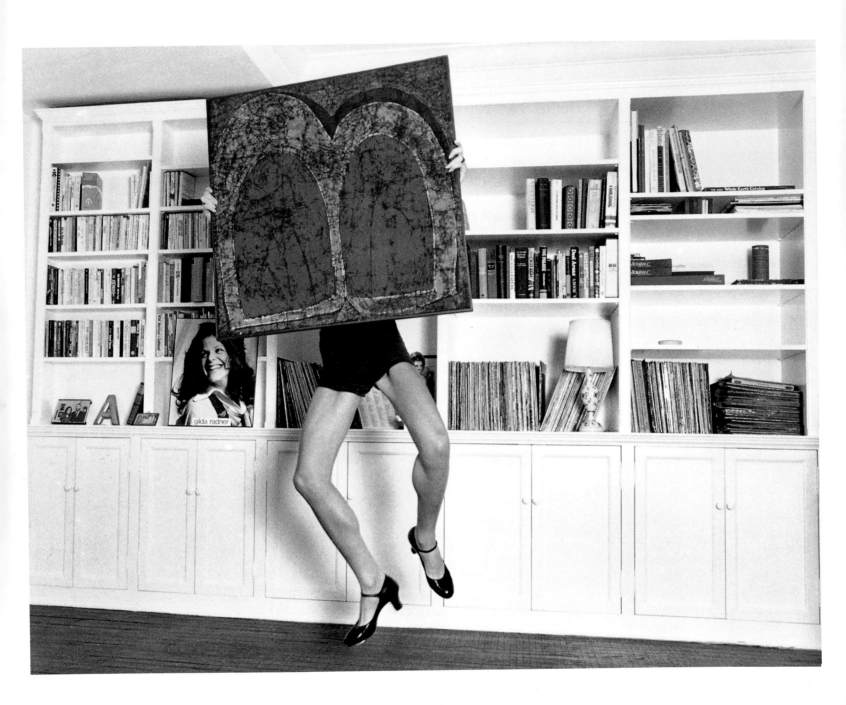

Gilda Radner. New York, 1977
It was not hard to take a funny picture of Gilda Radner. She was a funny lady
who told me that when she danced, in her mind she became Rita Hayworth.

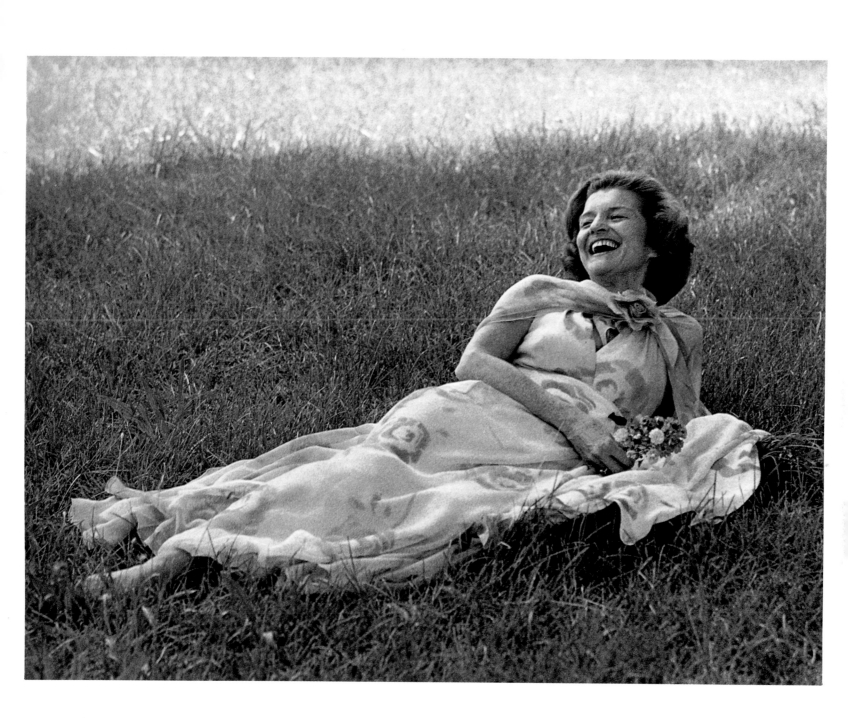

Mrs. Betty Ford. Alexandria, Virginia, 1974
Knowing she had wanted to be a model when she was younger meant she
probably knew how to have fun with the camera so I asked Mrs. Ford to lie
down in the grass in a vacant field near her home. There was something girlish
and charming about her.

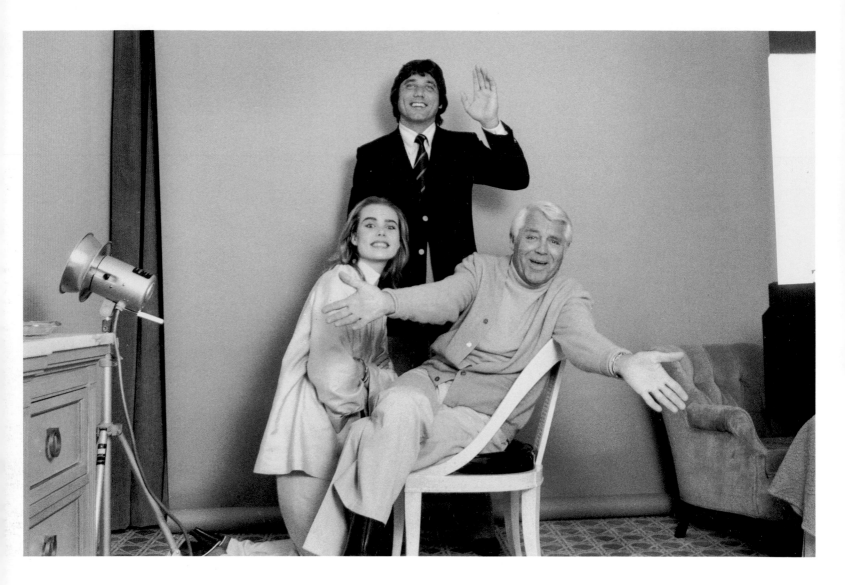

Joe Namath, Margaux Hemingway and Cary Grant. San Francisco, 1976
On the road, sometimes the only place for a studio is my hotel bedroom.
Football hero Namath, model Hemingway and movie star Grant were an
unlikely threesome, but they were together promoting a men's fragrance. *People*
magazine wanted a cover of the three of them and it was the only time they
would all be together.

Julianne Phillips.
Manhattan Beach, California, 1987
She told me she got more love from her dog than from
her husband, rock star Bruce Springsteen. Six months
later they were divorced.

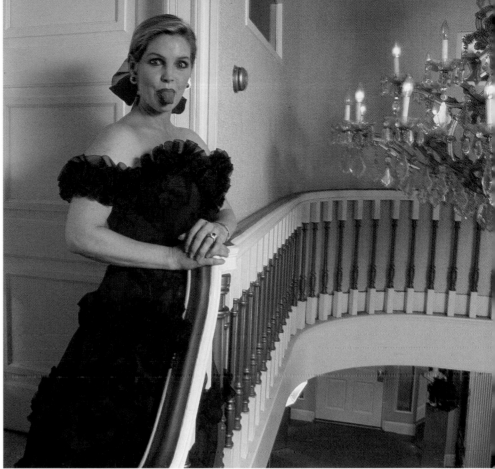

Priscilla Presley. Memphis, Tennessee, 1987
On the stairway outside Elvis's bedroom door, I asked Priscilla Presley to pose inside the bedroom, and this was her reply.

Robert Plant. Memphis, Tennessee, 1987
Life planned a tribute to Elvis on the tenth anniversary of his death. Plant, who travelled from London to be photographed at Graceland, was overwhelmed when he first set foot in the foyer. He had to leave and go stand by a tree.

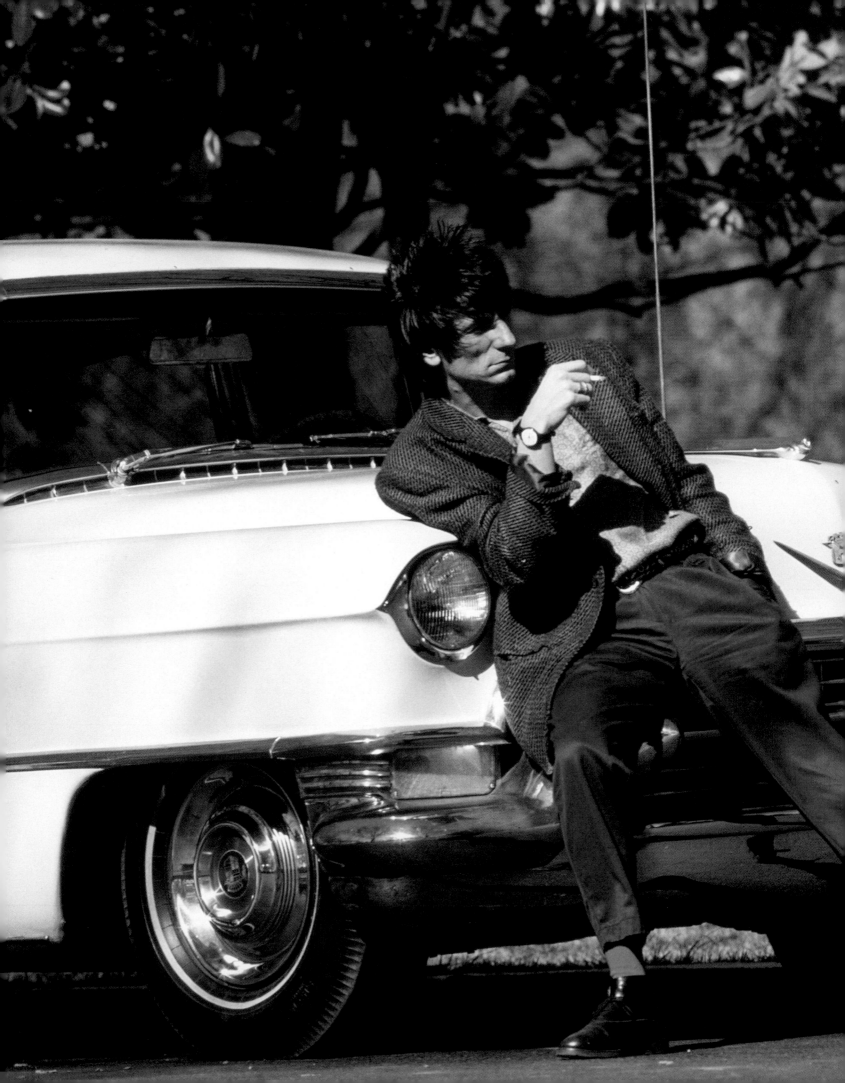

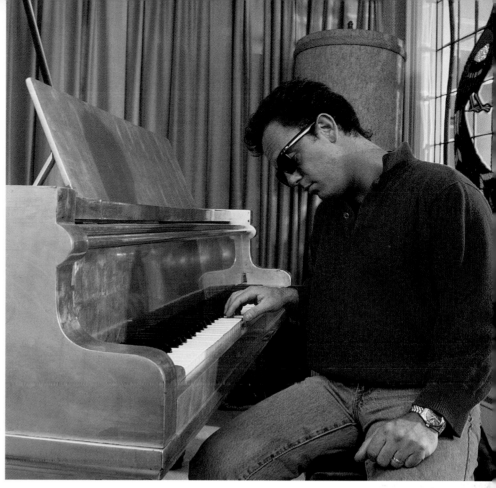

Billy Joel. Memphis, Tennessee, 1987
At Elvis's golden grand piano, a gift from Priscilla, Joel pounded out
'Heartbreak Hotel'. By the time Joel was in the fourth grade, he told me, he had
begun to imitate his idol in school talent-shows.

Ron Wood. Memphis, Tennessee, 1987
Rolling Stone Wood posed in front of the 1955 pink Cadillac that Elvis gave his
mother. All of the performers who came to Graceland for the *Life* tribute said
they owed their careers to Presley.

101

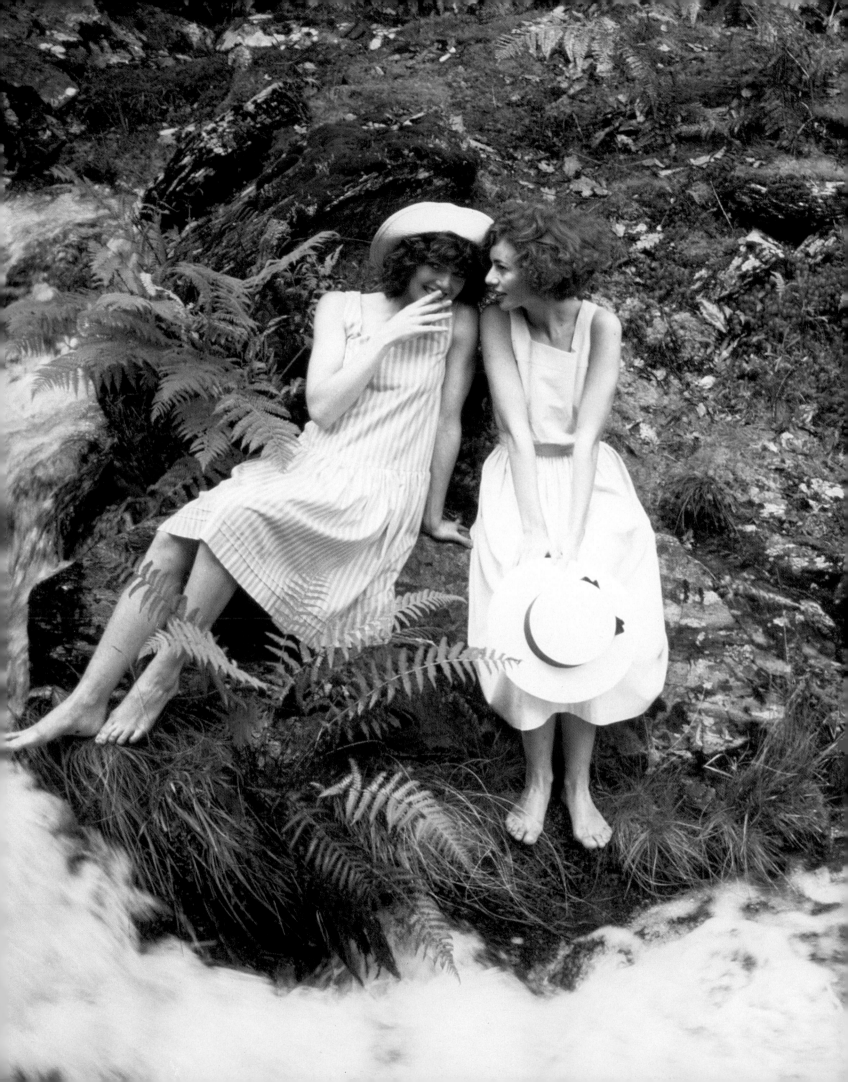

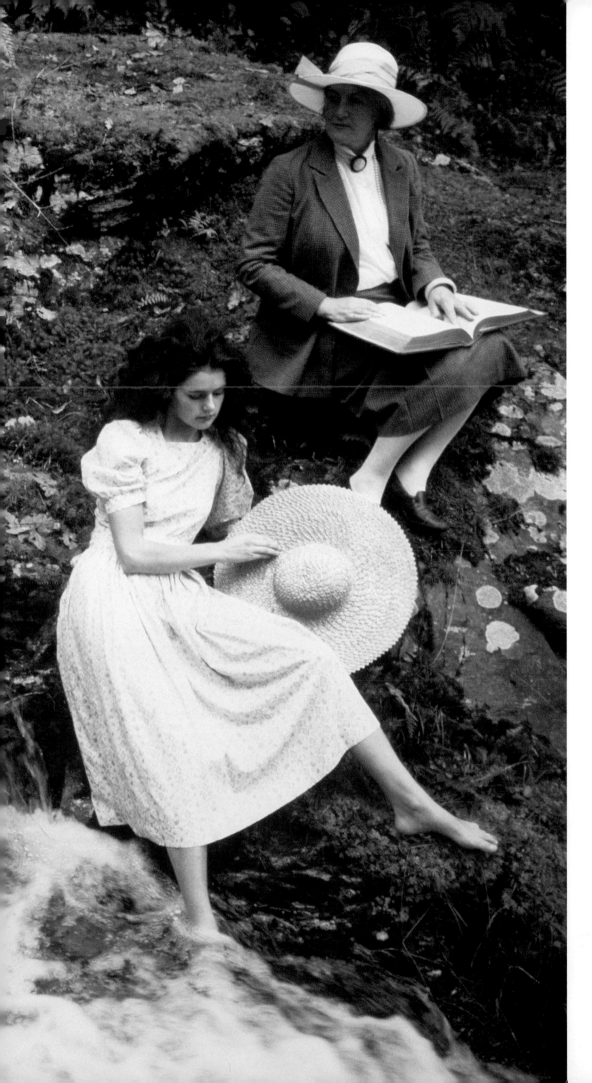

Laura Ashley. Rhydoldog Estate, Wales, 1983
She reminded me of a character from an Agatha Christie novel. I wanted the picture to look like a schoolteacher out for a picnic with her girls.

103

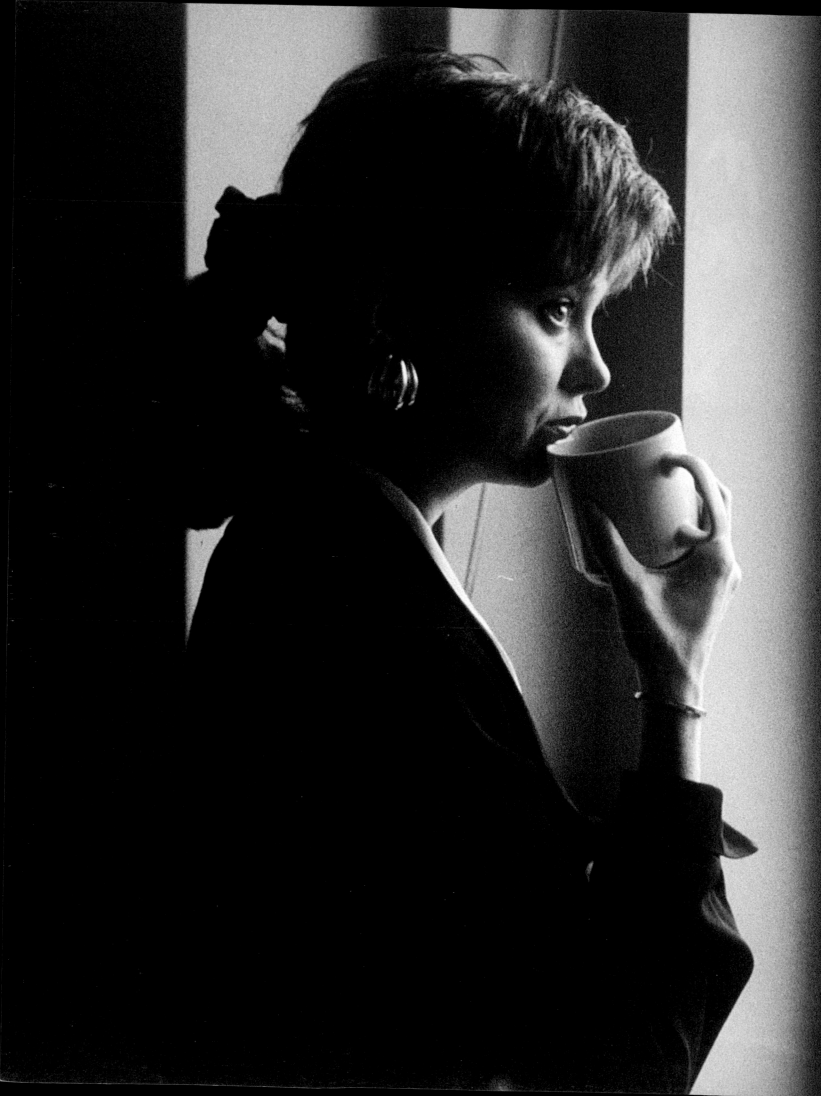

Jane Pauley. New York, 1989
After thirteen years on the *Today Show*, she had just
announced her resignation. At five in the morning,
with her usual cup of black coffee, as the sun rose over
Central Park, she stood by the window. She was
bewildered as to why *Life* wanted her for the cover.
This was the first picture taken in her home. She keeps
her family life separate from her public life.

105

**Mohammad Reza Pahlavi, Shah of Iran.
Noshahr, Iran, 1978**
The Shah wanted to show me the view from his window
and kept calling me over. Not moving, I told him if he
would ask his Great Dane guard dog, Beno, to get his
foot off my foot I would be able to cross the room.
Laughing, he told me Beno had no sense of humor.
When called off Beno sat by his master's side.

106

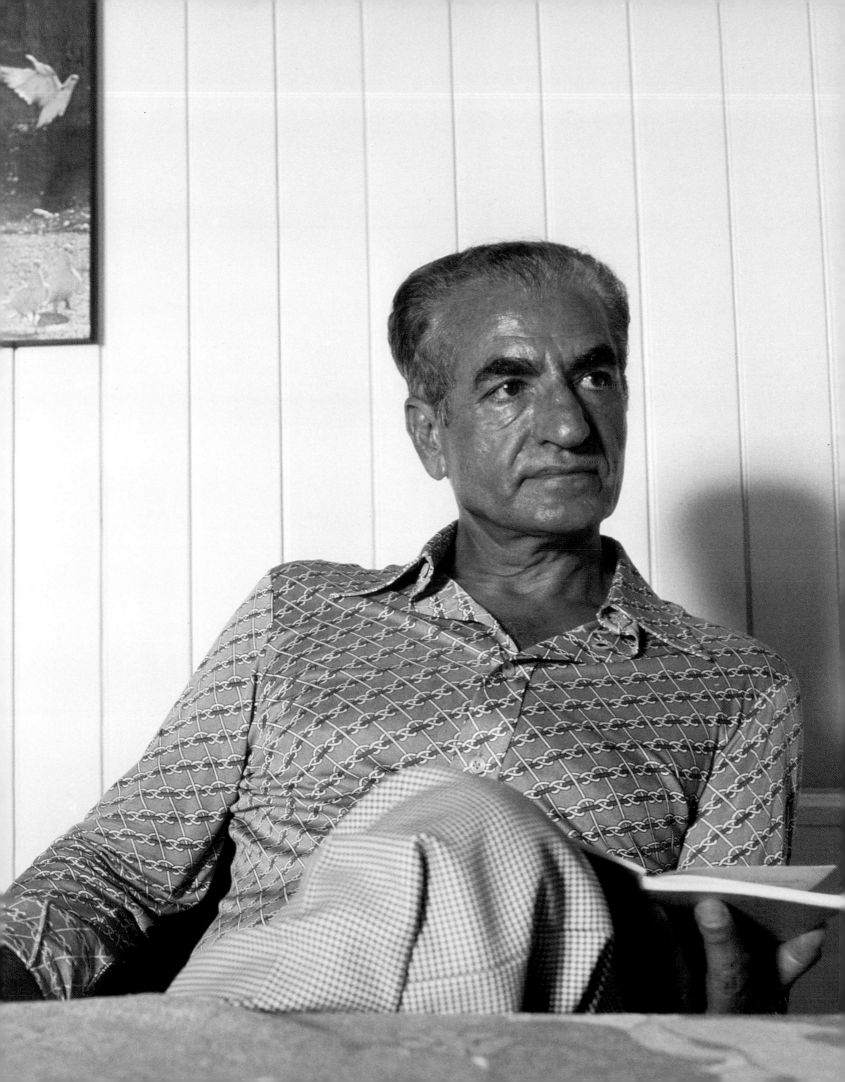

William Kunstler. New York City, 1990
Lawyer Kunstler, here with homeless people in
Tompkins Square Park, has always taken the side of
the underdog and the disenfranchised. Who else
throughout the years has consistently defended them?
You know that when he tells you somebody's got to
defend them, he feels he is the only one they can turn
to. Not at all modest, sometimes outrageous, and
always controversial, he is quietly articulate with a
sense of humor.

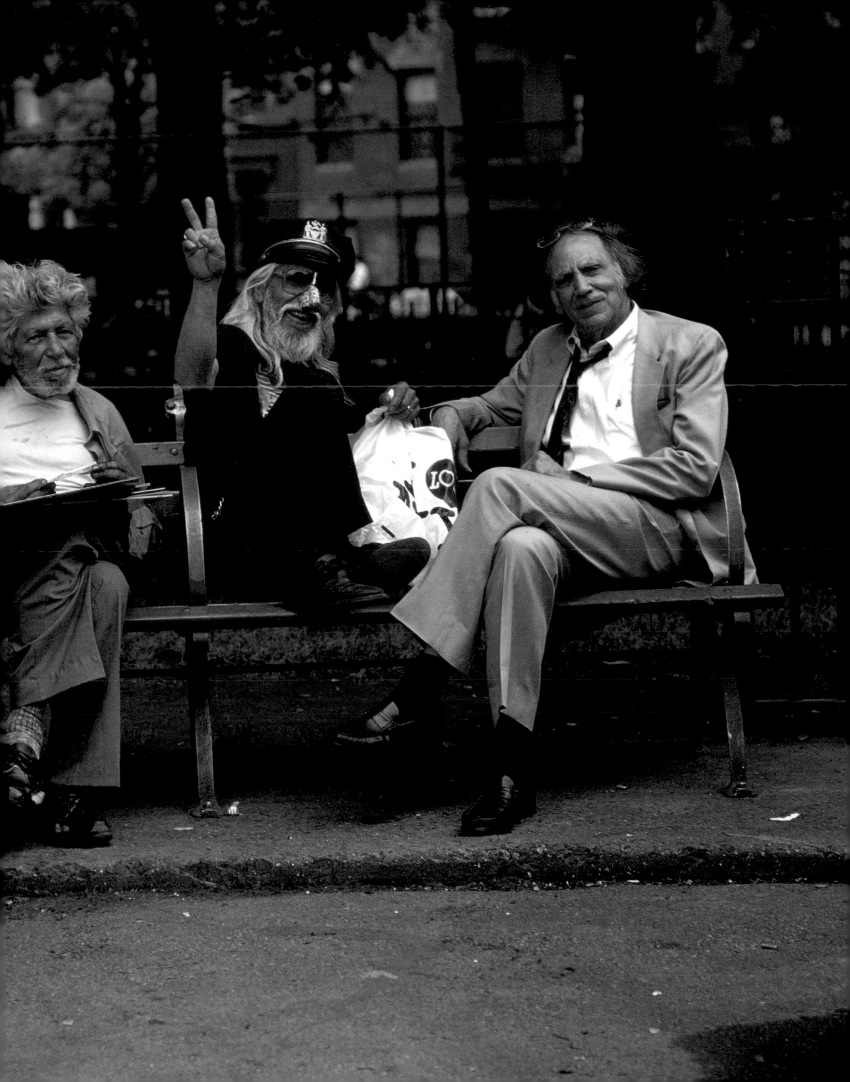

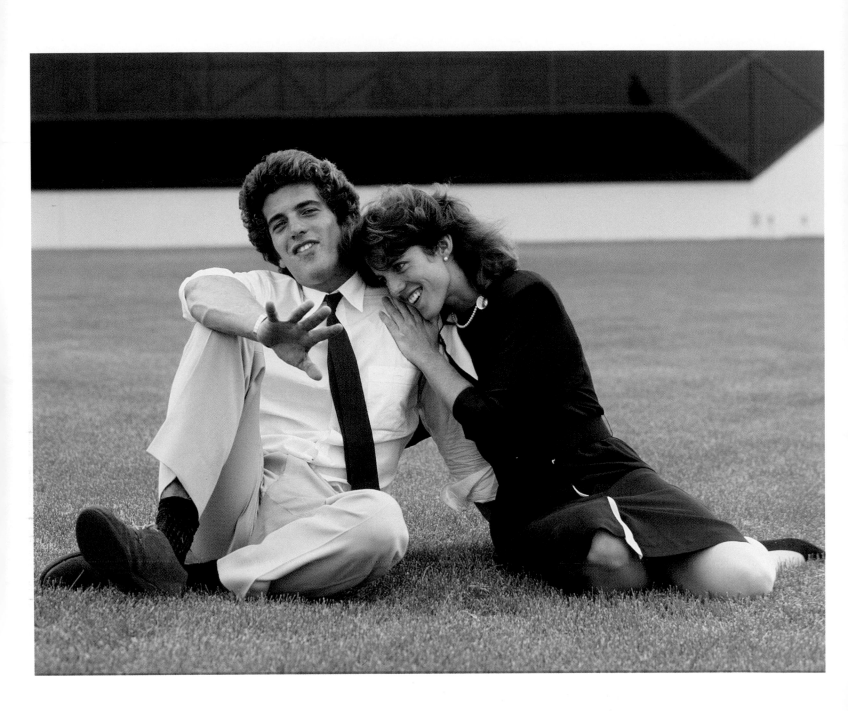

Caroline and John Kennedy, Jr. Boston, Massachusetts, 1984
For a story on all the presidents' children, Caroline and John Jr. sat on the
lawn behind the John F. Kennedy Library. They were posing for the first
time since childhood. Both asked what they should do, saying they had never
done this before.

Wendy and Tessa Benson. Oxford, 1989
No book would ever be complete without a picture of my children.

Robin Givens. Los Angeles, 1988
I had read about the carry-on in her divorce from Mike Tyson, but I must say I
found her to be charming, articulate and beautiful. People are never what you
expect. When a person tells me I'm going to love photographing someone,
then instinctively I know I will have problems. With Robin Givens it
was the opposite.

Alec Baldwin. New York City, 1986
It was at the beginning of the surge in his career and I was photographing
him for *People* magazine. He was personable and wanted to please and talked
openly and a lot. I asked him to put his jacket back on after he took off his
shirt; it seemed to look right.

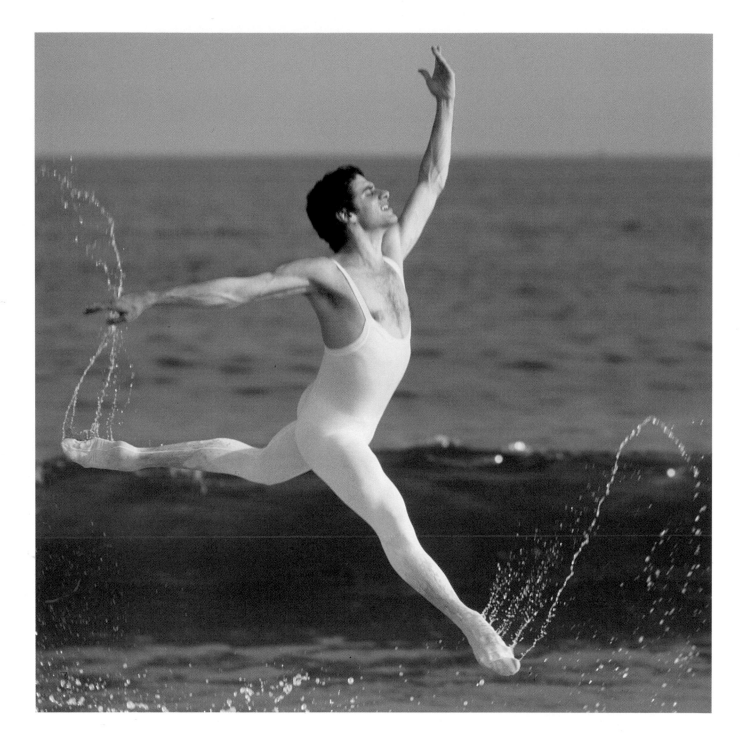

Fernando Bujones. New York, 1985
While photographing ballet dancer Bujones on the beach, I liked the way the
water seemed to dance around his feet. Earlier he had fun with his two children
in his backyard, playing ball with them, showing them ballet steps.

Farrah Fawcett. New York, 1981
I had photographed her before, when she first came to Hollywood. She was in
better shape now – tiny and fit. She was polite but firm in knowing how she
wanted to look, so while the hairdresser and make-up person sat watching, she
did her own hair and make-up for the cover portrait for *People*.

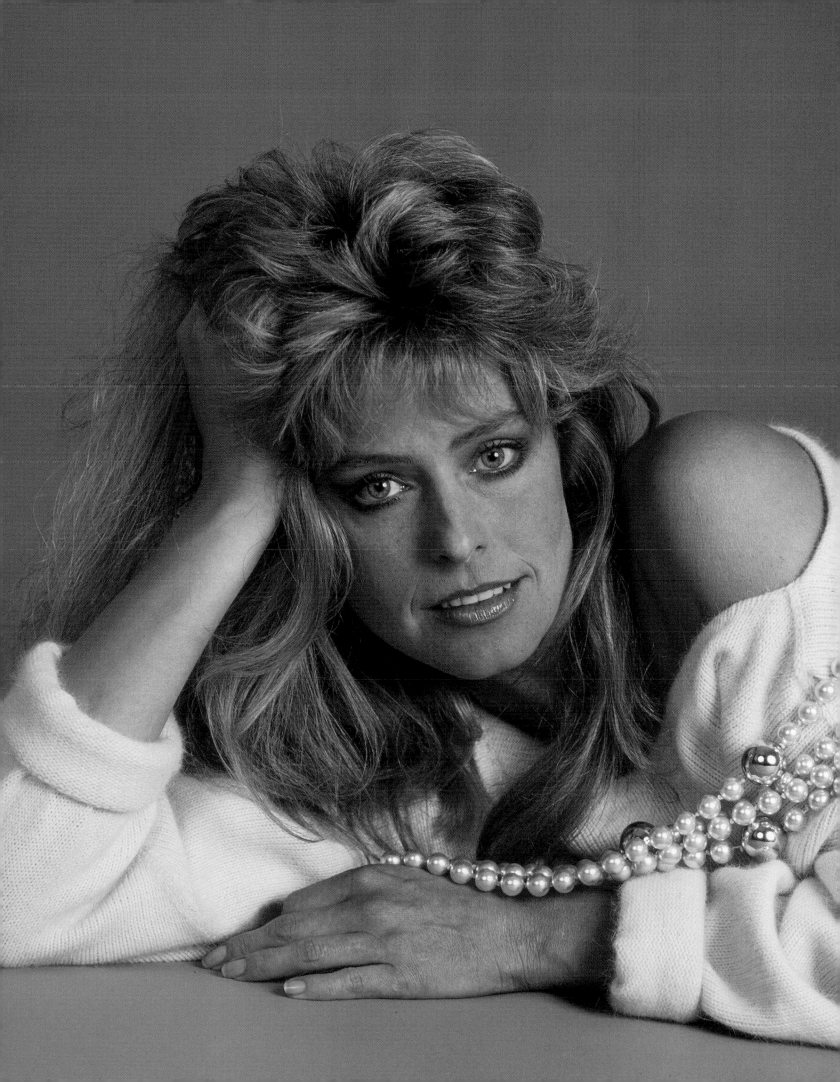

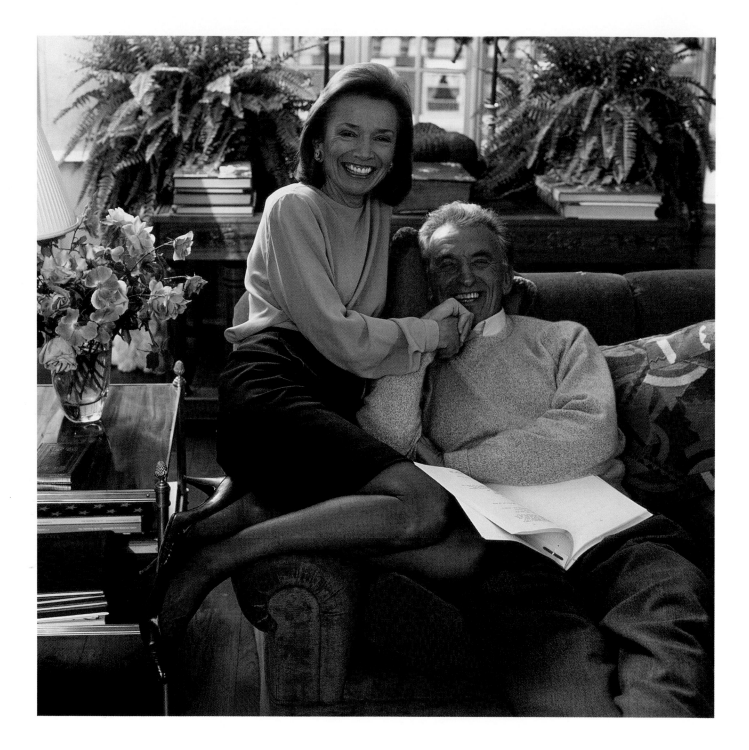

Lee Radziwill and Herbert Ross. New York, 1988
They had just recently married. When I came into her living-room she casually
sat on the arm of the sofa and asked what I wanted her to do. It was spontaneous
and I said just sit where you are.

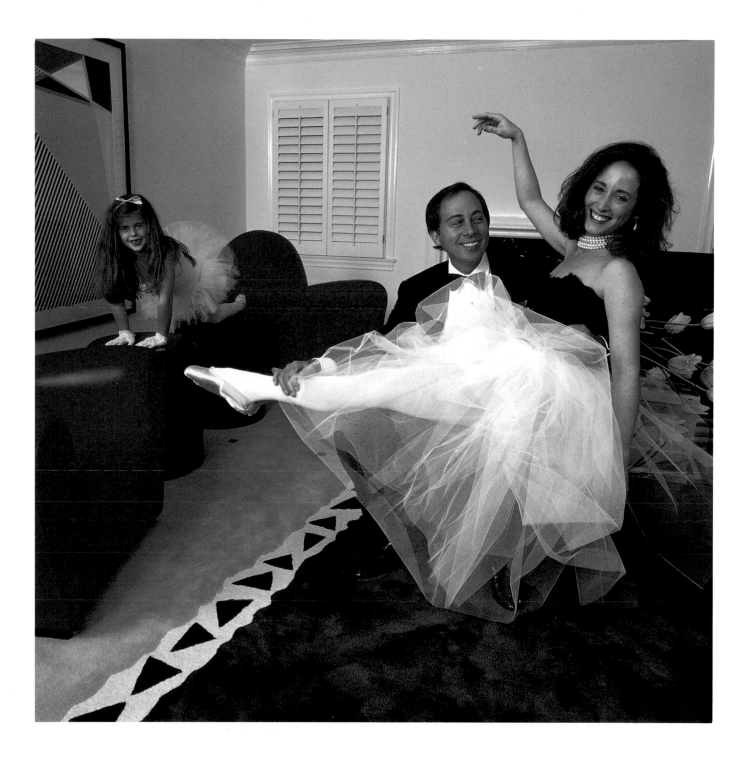

Brandon, Lilly, and Calla Lianne Tartikoff. Los Angeles, 1990
President of the NBC television network, Brandon Tartikoff and his wife, Lilly,
a former dancer with the New York City Ballet, and daughter Calla Lianne in
their Coldwater Canyon home. Mrs. Tartikoff has a fun-loving and zany
personality and I suggested she put on her ballet slippers and have some fun.
They have every reason to celebrate, for he took NBC from last to first place in
the television ratings with hits like *The Cosby Show* and *Cheers*.

Jack Nicholson. Aspen, Colorado, 1990
In Colorado for the filming of *The Two Jakes*, the
sequel to *Chinatown,* Nicholson had agreed to be
photographed for *Life.* We waited four days for him
to finally come out. Then he gave me two hours in
which he clowned around and basically did what was
needed to get some pictures.

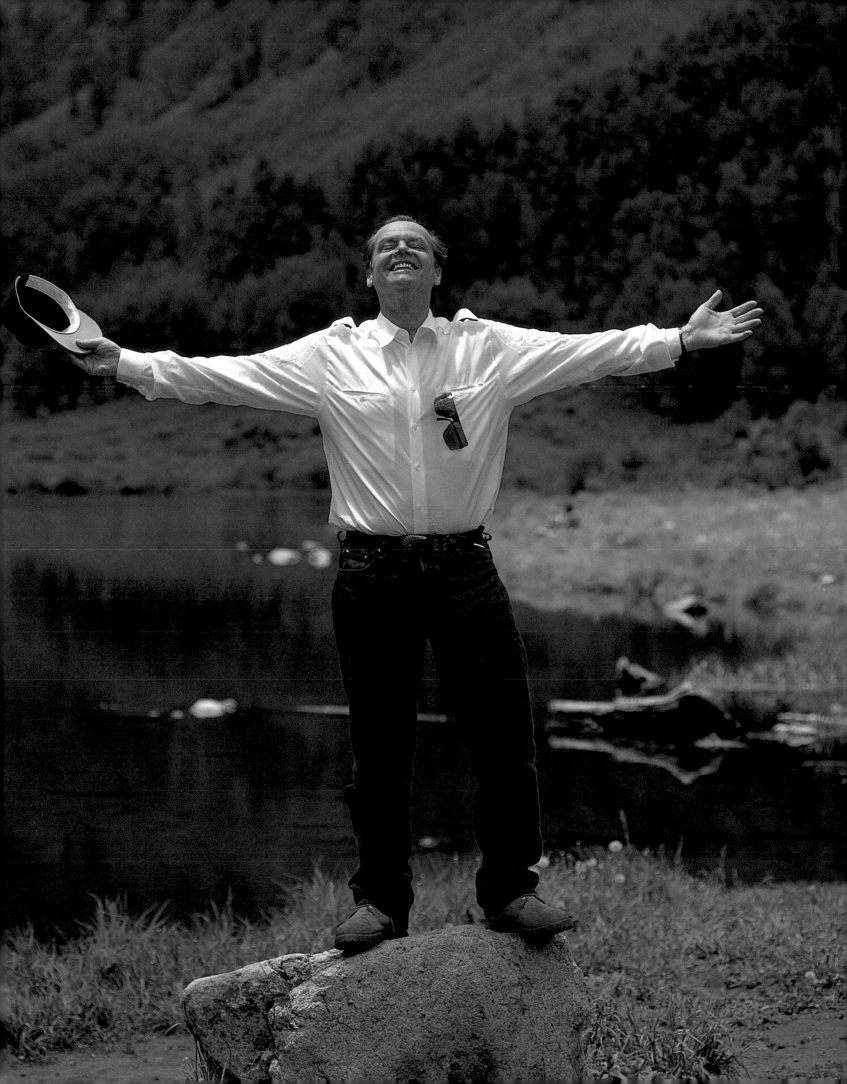

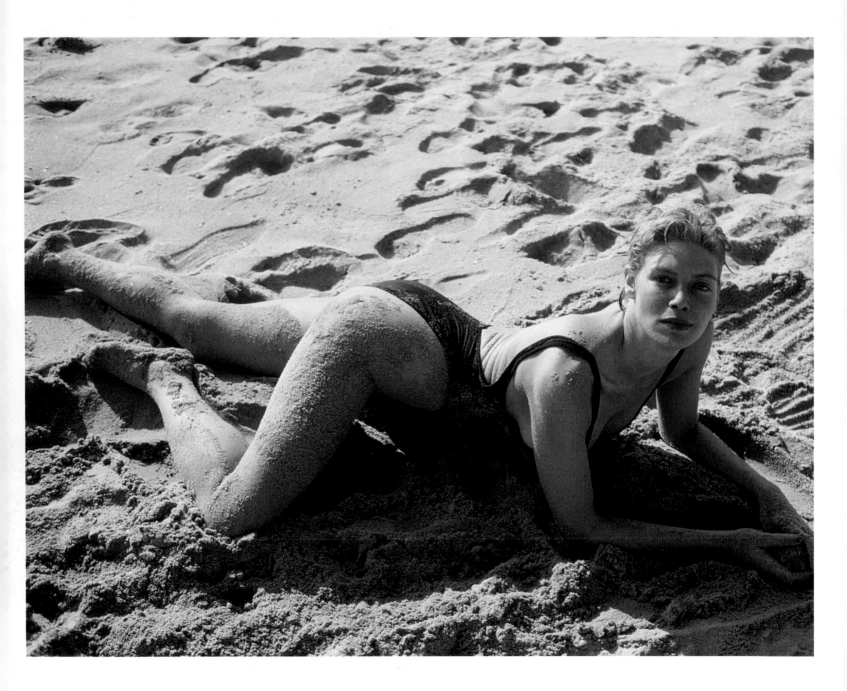

Kelly McGillis. Los Angeles, 1988
She was playing on the beach with her dog, throwing a ball for him to fetch, and
she had got sand all over herself. She was pleasant and likeable, and I had a good
time photographing her.

Roman Polanski. Seychelles, 1976
While doing an assignment for French *Vogue* on pirates, I thought of burying
Roman up to his neck in the sand. He got a bit frightened, a bit apprehensive,
when the tide came in and he discovered he couldn't get out without my help.

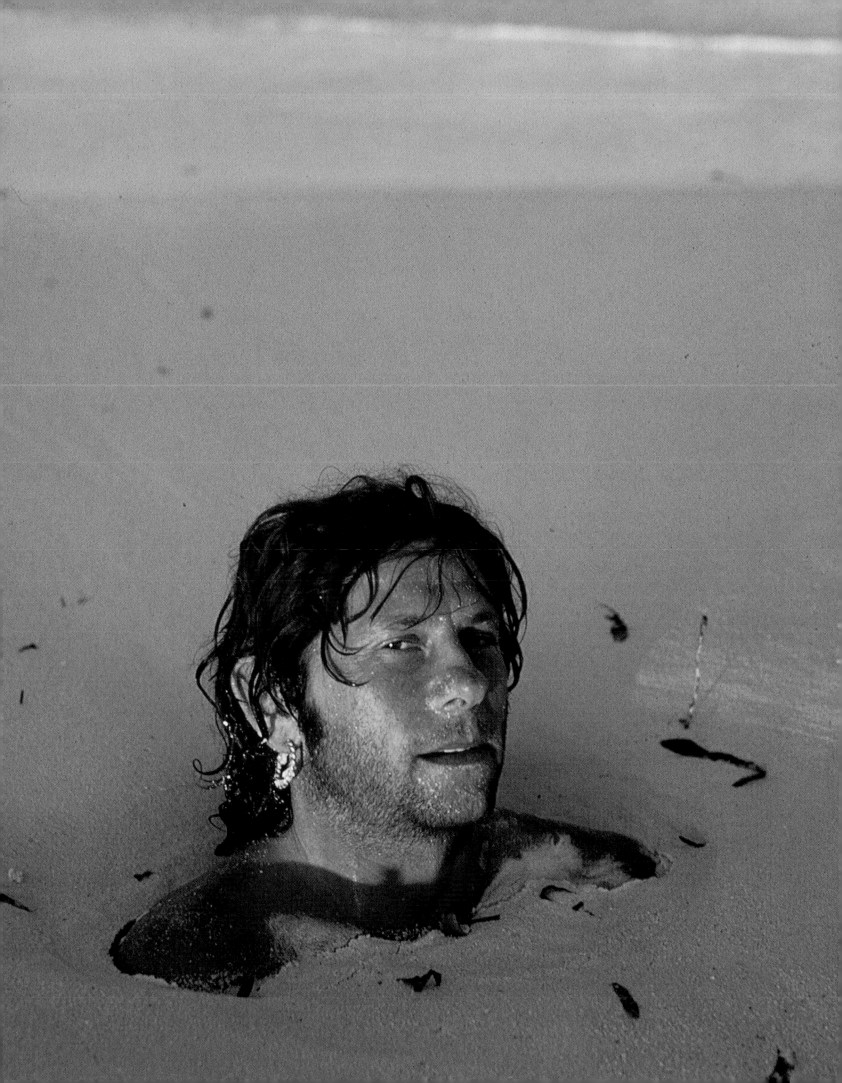

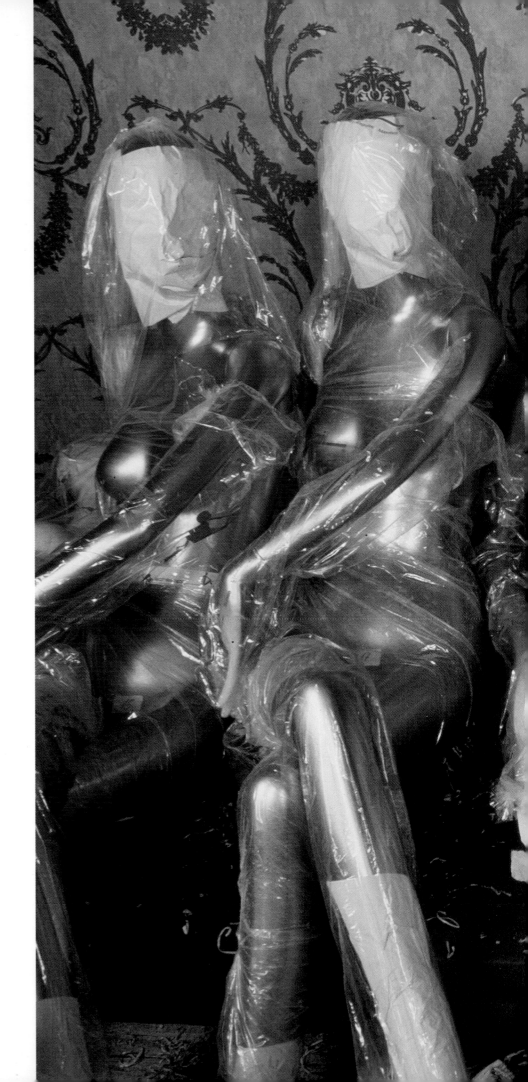

Diana Vreeland. New York, 1983
While preparing for an exhibit for the Costume
Institute of the Metropolitan Museum of Art, she
sat down among the mannequins. Mrs. Vreeland
had a great sense of drama and style. The first time
I met her in the 60s, she showed me two
photographs of models and asked what I thought
the difference between the two girls was. Before I
could answer she said, 'Take a look at the eyes, the
eyes. This girl's are alive and the other one's are
dead. That's the difference.' At the time she was
the most important woman in American fashion, an
American icon. Once an immigration officer came
to her office at *Vogue* to ask about an employee who
was an illegal alien. He asked Mrs. Vreeland if the
girl would run away and she answered, of course
not, she doesn't have the energy.

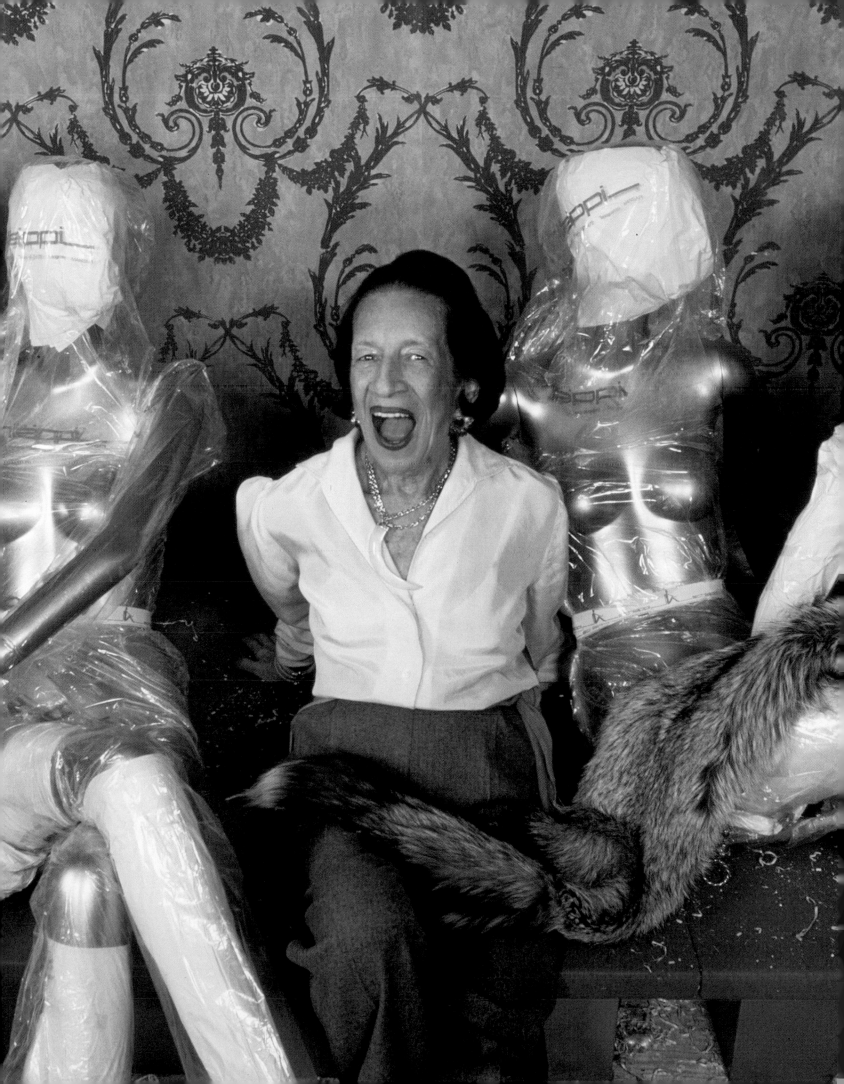

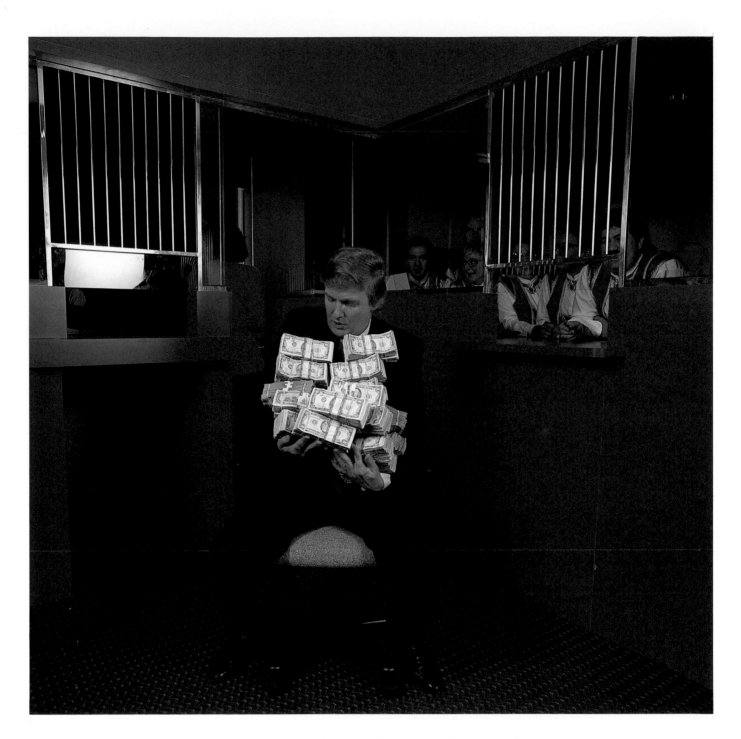

Donald Trump. Atlantic City, 1990
In Atlantic City at the Taj Mahal, Donald Trump was talking about the daily
receipts in the casino. He mentioned a million dollars a day and I told him I had
never seen a million dollars in cash, and it would make a good cover photograph
for *People*. In we went to the 'cage', a high security area in the casino with armed
guards all around. He has a good sense of humor even in the midst of his

financial woes.

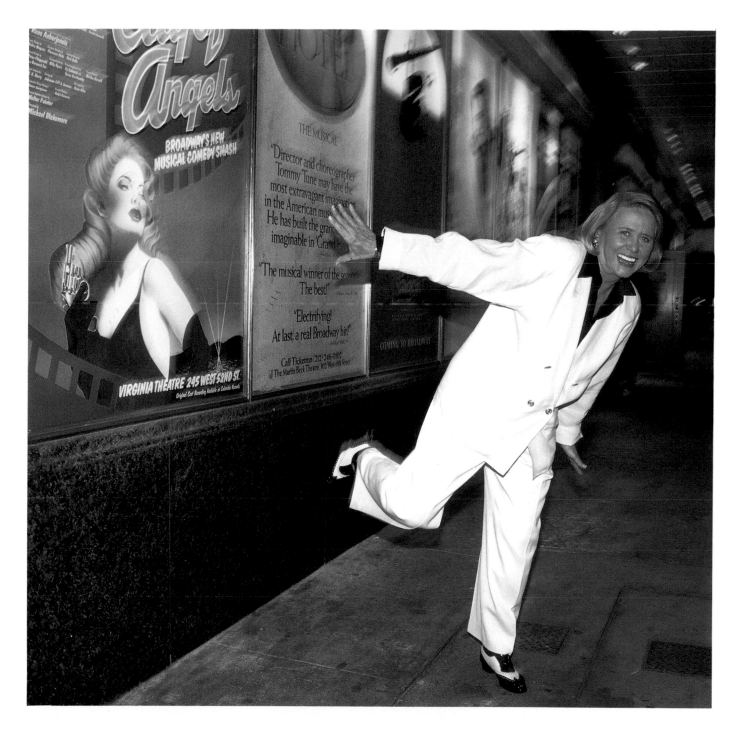

Liz Smith. New York City, 1990
When asked to be photographed in her favorite place in New York for
Architectural Digest, newspaper columnist Liz Smith chose the Broadway theater
district. We had a great laugh cavorting in Shubert Alley. A good sport, she
didn't seem to mind that we stopped traffic while I took photographs. She told
me the main reason she wanted to move to New York from her native Texas was
the theater. Now she is as famous as the people she writes about.

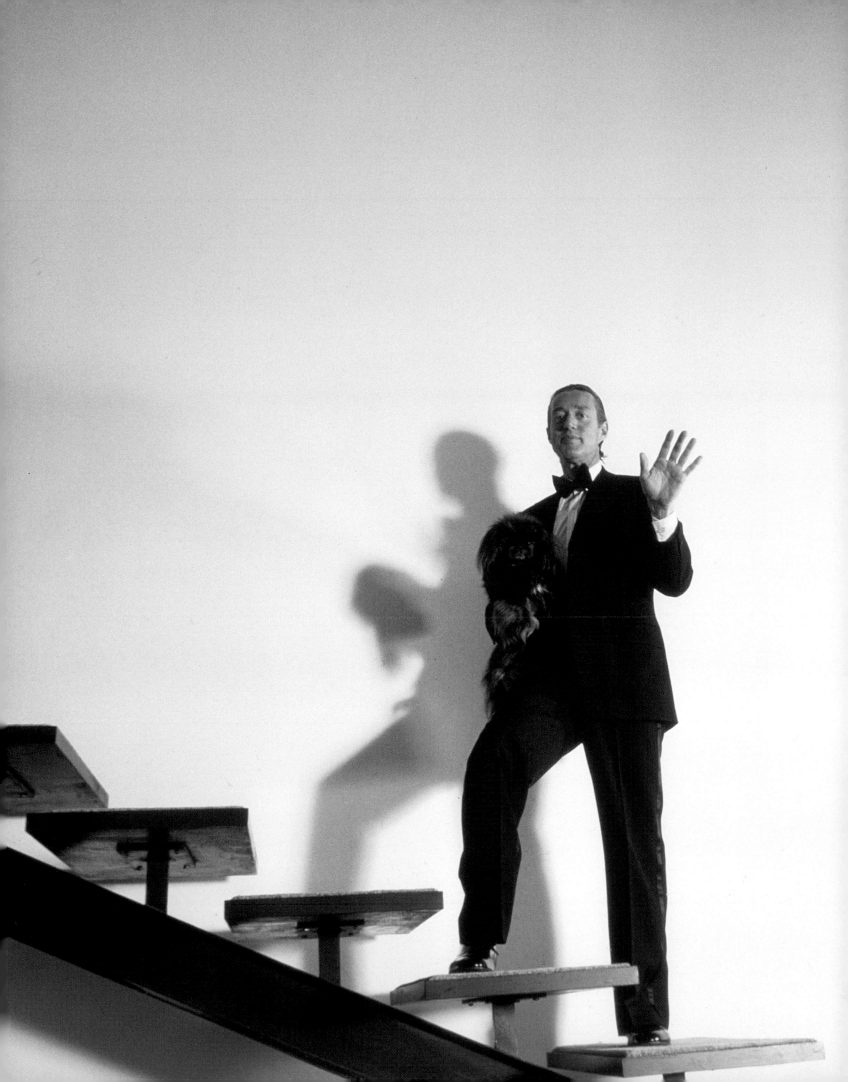

Halston. New York, 1978
Halston was larger than life. In the many times I photographed him, he never wasted my time – one of those celebrities who really wanted to oblige. I always knew with Halston I would not come back empty-handed. He knew his image was that of glamorous fashion designer and he loved it. This was the last photograph I took of him – running up the stairs of his townhouse.

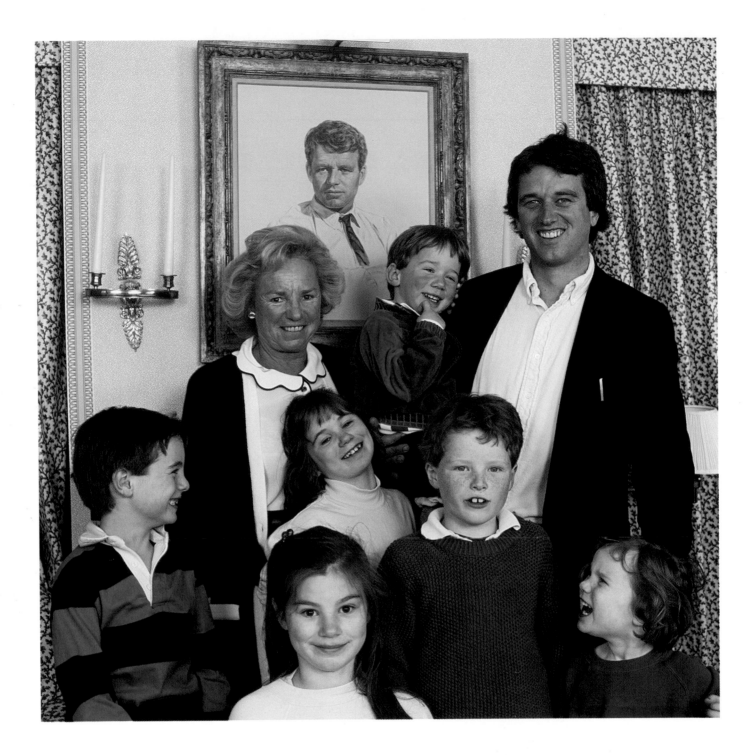

Mrs. Ethel Kennedy and Family. McLean, Virginia, 1988
On the anniversary of Bobby Kennedy's birthday, his family and friends
gathered at the family home, Hickory Hill. Most of them were celebrating
and remembering a father they hardly knew. Bobby Kennedy was one of those
people you were fortunate to touch in your travels. It's hard to believe that all
this time has passed. Mrs. Kennedy stands with Robert Jr., holding his son,
Robert II, and several of her grandchildren beneath a portrait of Bobby.

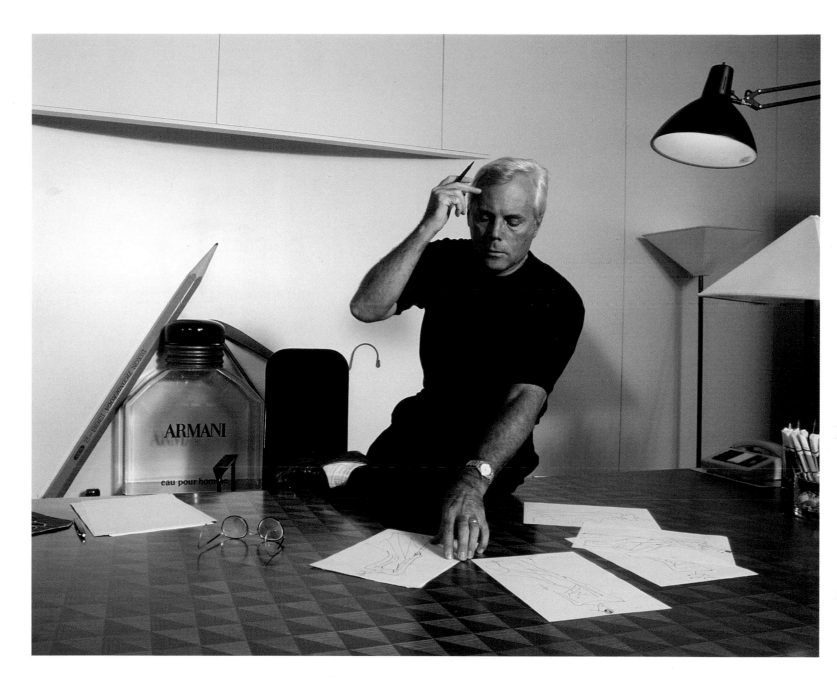

Giorgio Armani. Milan, 1987
What I find interesting about the very talented and the very busy is that they
will always find a moment. Nothing is too much for them. This picture was
taken right in the middle of Armani designing his Spring Collection, with
women with swatches of cloth running around and telephones ringing
constantly. Amid seeming chaos he stopped everything to give me
half-hour of his time.

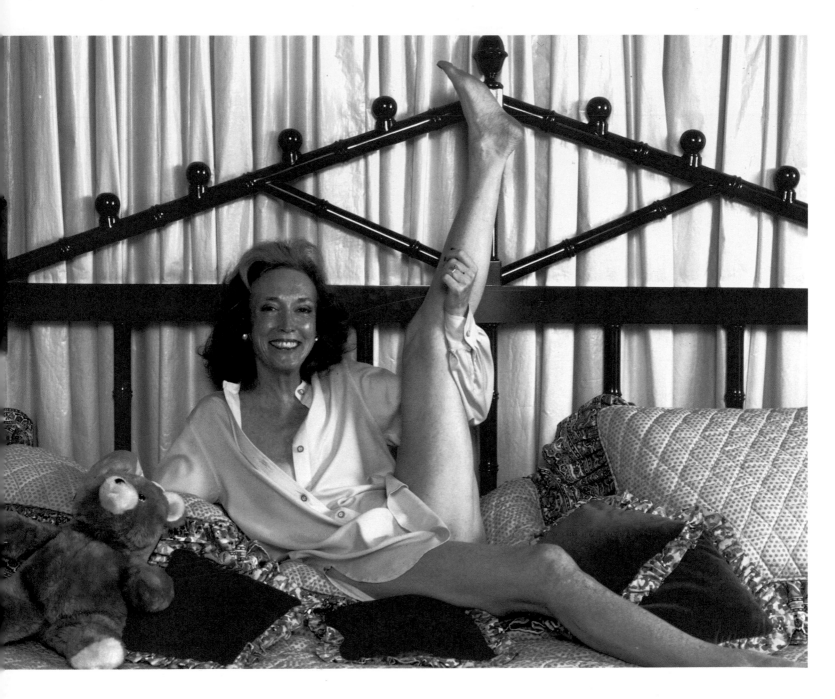

Helen Gurley Brown. New York, 1990
She told me she worked out every day. I asked if she would run through her
exercises, and I would tell her when to stop. It didn't take long, this was the
second pose she did.

Valentino. Rome, 1987
In his design studio in Rome, he was preparing a collection. He said he worked
so hard designing beautiful clothes so that he could enjoy seeing beautiful ladies
wearing them.

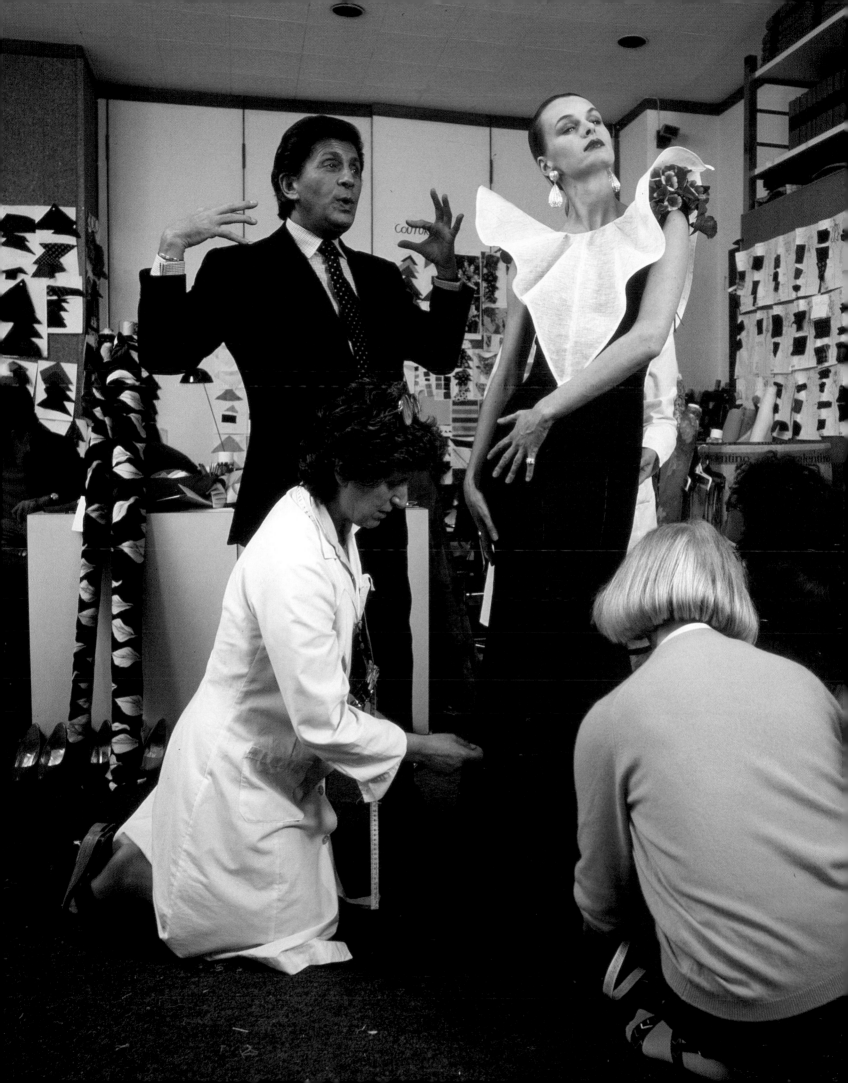

Elliott Roosevelt and wife, Patty. Indian Wells, California, 1984
I was struck by his resemblance to his famous father, in profile and in manner.

Francis Grover Cleveland. Tamworth, New Hampshire, 1984
While his father was President, the Statue of Liberty was dedicated and
Geronimo went on the warpath. Born after his father left office, he has never
been in the White House and doesn't seem to care. Eighty-one-year-old Francis
Cleveland rehearses for the comedy, *Harvey*, about a man and his imaginary
rabbit. An actor who helped found a theater group in 1931 near where he lives,
he still performs in its productions.

Michael J. Fox. New York City, 1990
He reminded me of what James Cagney might have been like when he was
twelve. He didn't have much time to be photographed. They said he had only
ten minutes and ten minutes is what I got, but he had plenty of time to talk to
his hairdresser about ice hockey. Photographing him for the London *Sunday
Times Magazine*, I put up a backdrop because I was given a room to photograph
in about the size of a large closet and I was trying to think of something to
make the picture more interesting.

Bunker Hunt. Dallas, 1980
He had reportedly tried to corner the market in silver and *Life* sent me, with a
reporter, to try to get the story. He said, 'Yes, if I can edit the text.'
Of course *Life* would not agree, but before leaving, I asked to take
one quick picture in his office.

Jimmy Breslin. Queens, New York, 1988
He is New York's number one newspaper columnist. He's that because he takes
the side of the little man, the dissatisfied, and he loves it. The people he writes
about come from all walks of life, usually from the boroughs of Brooklyn and
Queens. He's not afraid to take a shot at any official he feels deserves it.

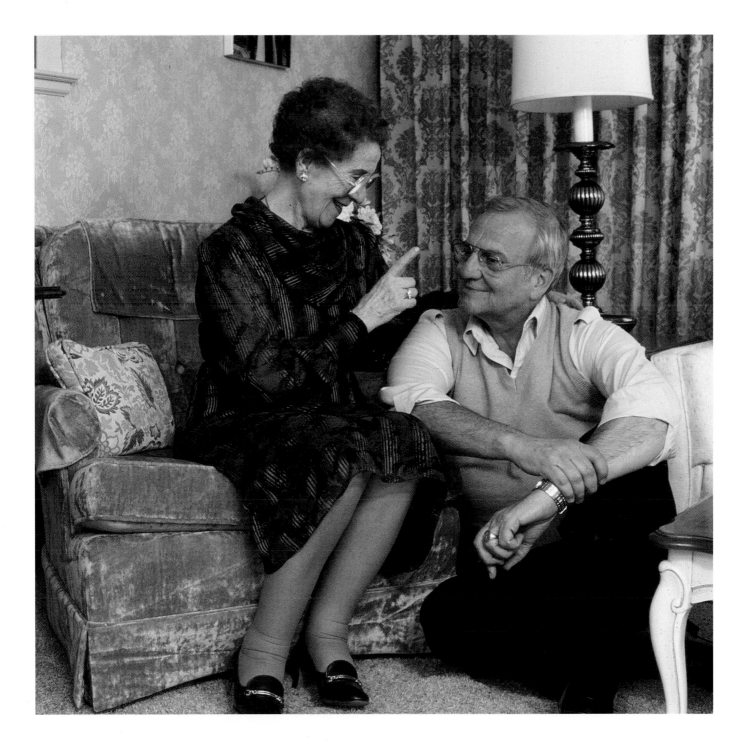

Lee Iacocca and his mother, Antoinette. Allentown, Pennsylvania, 1986
The Chrysler chief made the mistake of telling me that his mother was still the
boss so I asked her to give him a piece of her mind. She launched into an old
reprimand from his childhood which made him smile.

King Juan Carlos. Madrid, 1985
After photographing the King and Queen and their family, the King showed me his dogs. I must have been thirty yards away when he picked up two puppies by the scruff of the neck and put them back into their pen. I went back over to the pen and left the door open. Of course the dogs ran out. He looked at me as if to ask why I left the door open. He naturally had to go and get them again. This time I didn't have to run thirty yards to get the picture.

138

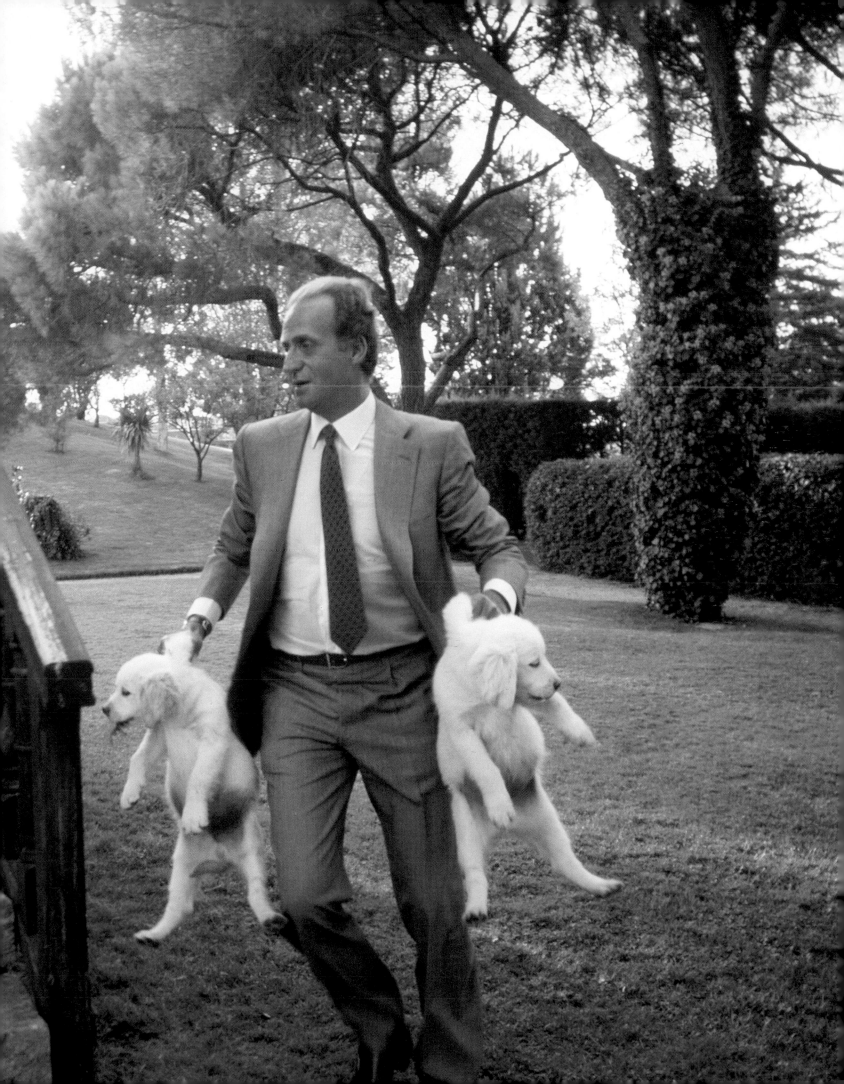

Donna Karan. New York, 1988
America's top woman fashion designer is always on the
run. She leaves her make-up for the limousine on the
way to work, and she talks incessantly on the phone at
the same time. She's very happy with her success.

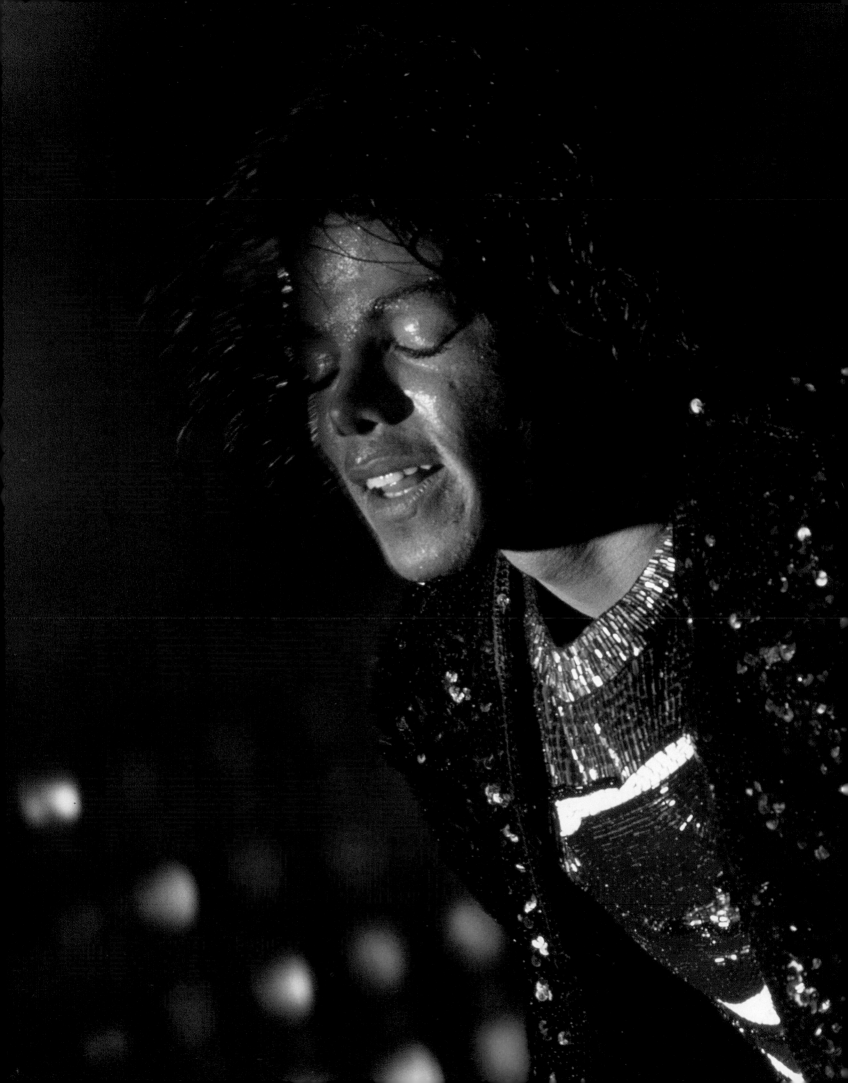

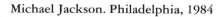

Michael Jackson. Philadelphia, 1984
On stage the tenseness, the nervous energy, show, but
off stage Michael is very, very quiet and shy. He liked
my jacket, an English tweed riding jacket, which I gave
him. He seemed pleased and immediately put it on.

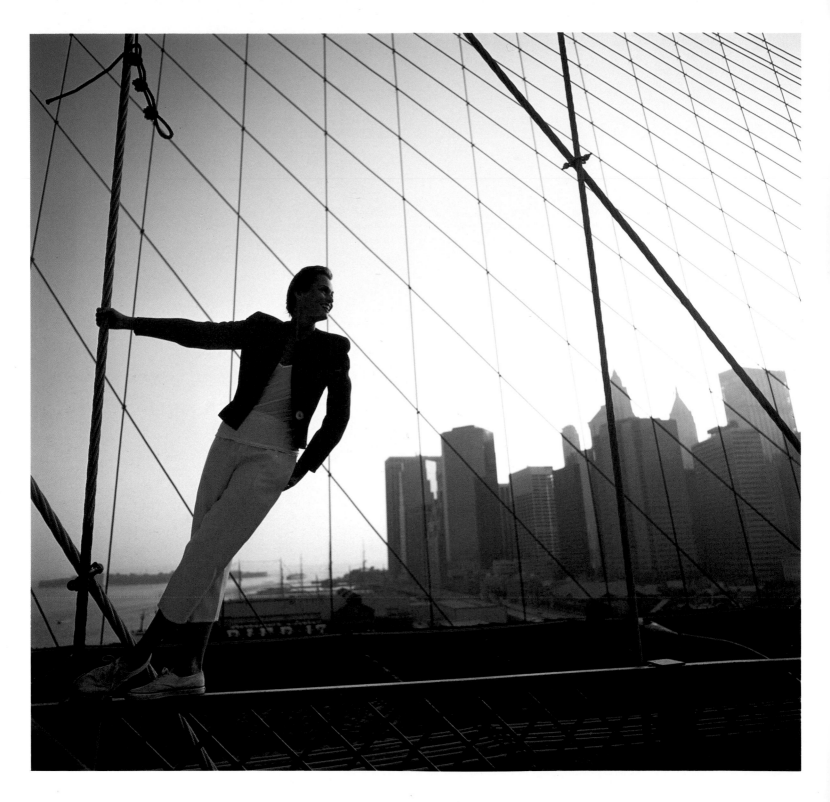

Lauren Hutton. New York City, 1990
Model/actress Lauren Hutton enjoys being photographed. With her it's fun
and that's the way it should be. I didn't tell her to climb on the railing of
the Brooklyn Bridge, not because I was afraid she would fall off, but because
I was afraid we would get arrested. She was asked by *Architectural Digest* to
choose her favorite place in New York. She told me she still remembers the
first time she came across the bridge into Manhattan and saw the skyline and
it gave her goosebumps. 'There's nothing like it,' she said.

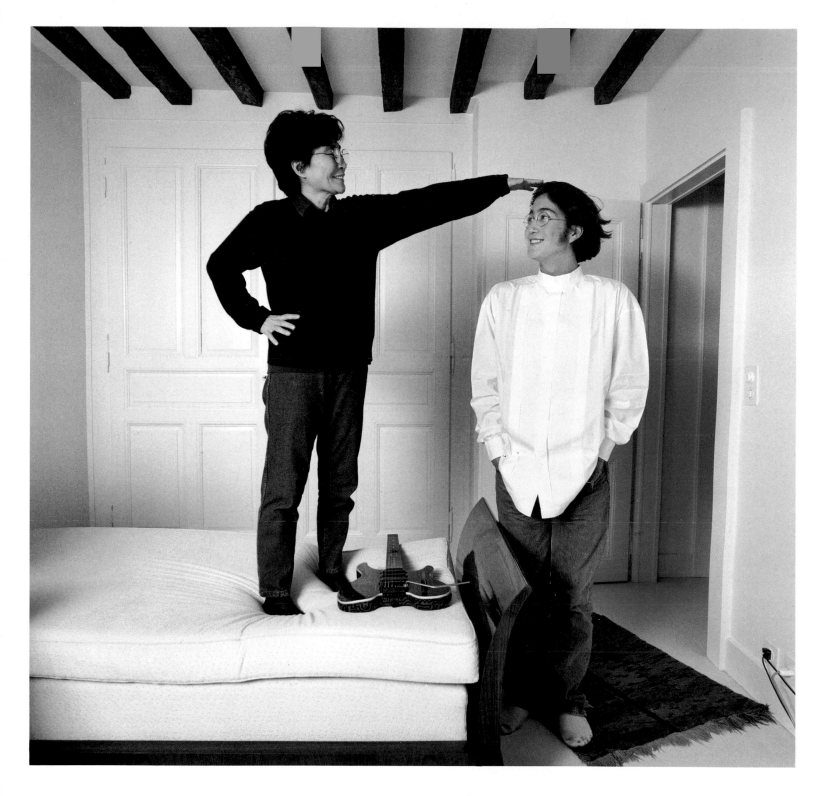

Yoko Ono and Sean Lennon. Geneva, Switzerland, 1990
On the tenth anniversary of John Lennon's death, I flew to Switzerland to
photograph them at their home for *People* magazine. I found Yoko Ono quite
down to earth. She wanted their son, Sean, to have values. She asked me to tell
him about John in the early years. I was surprised how tall Sean had grown
since I last photographed him. The last thing I said to him was, 'Your father
would be proud of you.' And I meant it.

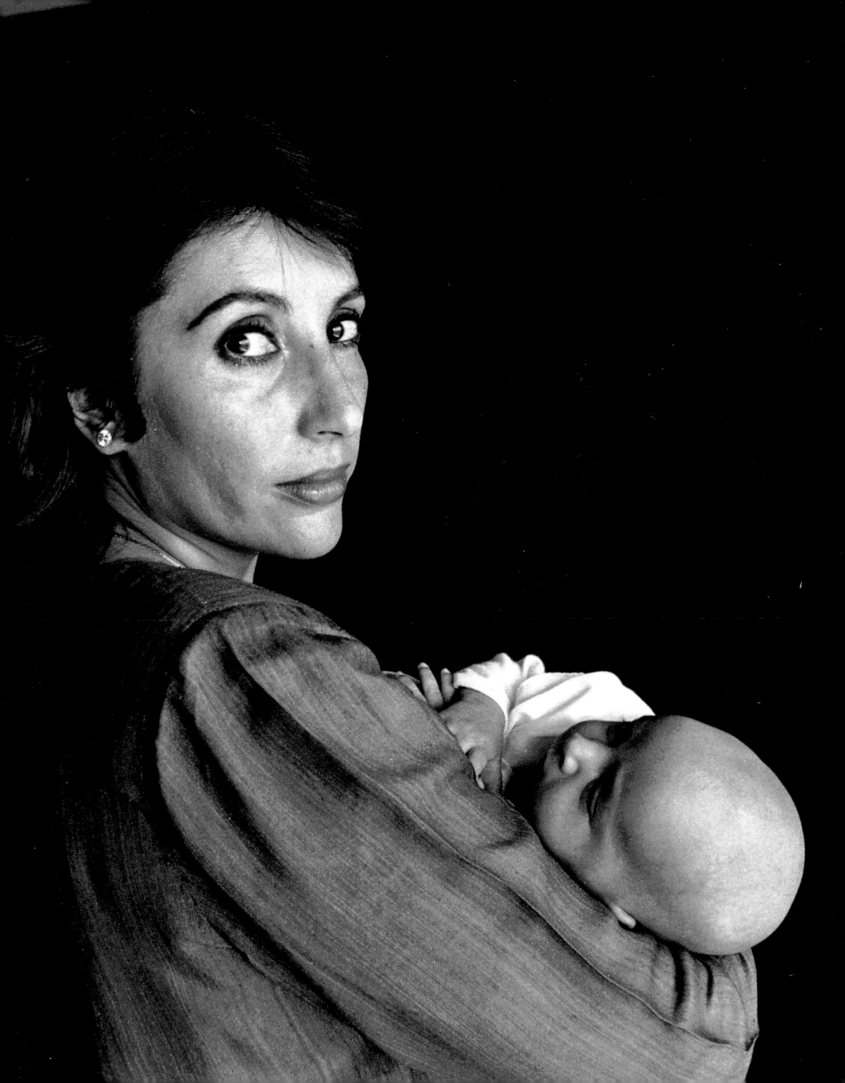

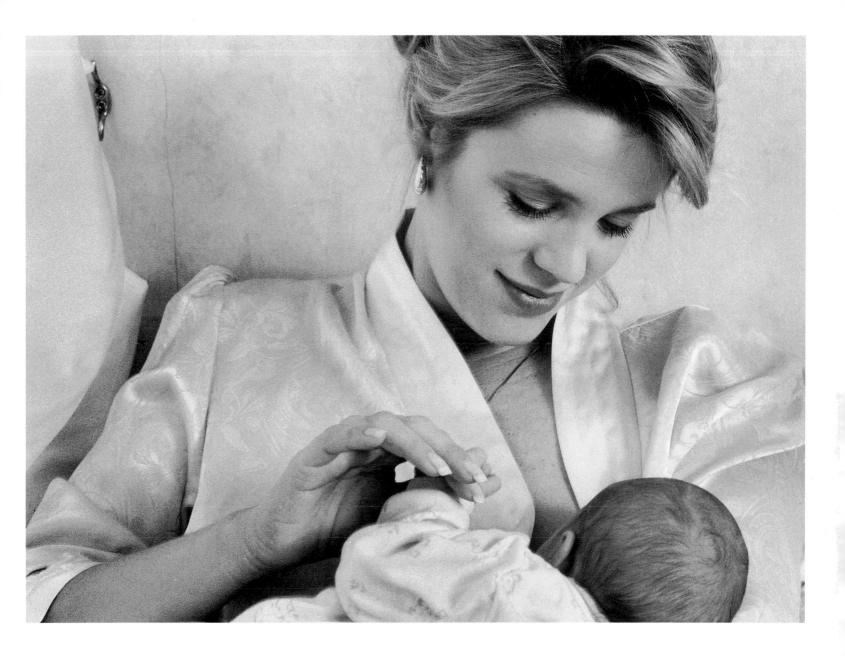

Deborah Norville and her son, Karl Nikolai Wellner.
New York City, 1991

Former *Today* show co-anchor Deborah Norville with her three week old son, Niki. I'd spent several hours photographing them for *People* when I asked if she had any ideas for another photograph. She said she had to feed the baby. Little did I know some of her colleagues would be critical—including a *Washington Post* reporter who said, 'no serious journalist would do that.' But I think if we took a vote of the readers of *People* and the viewers of *Today*, they would think it was good for the baby and perfectly acceptable. I said to her agent, Jim Griffin, if more people were open and natural, they would come across much better.

President Benazir Bhutto. Karachi, Pakistan, 1988

After travelling all the way to Karachi I was told she was off in the north campaigning for the presidency and wouldn't be back for three weeks. The thought of waiting three weeks was not something I relished. I hung up the phone, looked out my hotel window and the phone rang again. There had been a mistake and my appointment was for one o'clock that day. In Pakistan it's safe to say women come second, but no one told Benazir Bhutto that. She gives precise orders to her staff; she is totally in charge.

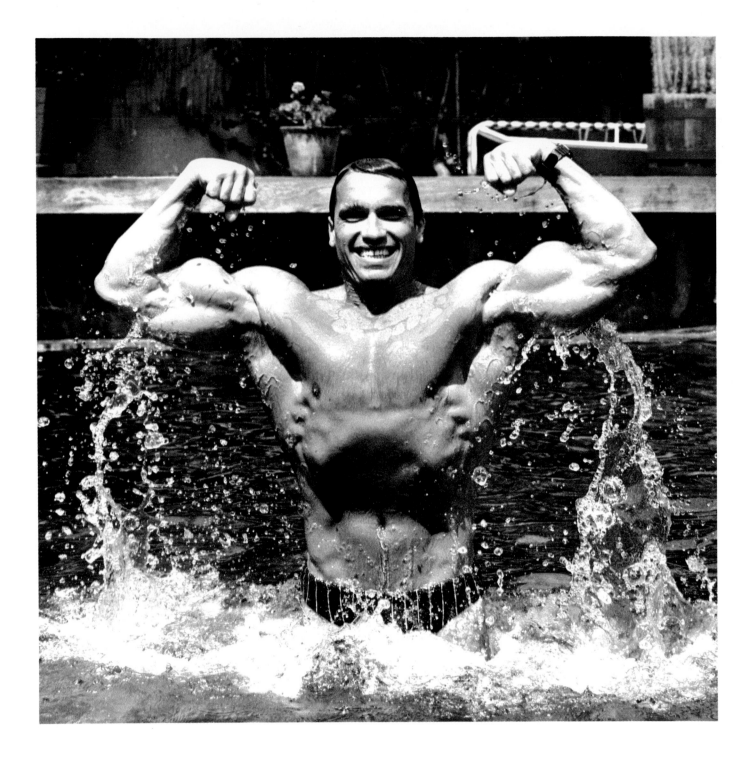

Arnold Schwarzenegger. Los Angeles, 1985
In the pool of his Los Angeles home, Schwarzenegger shows off the body that has
made him a star. He said he'd be sick in the head if he didn't appreciate the
life he's been given.

Dolly Parton. Nashville, Tennessee, 1976
She was looking into a full-length mirror and said she would be ready in a
minute. I answered, just keep doing what you are doing. It was a completely
spontaneous picture and by far the most natural one I took that day.

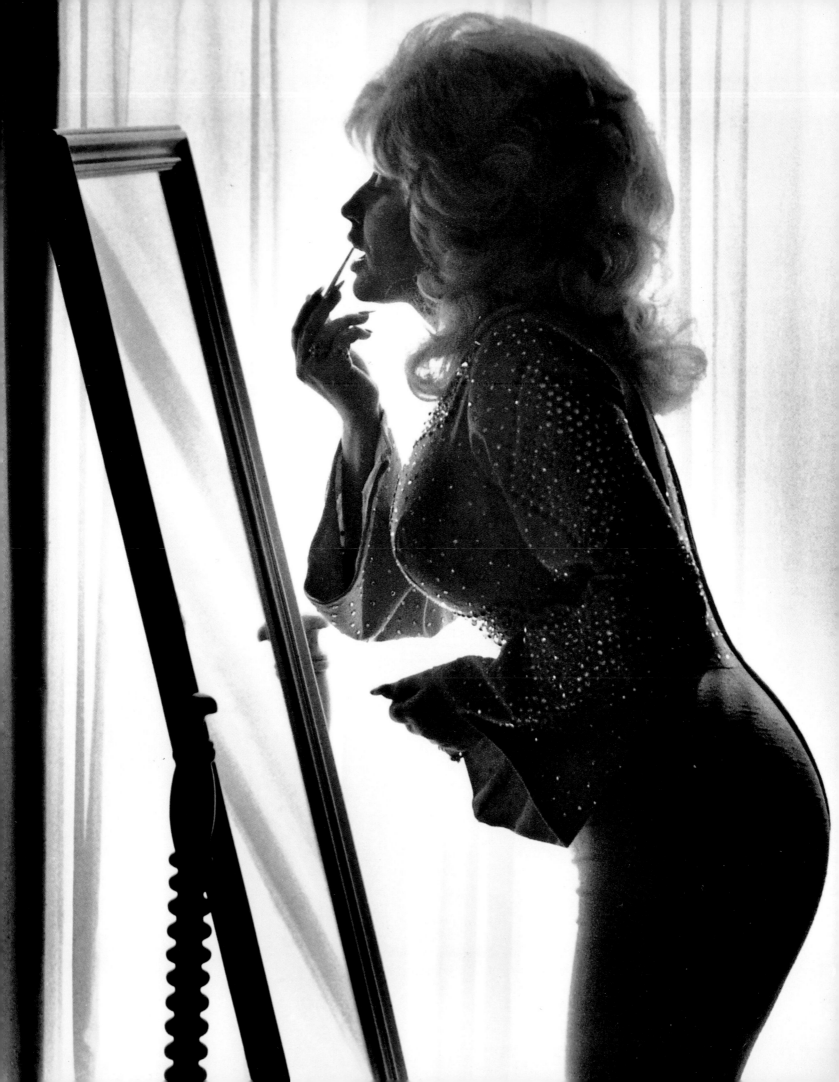

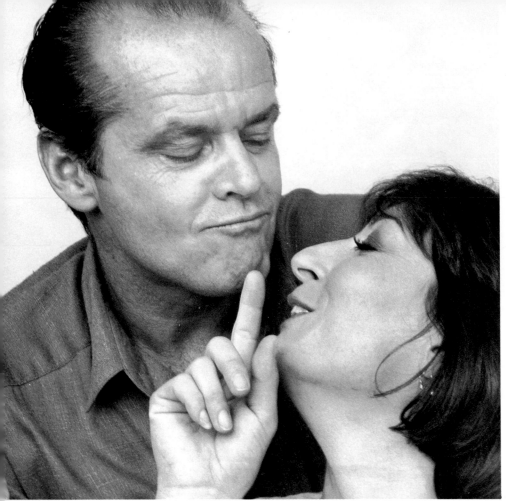

Jack Nicholson and Anjelica Huston. New York, 1985
They were both in *Prizzi's Honor* and posed for the cover of *People* to publicise the
film. He obliged strictly for her, to help her career. She was very quick-witted.
Nicholson, in my mind, is probably America's foremost actor today.

Mary Cunningham and William Agee. Bloomfield Hills, Michigan, 1982
Former chairman of the Bendix Corporation with his wife, Harvard Business
School graduate and former Vice President of Bendix, in their bedroom.
Together they had made a dramatic merger grab for Martin Marietta, the
aerospace firm, but lost.

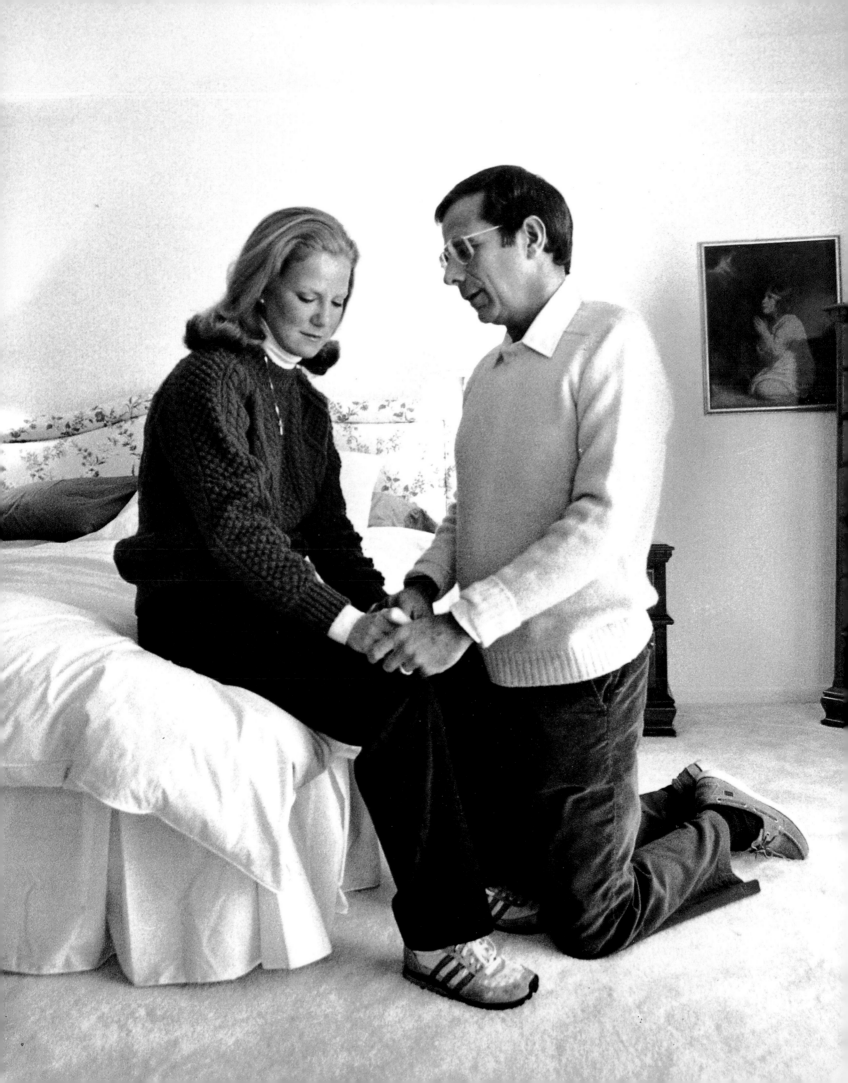

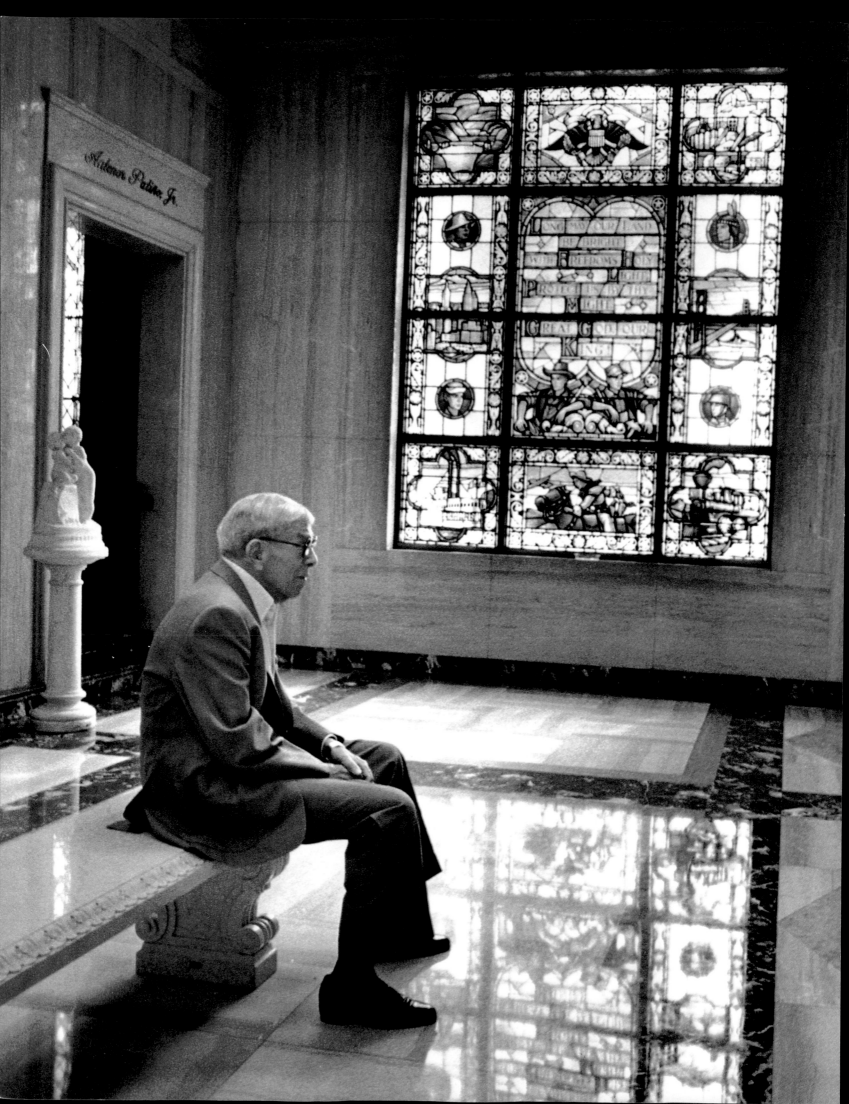

George Burns. Hollywood, 1988
George Burns visits his wife, Gracie, every week. He
sits there in the mausoleum and talks to her for a
while, telling her what he has been doing. He touches
the stone and, on tiptoe, kisses it before he leaves. He
told me she was in good company with Jeanette
MacDonald and Ramon Navarro in nearby vaults to
talk to at night when he's not there.

Princess Grace. Paris, 1982
This was one of the last photographs to be taken of her. She was a woman who
loved to be photographed. That day she was waiting, in her Paris apartment, for
her daughter, Stephanie, to arrive home from school.

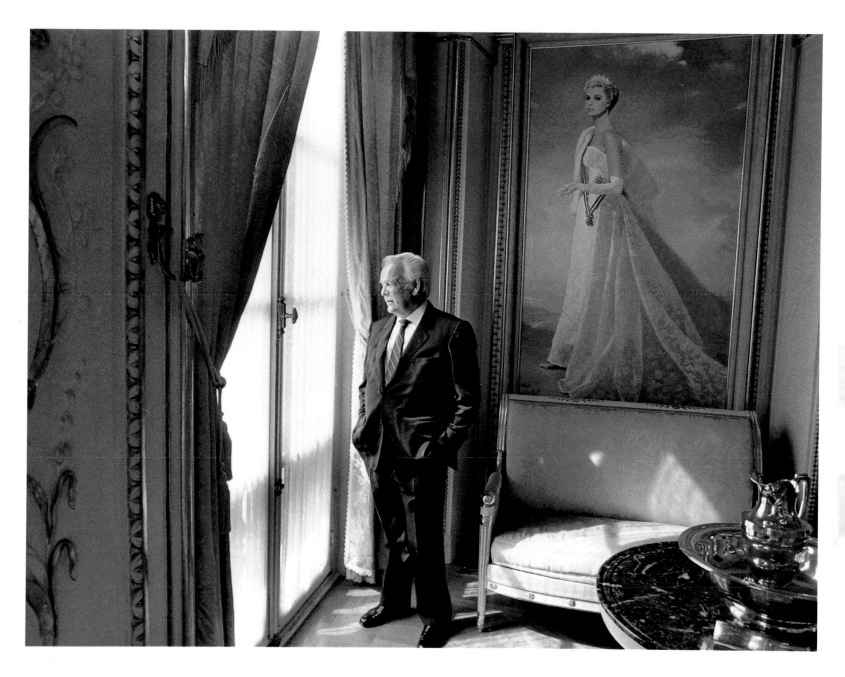

Prince Rainier. Monte Carlo, Monaco, 1989
A very quiet, refined man. There is a look of sadness and loneliness about him.
He said the portrait on the wall was just how he remembers her.

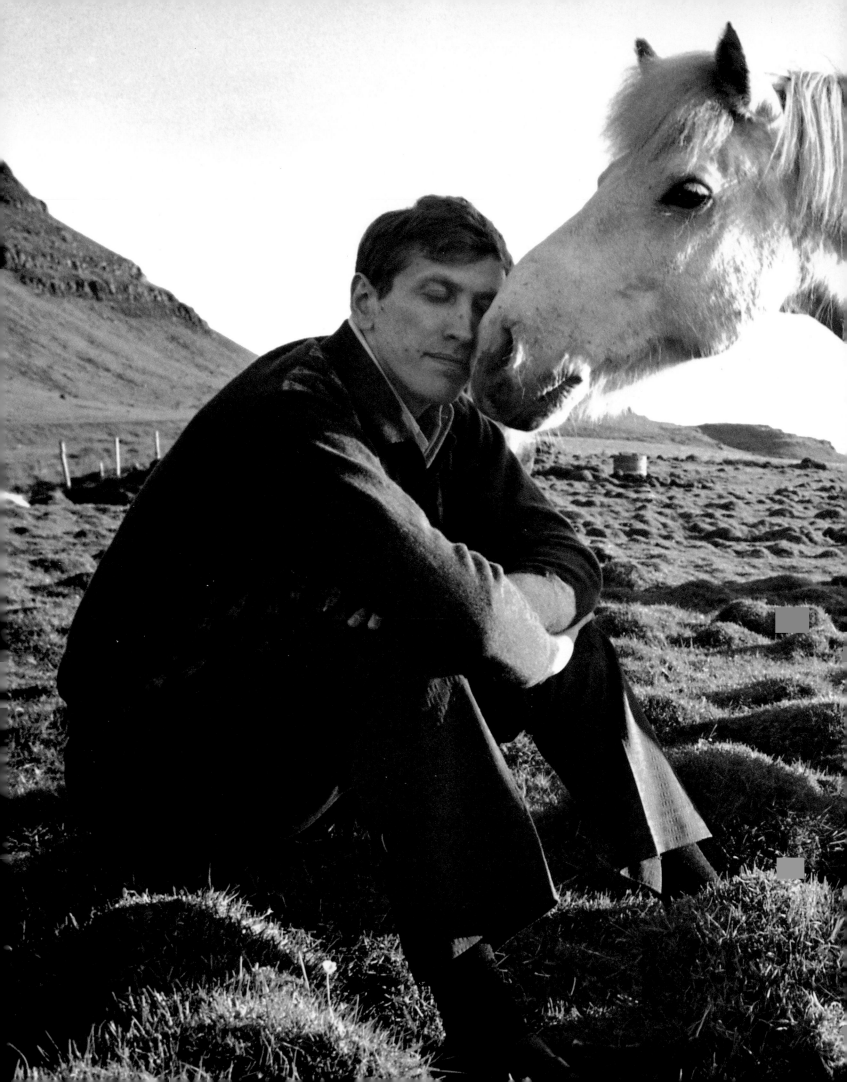

Bobby Fischer. Reykjavik, Iceland, 1972
While playing for the World Chess Championship
against Boris Spassky, he was literally a recluse.
Isolating himself from everyone, including his own
mother, he was afraid his telephone was being tapped
by the Russians and he kept his door tightly locked.
Having a horse kiss him seemed to fit in with the
idiosyncrasies of his personality. He asked me
afterwards if the horse would give him blood poisoning
– that question from a genius who could think twenty-
five moves ahead in a game of chess.

157

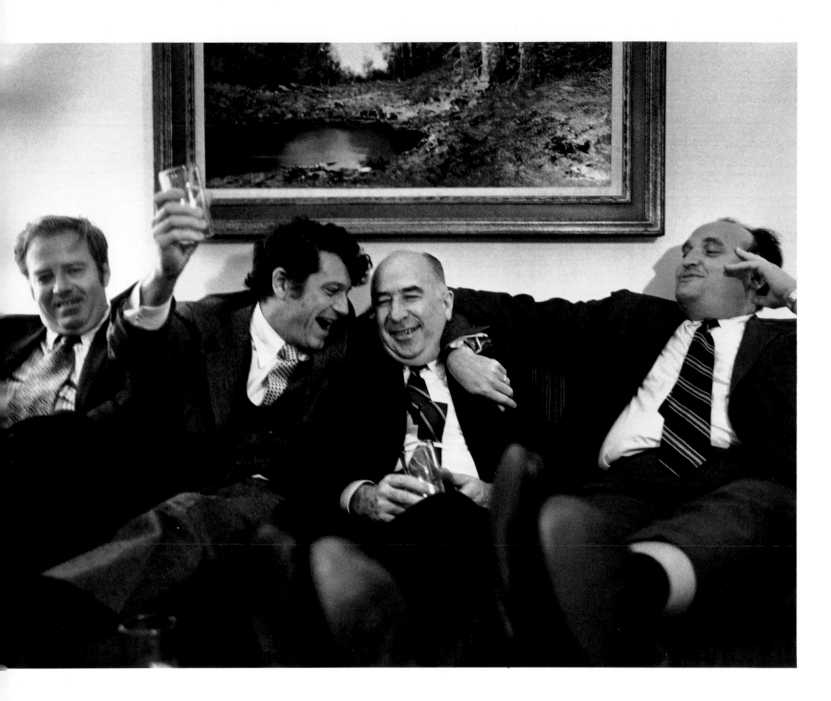

John Mitchell. New York, 1974

Attorney General Mitchell had been acquitted of conspiracy in the Vesco case in his first Watergate trial – and he was jubilant. After everyone else from the press had gone, he invited me into his hotel suite. When he heard I was Scottish, he sang the songs of Harry Lauder, an old-time Scottish vaudeville comedian.

President and Mrs. Richard Nixon.
The White House, Washington D.C., 1974

I always knew Pat Nixon was an emotional person, not as cold as the press had made her out to be when they dubbed her 'plastic Pat'. So I was ready for her tear during the President's farewell speech to his staff on his last day in office.

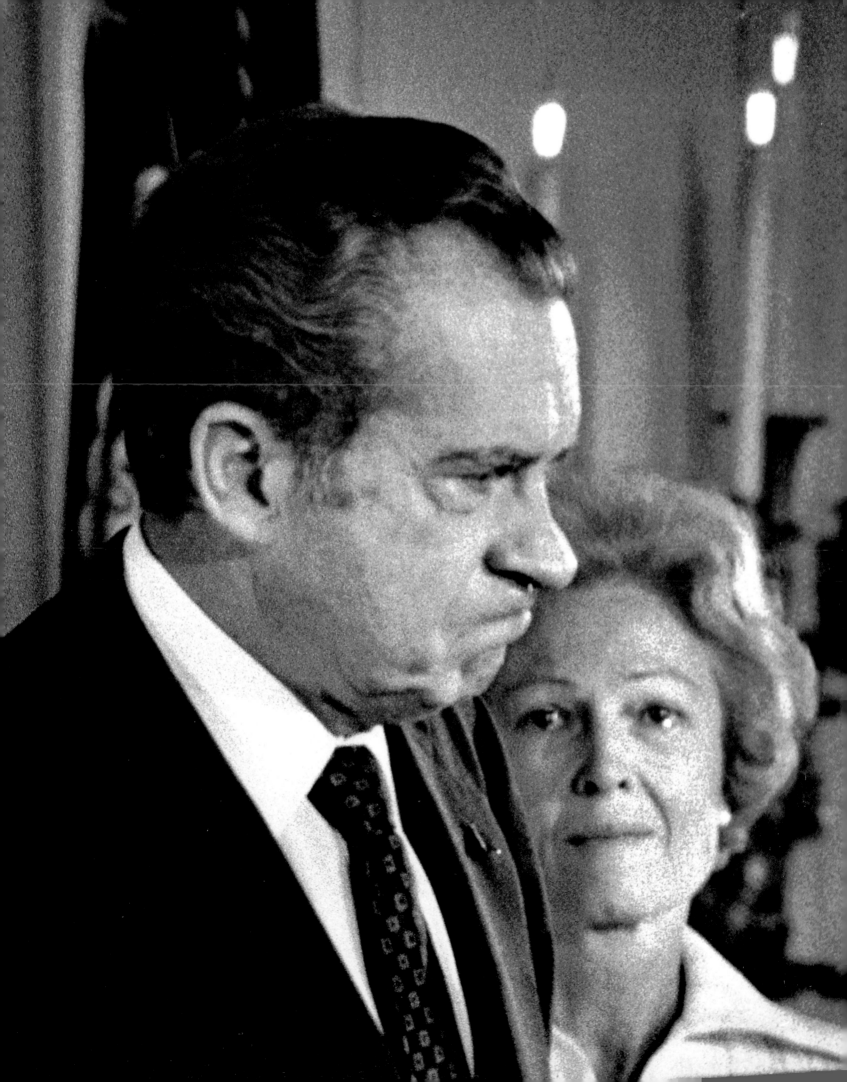

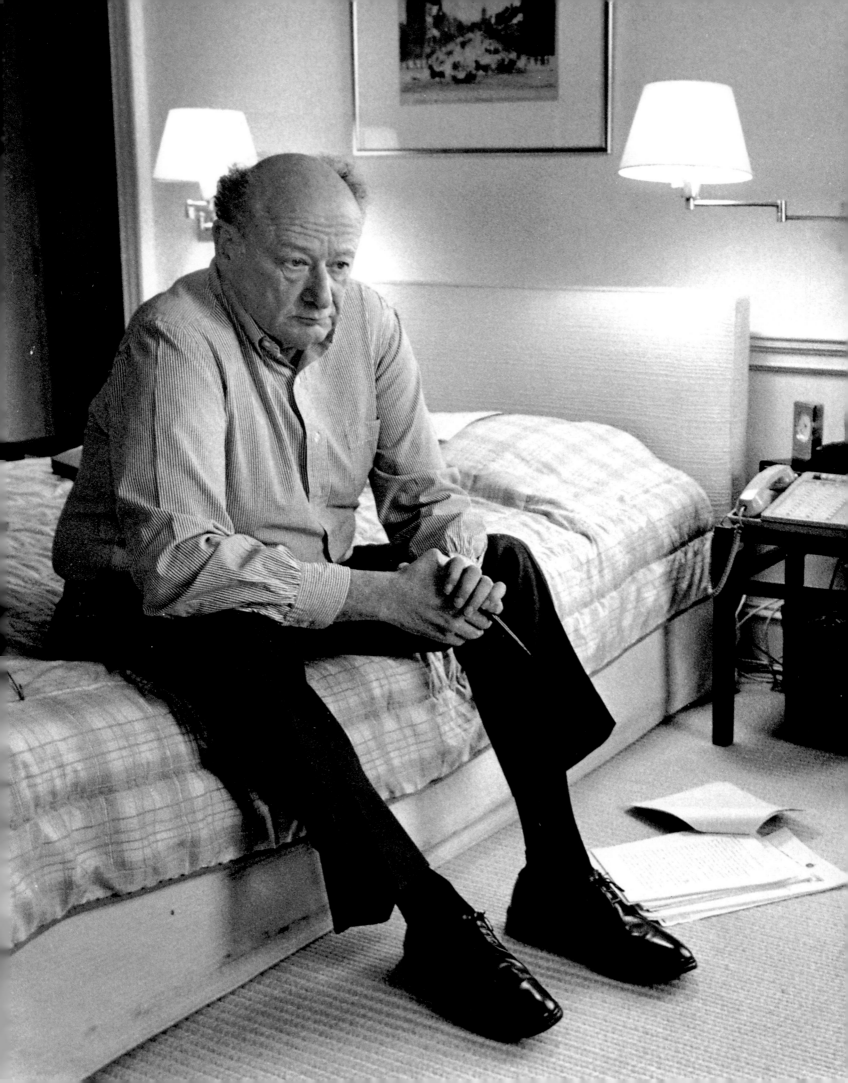

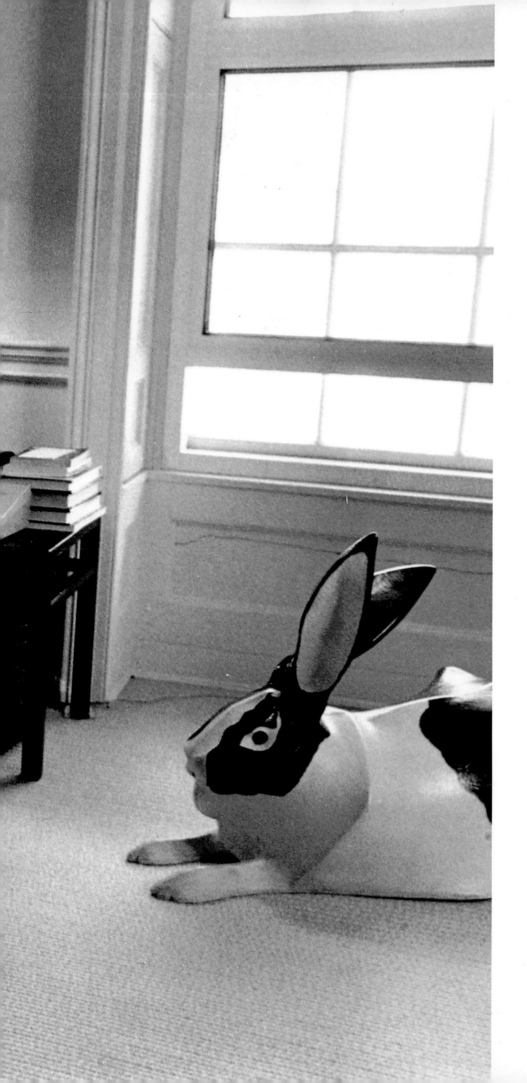

Mayor Ed Koch. New York, 1989
The lonely bachelor at home in Gracie Mansion with a
solitary porcelain rabbit was fighting for his political
life. The polls gave him no chance of winning
re-election – and win he didn't, but it was close.

161

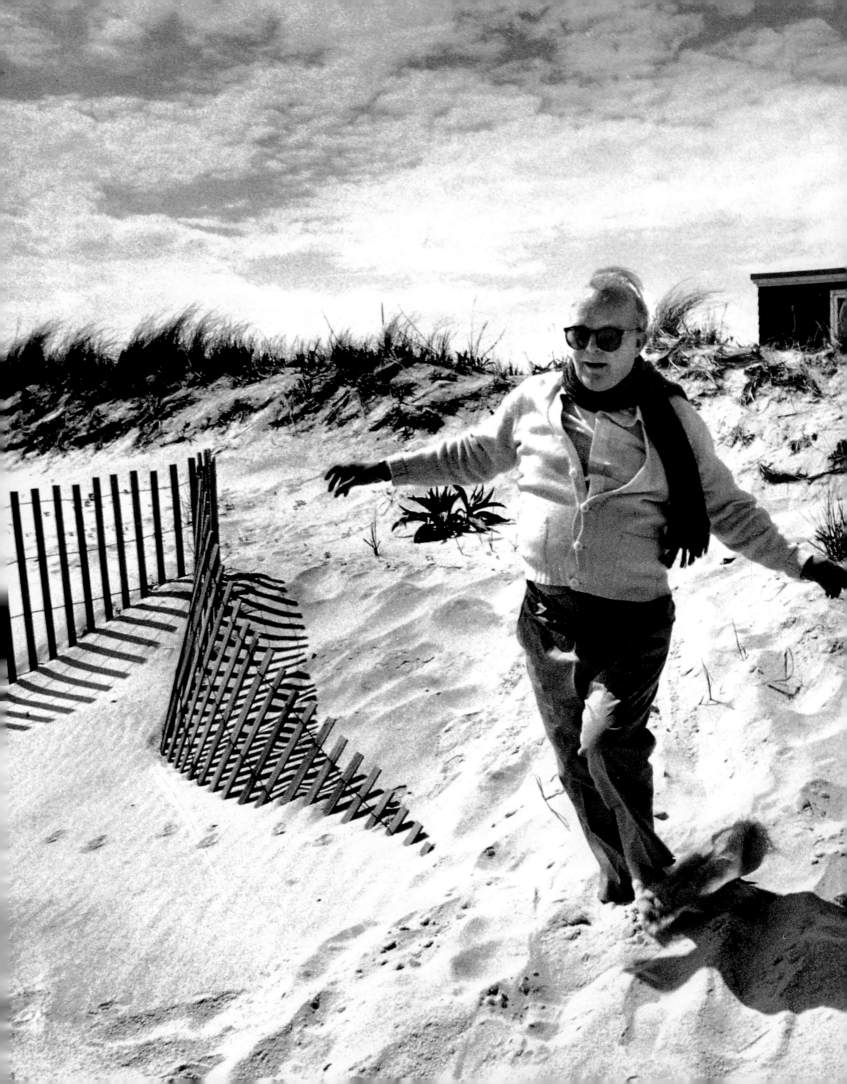

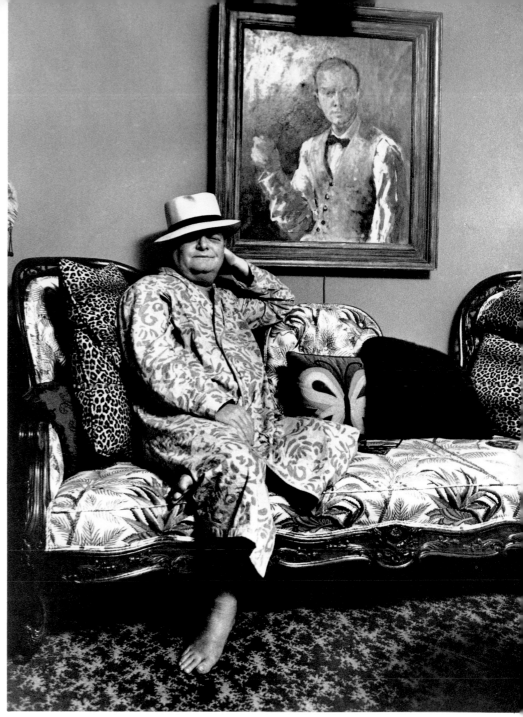

Truman Capote. New York, 1976
He was very bright and had an uncanny way of reading your mind. A very tough
little man. He always had an amusing story to tell – he made me laugh.

Truman Capote. Long Island, 1984
Truman was the most delightful, most
melancholic person I have ever met. Months
before he died, he took me to the beach at his
summer home where he had scampered as a
young man.

J. Paul Getty. London, 1974
In his London mansion shortly before he died, he
talked about how daffodils were his favorite flower,
how they were harbingers of spring. Only later did I
recall the poignancy of his remarks that day. When I
told him I had attended a gala party years before at
his home he said he was thinking of having another
one. But the party never came about.

164

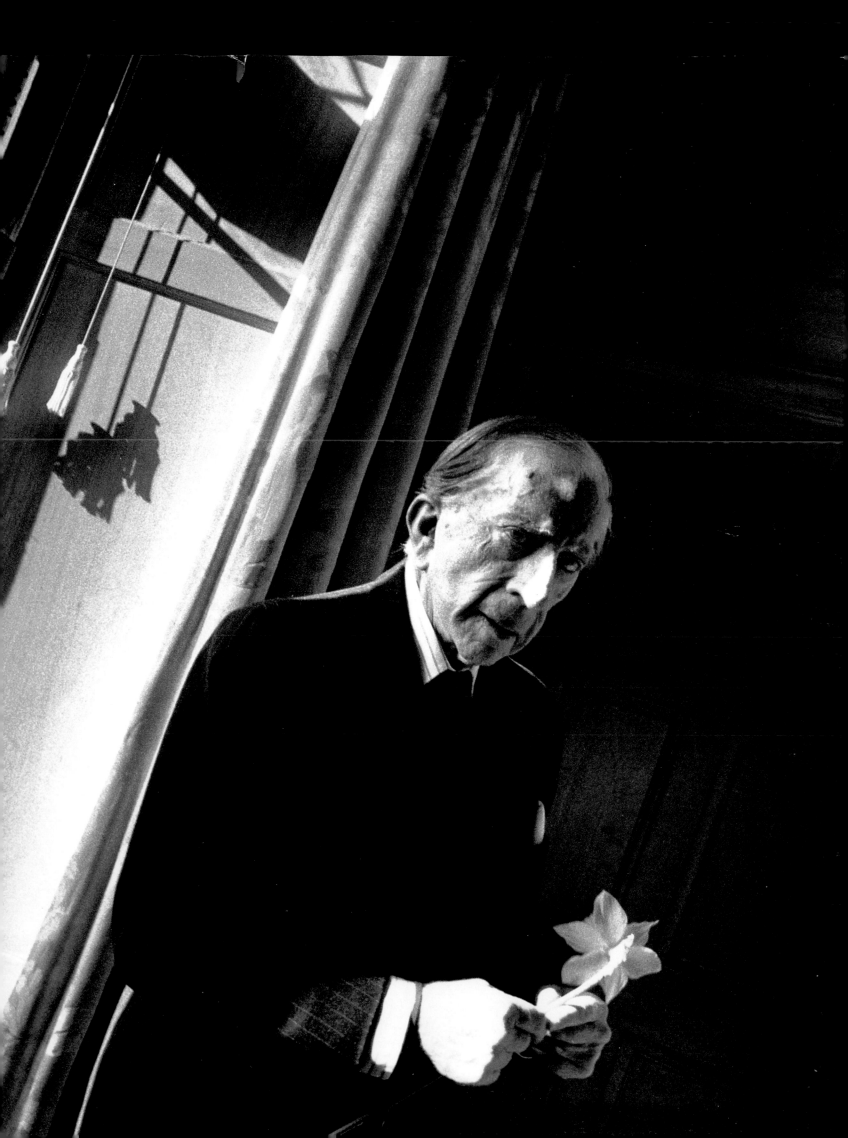

Dan Rather. Amman, Jordan, 1990
It was August 7th, four days after Saddam Hussein invaded Kuwait. I had been
sent by *People* to photograph Rather as he was the first journalist to arrive in the
Persian Gulf area. Dan Rather really loves the business of reporting, getting out
there and getting the story, wanting to do better all the time. In some ways he
reminds me of myself, for unless you go to see for yourself, no matter what is
said at editorial meetings in the office, unless you're there, doing your job, you
won't get the story.

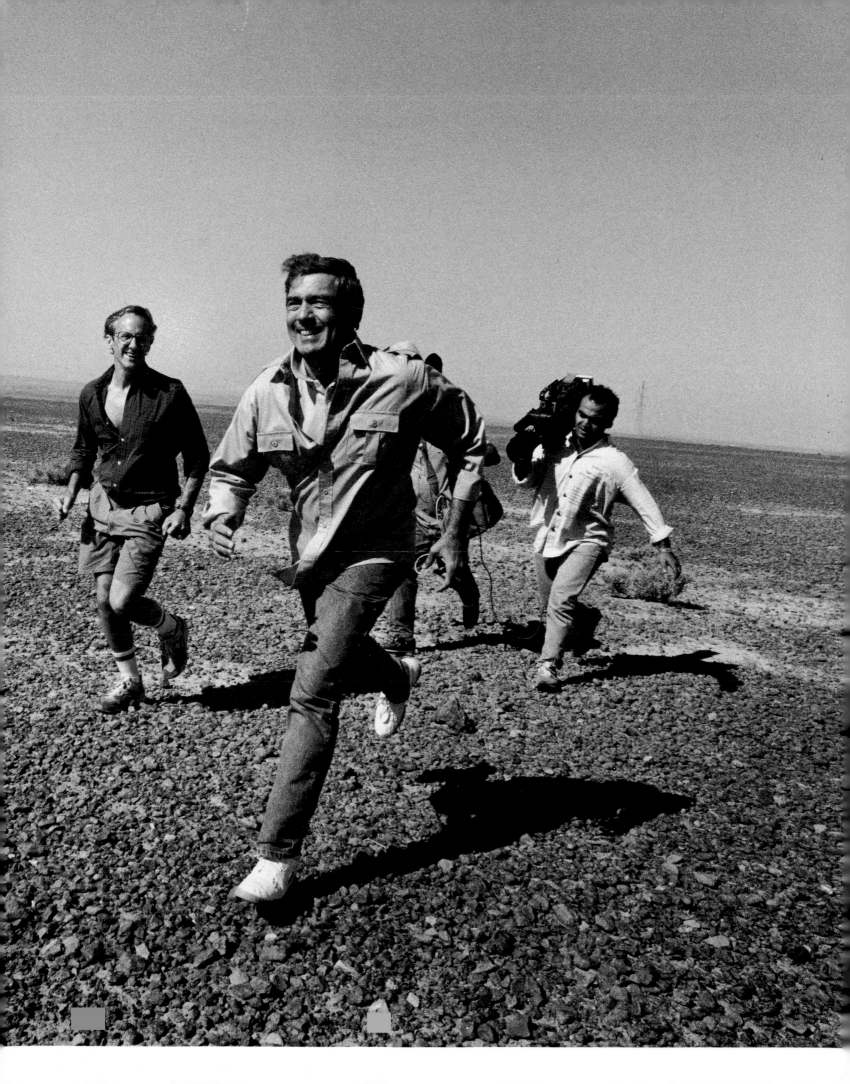

INDEX